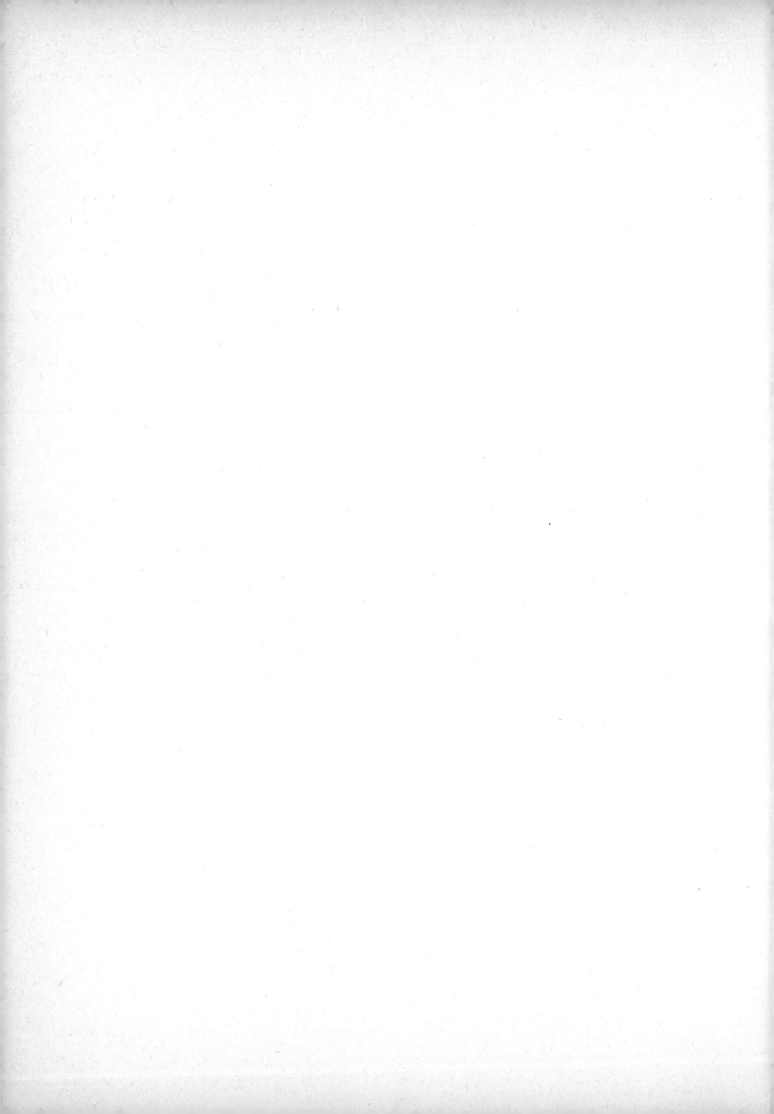

Treasures of WORLD ART

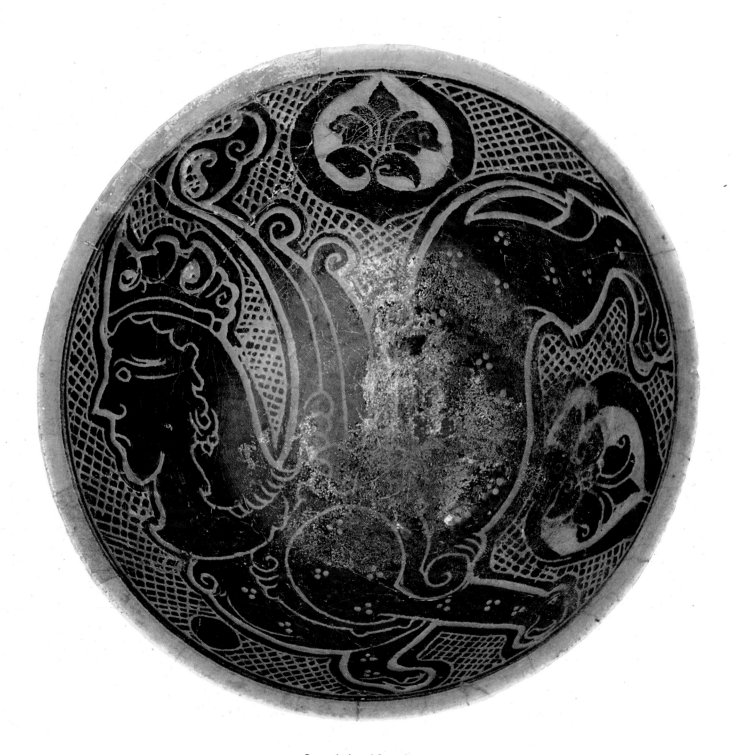

Ceramic bowl from Iran.
12th century. Underglaze
painted decoration. diam.
7½ in. (19 cm). Collection
of Edmund de Unger,
London.

Treasures of WORLD ART

Nicholas Fry

Hamlyn

London · New York · Sydney · Toronto

Contents

Published by
The Hamlyn Publishing Group
Limited
London · New York
Sydney · Toronto
Astronaut House, Feltham,
Middlesex, England
© Copyright
The Hamlyn Publishing Group
Limited 1975

ISBN 0 600 38722 4

Typeset by
V. Siviter Smith & Co. Limited
Printed in England by
Jarrold & Son Limited, Norwich

Introduction

Page numbers in margins refer to illustrations

The arts of man are the supreme expression of that which sets him apart from his fellow creatures. Man's technology is a product of his infinitely sophisticated mind, but the possession of technology in itself does not differentiate him from other animals. Faced with the ingenuity of a beaver's dam or the delicacy of a spider's web, man wonders at Nature's own technology.

Man can communicate with his fellows – and so it is proved can many other species. The fact that they may not appear to do so in an intelligible form merely betrays man's lack of communication with that species. Dolphins may be man's equal in intelligence, apes may be able to express themselves in human thought-patterns. Man in fact is left with little which he can call his own, save the knowledge that he is the earth's most successful species and is suffering from a surfeit of success. Even his now much-publicised penchant for fouling his own nest is not something for which he can claim exclusive discredit.

Yet there is one characteristic which we may call uniquely that of man, and this is his capacity for the particular form of play which he refers to as 'art'. Art is a form of play because it has no visible technological purpose – architecture is a combination of art and technology but in a sense the art is superfluous to its practical function. Art is the 'software' of human creativity; instead of having a practical technological function it affects man emotionally and intellectually, relating to the psyche and not to the physique.

If we divide art from technology in this way, we can see in the former two main facets, two poles which between them provide the motive force of artistic creation. And the first of these poles is man's passion for commemoration.

Man is obsessed with time, its passage and its irrecoverability. He shows an obsessive desire to measure time, to contain it and to freeze it in what might be called commemorative art – an art which aims to entrap the fleeting moment by recording a face, a gesture, an emotion, a particular incident or scene.

In a sense all art is commemorative, though it may have other functions. The shamanistic function of the earliest cave paintings which have survived does not detract from their commemorative value as a record of the animals which existed at the time, of the way the painter-hunter saw them, of his belief in that very magical value of his art. The royal portraits of the Mesopotamian kings and Egyptian pharoahs are obviously commemorative, but no less so are the great pyramids or the finely wrought utensils which have survived from that time, all a record of an epoch's attitude towards and interpretation of the world.

It is inevitable that portraiture, that quintessentially commemorative art, has remained popular throughout the ages. Comparing Roman busts and portraits with those of the present day, we are immediately struck by what we call their 'modernness'; but in calling them modern we are merely acknowledging that they too express man's desire to stem the onrushing tide of time and leave something of himself for 'posterity'. In the cinema, modern technology has enabled man to achieve the ultimate perfection of commemorative art whereby he can record his dreams and repeat them over and over again.

The second pole of man's artistic endeavour is his passion for decoration. The very fact that modern movements such as the Bauhaus have made a virtue out of functionalism merely demonstrates that his natural penchant is in precisely the opposite direction. Man is practically never content to produce an artifact for its sole functional purpose. Always he tends to decorate and embellish, be it with the patterns on an Iranian ceramic bowl or the airline livery on a modern jet.

The history of styles is the history of decoration. Throughout the ages, relative severity has alternated with decorative extravagance – one need only think of the contrast between Baroque and Classical, Rococo and Neo-classical in the 17th and 18th centuries. In modern times the issue has become more confused – industrial manufacturing processes and ever more specific and sophisticated technology have become strong coercive forces in man's treatment of the objects with which he surrounds himself in his daily life. The rapid alternation between the decorative extravagance of Art Nouveau and the severity of the Bauhaus movement and the work of architects such as Le Corbusier and Mies

van der Rohe betray man's uncertainty of how to compromise with these new demands; as we have said, he has found a characteristically human solution by making functionalism a form of ornament in itself.

But whatever the style of the moment, man has never entirely abandoned his penchant for decoration, applying it even to his most mundane technological inventions. It is a tendency which perhaps demonstrates the reasons for his unique success as a biological species, for it reveals his boundless creativity, his ability to meet the demands of any technological situation with such competence that he always has capacity left over for embellishing the finished product.

Commemoration and decoration, then, are the two poles of man's creative and artistic urge. This book will provide examples of both, sometimes in a purely artistic, at others in a more or less technological context. In providing a survey of man's artistic output over the ages, it is a celebration of his creativity, his capacity for invention, his passion for play, and his desire to achieve that timelessness which thinkers, critics and laymen alike have pronounced to be the essence of art.

Diego Velasquez. *The Infanta Margarita in Blue.* 1659. Oil on canvas. 50 × 42 in. (127 × 107 cm.). Kunsthistorisches Museum, Vienna.

The World of Primitive Man

Man, by current estimates, has existed on the earth for some two million years. For most of this time, as far as we can tell, he remained in an uncultured primitive state, living as a food gatherer, preoccupied largely with the need for survival. During this period, probably not more than half a million years ago, he began to develop language, and took his first technological steps in the form of simple tools. What his other activities may have been remains a matter of conjecture, for only fossilised bones and fragments of his tools remain to tell his story.

During the last Ice Age, the presence of large herds of game on the frozen wastes of the great continents led man to make a great evolutionary advance. From being a food gatherer he became a hunter, and it was as a hunter that he showed the first signs of cultural and artistic development. It was during this time also that he devised the earliest forms of religion, and as we shall see, this significant development was closely linked with his artistic activity.

Around 9000–8000 BC the last Ice Age came to an end, bringing with it a radical change in the earth's climate. The herds of game disappeared, the forests began to grow and, in the central portions of the earth's land-mass at least, man was forced to abandon his hunter's role. In the Middle East another great evolutionary step was taken – the discovery of domestication and agriculture. Gradually, agricultural communities spread throughout the world, leaving the hunter cultures intact only where climate or terrain were such as to make hunting a more efficient means of survival. By 2000 BC, food-production was established as the major mode of existence in Europe, and the so-called 'mature' cultures had already begun to develop. From around 5000 BC down to 500 BC, in China, India, the Middle East, Europe and finally America, civilisations appeared distinguished by an agricultural economy and sufficiently organised to have towns, calendars, numbers and writing. The appearance of these mature cultures, spreading like a belt round the centre of the earth's land-mass, spelt the end of the true primitive cultures, which were henceforth inevitably influenced by their more sophisticated neighbours. Hunting and primitive agricultural communities nevertheless survived, the former chiefly in the far north of Asia, Europe and America and in Australia, and the latter chiefly in Africa. And the fact that they survived, and have left quite recent examples of their art, enables us to gain a clearer picture of the earliest forms of human culture.

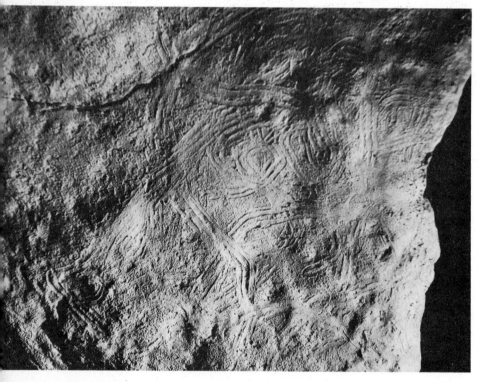

Musk-ox from the right-hand gallery at Altamira, Spain. *c.* 30,000 BC. l. (of drawing) 16 ft. 5 in. (5 m.).

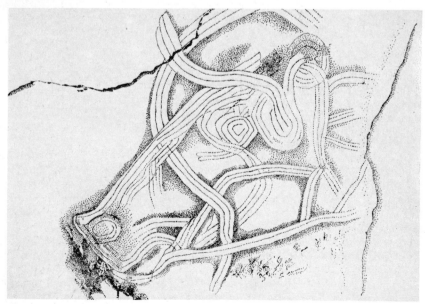

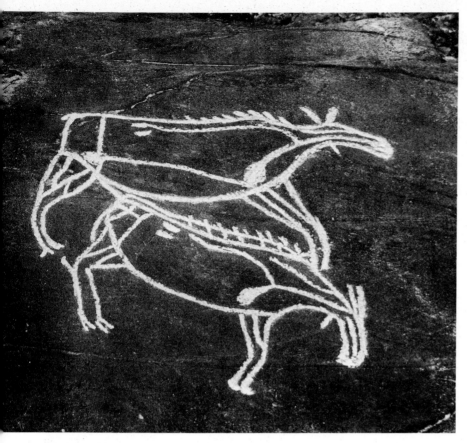

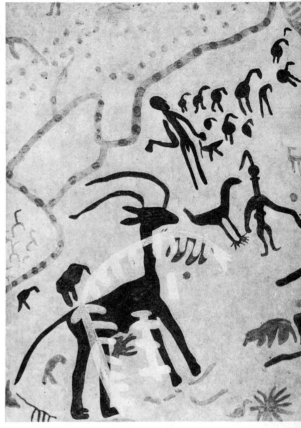

Rock engraving of elks mating, drawn over with chalk. Arctic art (eastern group). *c.* 5000–2000 BC. l. (of figures) 28 in. (70 cm.). Kløtefoss, Gjeithus Modum, Buskerud, Norway.

above right
A stag and other figures with abstract signs superimposed. Second Hunter style. *c.* 6000–2000 BC. Copy of a rock painting. Cueva de Tajo de las Figuras, Casas Viejas, Cadiz.

The Beginnings of Human Art

Man's recorded history as an artist begins around 30,000 BC, in a cave at Altamira in northern Spain. Here a hunter-artist daubed a design with his fingers in the wet clay of the cave wall which at first appears no more than an abstract doodle, but on closer inspection proves to be a coherent representation of a musk-ox's head. Immediately we recognise the two main elements which even at this early stage characterise man's artistic endeavours – the commemorative or representational, recording a facet of the hunter's everyday existence, and the decorative, revealed in the playful curves and spirals which form an ornamental pattern in themselves.

Yet the art of the early hunters was not only representational and decorative, it had a definite function. Sophisticated man manipulates nature to his own ends; primitive man felt himself a part of nature, part of an organic whole into which he tried to integrate himself by magical means, as in a series of animal paintings on the wall of a cave at Lascaux in France. These paintings are characteristic of early hunter art, and to a mind conditioned to think of 'primitive' man as being necessarily backward or naive, they are astonishingly assured and sophisticated in their representational style. The fact that the paintings are often superimposed supports the theory that they were executed with magical intentions. The hunter hoped by painting a picture of his game to gain control of it and thereby overcome it the more easily. Such a painting would have a limited life; once its magical virtue had been exhausted it would be replaced by another, often painted over the top of the first. Many such paintings appear to contain stylised representations of traps, and the red marks above the ox's muzzle on the left may well come into this category.

The early hunters' art gradually spread from south-western Europe, assuming the status of a universal style. In northern Europe, rock engravings show a refinement which is known as the 'X-ray' style. In this the animal's internal organs are portrayed in a stylised form, in the belief that this will enable the hunter to capture the animal's soul and ensure its reincarnation in the world of animal spirits. The engraving of two mating elks shows these two features and is also clearly an attempt to promote the procreation of game by magical means.

Under the influence of the mature cultures in the Middle East, the style of the hunters' art began to change. In what is known as the 'Second Hunter' style, human figures begin to appear, and smaller animals such as deer, boar and dogs. First appearing on the Mediterranean seaboard of Spain, these new rock paintings are less representational, more stylised than before, but the human figures in particular have an unusual sprightliness and grace.

9

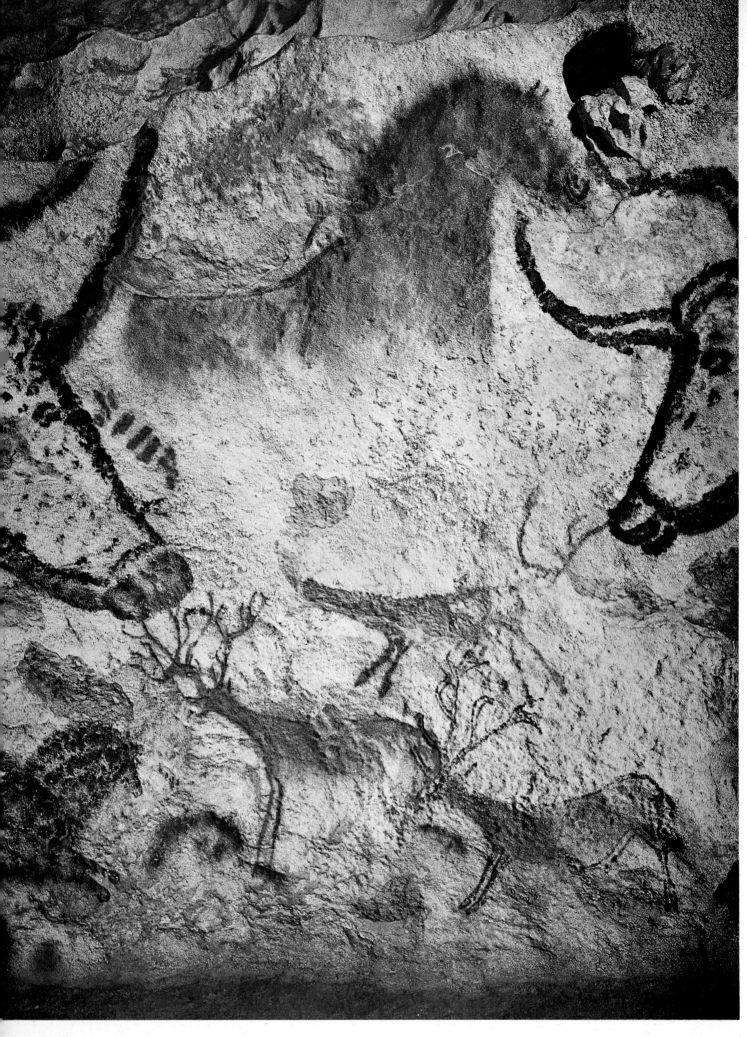

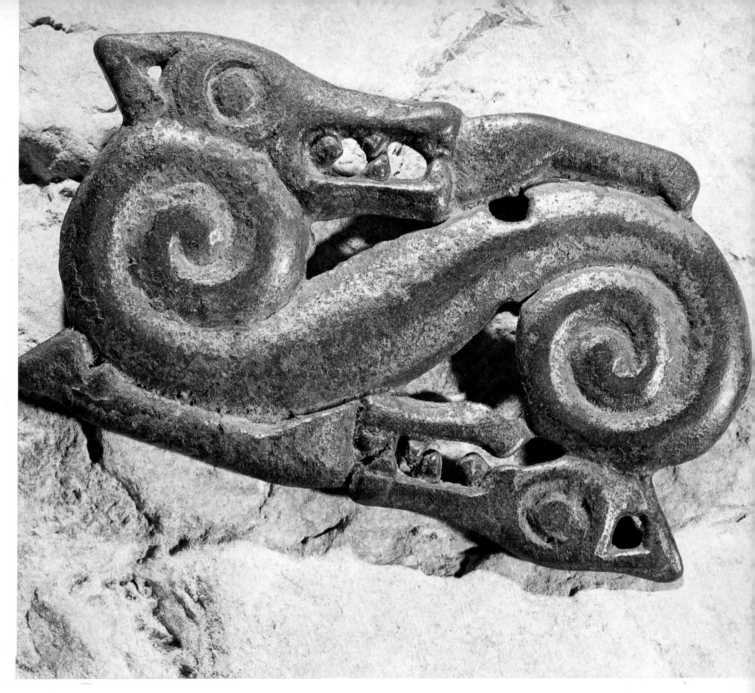

Animals of the chase. *c.* 15,000–10,000 BC. Cave painting. h. (of deer) *c.* 31½ in. (80 cm.). Lascaux, France.

Ornament with spirals and animal heads from northern China. 5th–2nd centuries BC. Bronze. h. 2 in. (5 cm.). Museum für Völkerkunde, Munich.

Agriculture and Fertility

The coming of agriculture brought about a radical change in the relationship between man and his environment. Whereas the hunter tried to control nature's creatures by magic, the primitive farmer was more concerned with the fertility of his soil. The snake, symbol of the soil, began to appear in art.

The beginnings of systematic food production naturally led to a demand for storage vessels. And the neolithic or New Stone Age, which began with the discovery of agriculture, also saw the invention of pottery. As we have said, man is never content to produce an artifact for its sole functional purpose, and the smooth surface of the newly created vessels was an obvious invitation to decorative ornament. Early painted pottery from western Asia is decorated with abstract patterns in which the snake symbol, stylised into a spiral, frequently appears. The spiral is in fact one of the characteristic motifs of early civilisation and its presence can be used to trace the spread of cultural influences right across the world from Mesopotamia as far afield as India, China and America. It appears in Chinese bronze ornaments, South American fabrics, and in the monuments of the megalithic culture which spread by sea through north and western Europe around 2000 BC. Megalithic tomb builders in Ireland, for example, used the motif extensively on the lining slabs of their tombs.

The early hunters were concerned with the fertility of their game, the farmers with the fertility of the soil. For both, woman became a symbol of nature's procreative powers, and from as early as 15,000 BC we find stylised representations of the

11

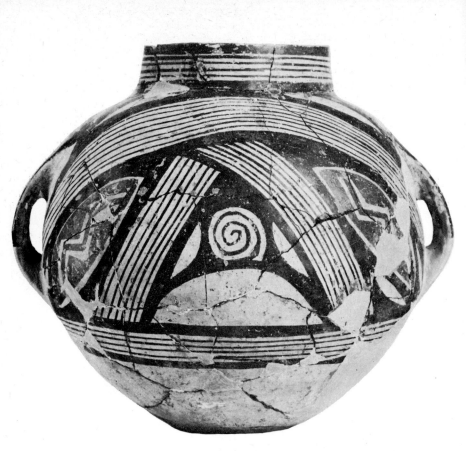

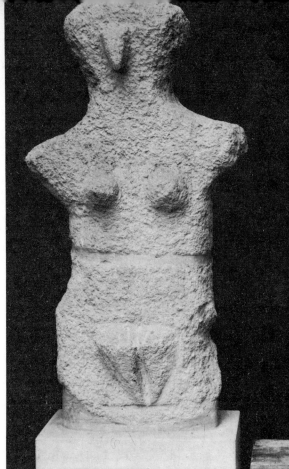

Late neolithic polychrome painted vessel from Thessaly. *c*. 2500 BC. White pottery painted black and red. Dimini, near Volos, Greece. National Museum, Athens.

right
Incised spirals (in the north recess of a barrow tomb). *c*. 2000 BC. New Grange, Ireland.

above right
Early 'Cycladic' female figurine, probably a primitive fertility goddess. British Museum, London.

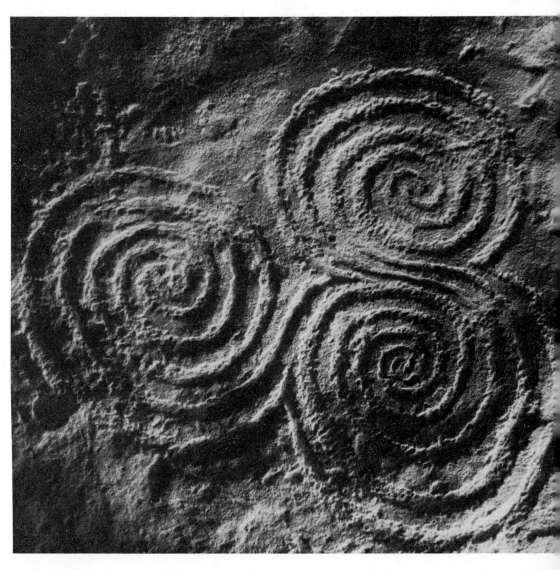

female form in which the female attributes and sexual organs are exaggerated often to a grotesque degree. The early 'Cycladic' stone figures found in the area round the Aegean are typical of these idols to some primitive goddess of fertility. In the example shown the breast and vulva are accentuated while the arms and head are treated in the most perfunctory fashion.

The Art of The Steppes

While the peoples closest to the belt of the 'mature cultures' which spread round the earth from 5000 BC onwards came under their direct influence at an early stage, farther to the north and south the ways of the hunters survived, particularly their belief in the magical potency of animal images. On the broad steppes which cover the northern parts of Europe and Asia, the hunters were succeeded by nomadic herdsmen who ranged freely between East and West, carrying the themes of hunter to China and beyond. The nomads applied their decorative talents to the everyday

articles of their way of life – their harness, tents and rugs and other portable goods. Decorative metal work was common, in the form of clasps and ornaments or simple plaques. The backward-glancing animal is a characteristic theme of hunter art and here it is refined almost to the point of abstraction.

An elaboration of the hunters' magical beliefs which belongs specifically to the nomads, the familiar spiral, once representing the snake-earth symbol, has now become an integral part of a different kind of animal. The combination of apparently unrelated animal parts in the so-called 'dismembered' style stems from the belief that possession of even the parts of an animal gave the Shaman (tribal medicine man or witch-doctor) the power to resuscitate the whole animal.

Though originating in the mature cultures of the Middle East, the spiral may also be seen as an extension of the X-ray style in areas which underwent the influence of hunter art. In this context, the spiral appears as a stylised representation of the animal's intestines, eventually turning into an overall surface pattern. Whether in its original form or metamorphosed by contact with the traditions of hunter art, the spiral motif had by the end of the second millennium BC reached the islands of Japan, where it appears, in a purely abstract form, on neolithic Japanese pottery. The tenacity of this particular motif forcibly illustrates man's passion for decoration, showing how he will become obsessed with a particular form, using it over and over again while its original symbolism or significance has long been forgotten.

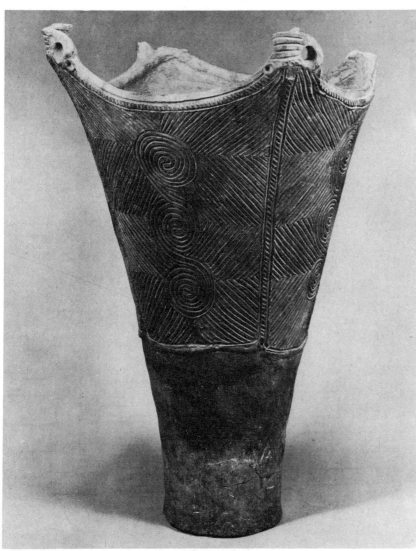

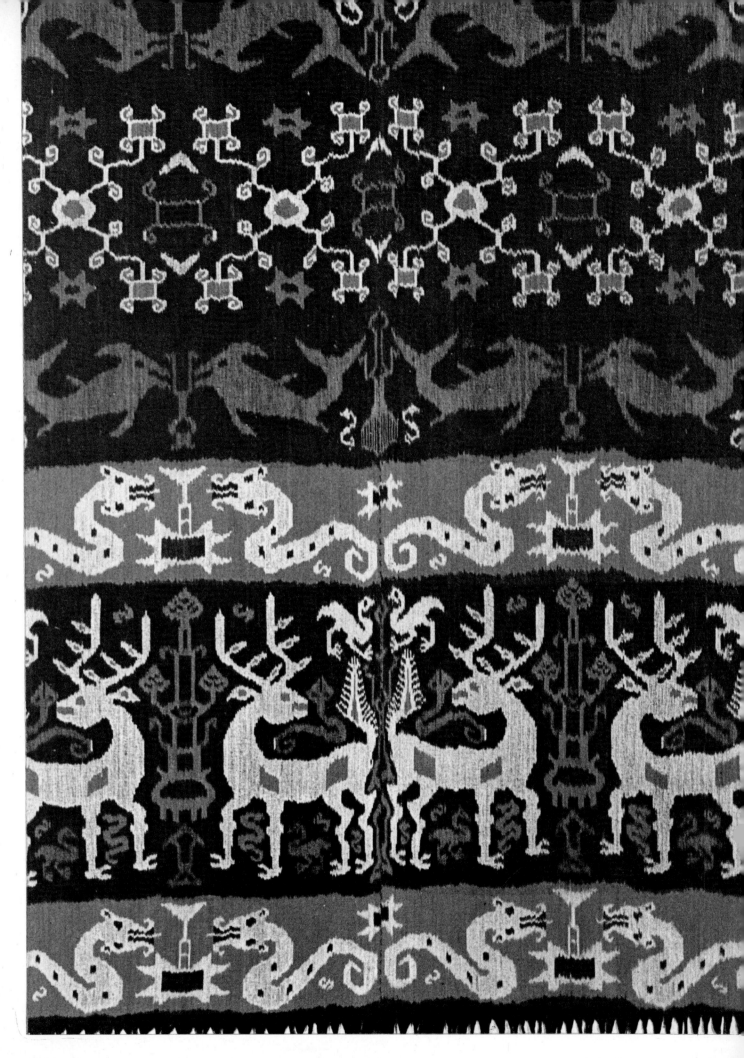

Ikat textile from Sumba Island, Indonesia. Late 19th century. Woven cotton. h. 3 ft. 10 in. (117 cm.). Museum für Völkerkunde, Munich.

Painting from Gaua Island, Banks group, New Hebrides, Melanesia. 19th century. Wood. h. 27½ in. (70 cm.). Museum für Völkerkunde, Munich.

15

Oceania and Indonesia

As we follow the spread of the primitive cultures farther to the east, we find ourselves in areas where these early types of civilisation have persisted into modern times, and their art with its characteristic motifs remains part of a living tradition. Indonesia has been an area of primitive farming cultures from the first millennium BC, and they fall into two main types – neolithic or Stone Age cultures originating around 1500 BC, and Bronze Age cultures originating between 150 BC and 50 AD. The art of the neolithic farmers was megalithic in style – great stone monuments, menhirs, dolmens, pyramids and mounds. The Bronze Age art however follows the decorative tradition of the nomad cultures, particularly in its use of writhing animal forms which obviously relate to the serpent-spiral motif.

The most vigorous Bronze Age culture is given the name of 'Dongson', from the name of a village in Vietnam which is one of the principal archaeological sites, but the traditions of Dongson art still live on among the Dayak people of Borneo. Their intricate wood carving shows very obvious links with the serpentine animal forms of nomad metal work, and Dayak art may well have undergone direct influence from China.

The persistence of these primitive motifs into the modern era is found on Sumba Island in Indonesia. The snake and the backward glancing stags have already been noted as characteristic motifs of primitive art, and the dolphin-like creatures in blue

Carved wooden Dayak doors from Borneo in the 'ornamental-fanciful' style. British Museum, London.

Indonesian carved wooden bowl supported by two squatting figures, from Sumatra. h. 9½ in. (24 cm.). Museum für Völkerkunde, Munich.

show a curious resemblance to the 'dismembered' style of the hunters. Ornamental fabrics such as these were used as shrouds for the dead, and an interesting feature is the 'skull trees' between the stags; these were set up at the entrance to every village and festooned with the skulls of slain enemies as a protection against evil spirits. The belief in the magical potency of the skull is one aspect of a system of beliefs which is highly developed in South-east Asia and Indonesia.

Ancestor Worship: the Squatting Figure and the Skull

In the artistic expressions of the ancestor cult, the idea of commemorative art takes on a new significance. To the primitive farmer peoples of South-east Asia and Oceania, an artistic representation or token of a dead ancestor is not only a reminder of the past, it is a source of spiritual power and fertility which ensures the community's survival both through the production of offspring and through the maintenance of long-established traditions. Whereas the commemorative art of 'rational' man aims to freeze a particular moment in what he regards as the linear progression of time, the commemorative art of primitive man regards the past as everpresent in the watchful spirits of his dead ancestors.

The principal artistic form of the ancestor cult is that of the squatting figure. The posture symbolises both the foetus and the mother giving birth. In the early farming communities in southern China, the dead were buried in the squatting embryo position in the belief that this would ensure their rebirth, and hence the representation of the dead in this posture is natural enough.

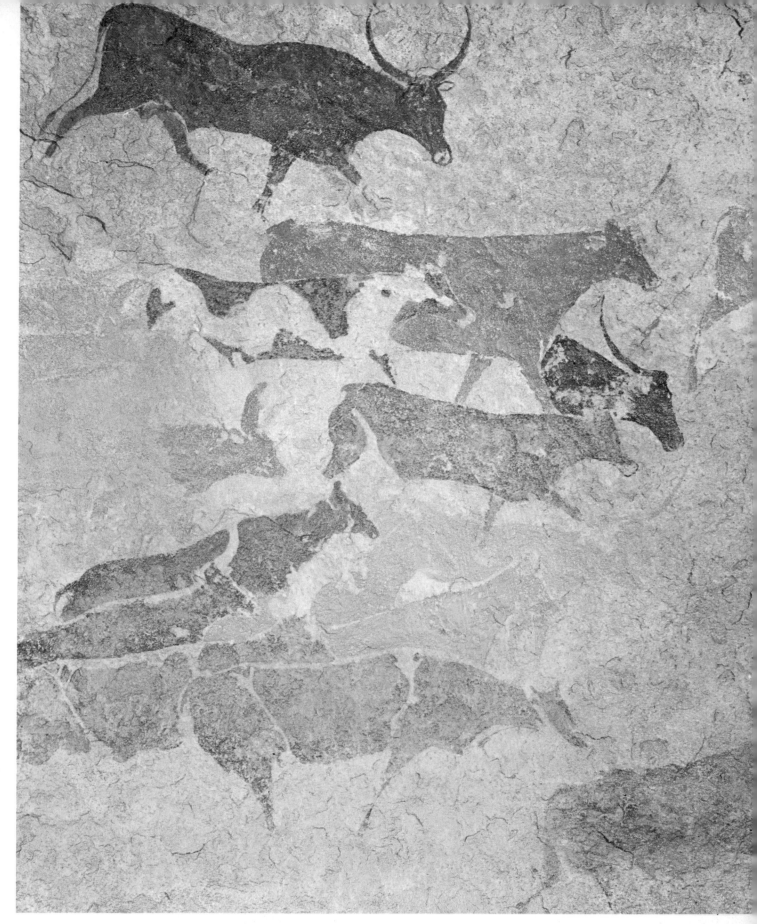

Mask from Saibai Island,
Torres Strait, Papua.
Probably early 20th
century. Wild plum wood,
shells, grass and fibre. h.
$28\frac{1}{2}$ in. (72·5 cm.). Royal
Scottish Museum,
Edinburgh.

Cattle. 'Bovidian' period,
c. 5000–1200 BC.
Polychrome painting on
rock. l. 46 in. (116 cm.).
Jabbaren rock shelter.
Tassili-n-Ajjer, Algeria.

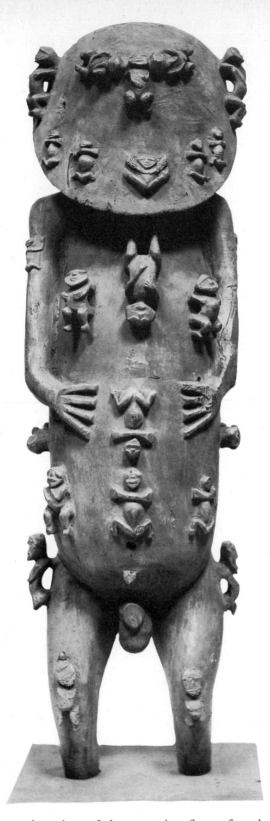

born gods bursting forth from the bent-knees figure of their creator.

While the squatting or bent-knees figure represents, in the South-east Asian ancestor cults, the spiritual power of a dead ancestor, the true repository and focus of that power was believed to be the head. Thus possession of the dead ancestor's skull itself was the most direct means of entering into contact with his spirit and partaking of that power. And to possess the skull of an enemy would give control of his spirit while depriving his own descendents of its power. The latter belief explains the practice of head-hunting, while the former resulted in skull-cults in which the skull of an ancestor was retained as an object of worship, sometimes incorporated into a squatting figure. The skull could be covered with clay and modelled into a realistic representation of the dead man's features. Thus the skull becomes not only a source of spiritual power, but also a reminder of the dead man's physical presence and personality.

If the skull has a magical potency of its own, then so, clearly, does the face. The mask is a widespread motif in the art of primitive agricultural communities. It is a stylisation of the face which no longer has a commemorative value but is created solely for the magical purpose of warding off evil. A dramatically decorated mask was worn in Melanesia for the celebration of the wild plum harvest, where it would no 18 doubt have served to discourage evil spirits and ensure the fertility of future crops.

Africa

If we now move to the African continent, we find that primitive art here displays much the same characteristics and preoccupations as in those areas which have already been mentioned. Moreover it is in Negro Africa above all that the forms of primitive art still find their most lively and vigorous expression.

Stone Age art in Africa bears striking resemblances to what we have already observed in Europe. Monumental rock engravings in the Atlas mountains of Algeria mark the southward course of the hunter art which began in the Franco-Cantabrian caves. The most dramatic examples of Stone Age art are to be found in the famous Tassili rock pictures in the central Sahara. The paintings date from the period at which the area was occupied 19 by nomadic herdsmen, and once again one is struck by the sophistication and assurance of this representation of a herd of moving cattle. The style clearly derives from the 'Second Hunter style' of south-eastern Spain, which gradually spread the whole length of the African continent, and

Tangaroa at the moment of creating the other gods. Polynesian carving in ironwood from Rurutu, Tubuai Islands. 18th century. h. 44 in. (112 cm.). British Museum, London.

17 A variant of the squatting figure found particularly in Polynesia and New Zealand is what is known as the 'bent-knees' figure, a kind of half way stage between the full squatting figure and a standing one, which finds its most monumental expression in the famous stone carvings of Easter Island. Its origins are uncertain, but the modification may have been due partly to practical considerations – it would have been easier to carve with primitive tools than the full squatting figure – and partly to aesthetic 20 ones. A remarkable combination of the two types shows the squatting figures of new-

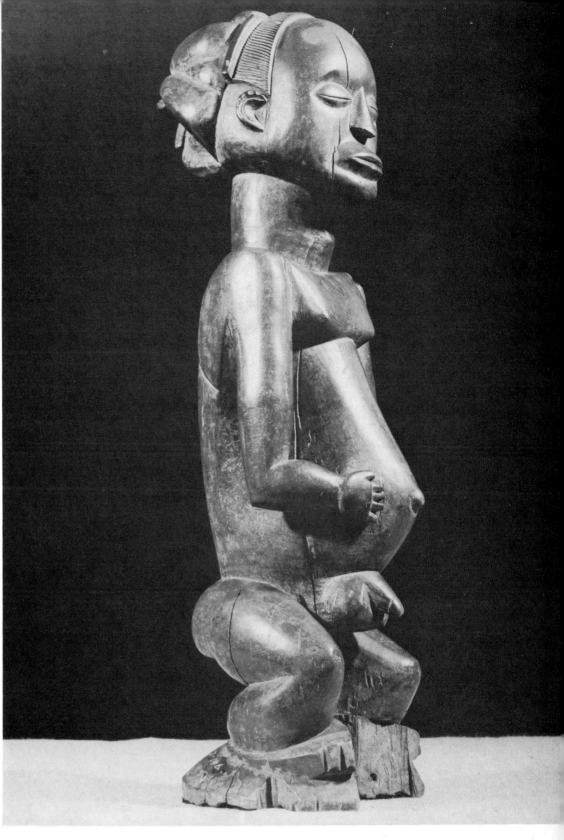

Baluba ancestor figure carved in wood from Urua, Congo. h. 19 in. (48 cm.). Museum für Völkerkunde, Munich.

was kept alive until the mid-19th century by the Bushmen of the Kalahari Desert.

Negro art, and particularly Negro sculpture, has remained the most vigorous manifestation of African art from the late Stone Age to the present day. It is found almost exclusively in the area of agricultural communities grouped around the river systems of the Niger and the Congo, and its themes are substantially the same as those of the primitive farming communities of Southeast Asia and Indonesia. Ancestor worship and the fertility of soil are the overriding preoccupations and indeed most Negro sculpture consists of either masks or ancestor images. The bent-knees figure, the distinctive form of Polynesian art, is also the characteristic form of Negro ancestor images, and was probably introduced from South-east Asia via Madagascar. Examples from the Baluba people of northern Katanga are particularly forceful, the aristocratic reserve of the face and the strongly sculptured forms being typical of Baluba art. Here again the commemorative, representational aspect is played down in

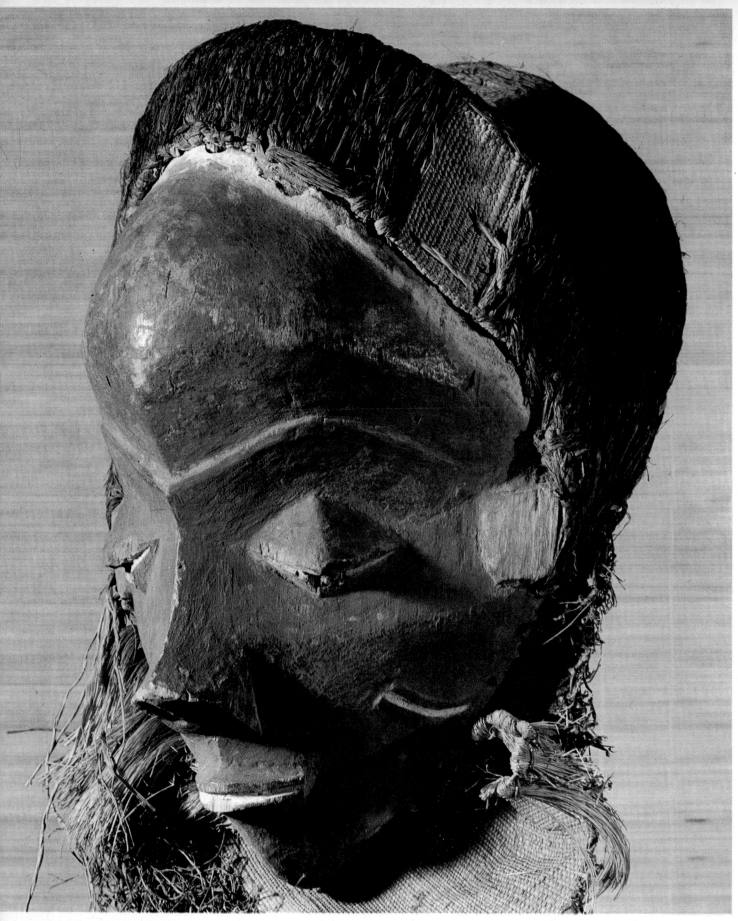

Bapende female mask
from Kwango, Congo.
19th century. Painted
wood. h. 12½ in. (32 cm.).
Museum für Völkerkunde,
Munich.

Kurumba dance headdress
in the form of an
antelope's head from
Aribinda, Upper Volta, W.
Africa. 20th century.
Painted wood. h. 43 in.
(109 cm.). Museum für
Völkerkunde, Munich.

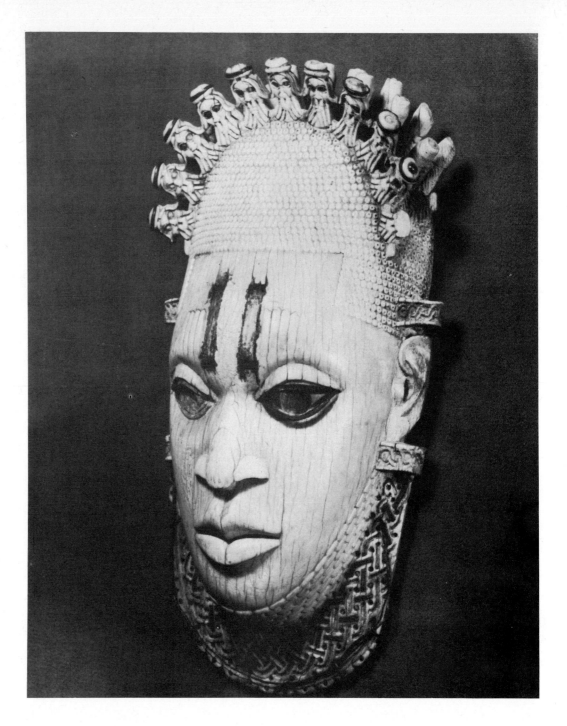

Pendant mask from Benin, Nigeria. Probably 16th century. Ivory. h. 7½ in. (19 cm.). British Museum, London.

favour of an exaggeration of those elements – the head and the sexual organs – which relate to the magical virtue of the figure.

As in Indonesia and Oceania, the mask plays an important part in African Negro art, always with a magical significance. A Bapende female mask of the type worn at initiation ceremonies to drive away evil spirits shows how the ritual function of the mask is accompanied by a purely artistic expressiveness – the face is abstracted into a series of flat planes which paradoxically convey a remarkable impression of female tenderness. There are innumerable regional or tribal styles throughout the area of African Negro art, of which the Bapende style is just one example.

While many of the Negro agricultural communities remained isolated from European influences before their contact with the Portugese navigators in the 15th century, North Africa and the Sahara became the receptacle of Mediterranean cultural influences, particularly after the spread of Islam in the 8th century AD. The Niger basin probably marks the southernmost penetration of these influences, which combined with the local Negro culture in a remarkably fertile artistic strain. The bronze sculptures of the Yoruba tribe from Ife and Benin are world famous, and their naturalistic style contrasts with the more formal symbolic masks from the same area, which have an almost Ancient Egyptian flavour.

African Negro culture suffered greatly from the disruption caused by European

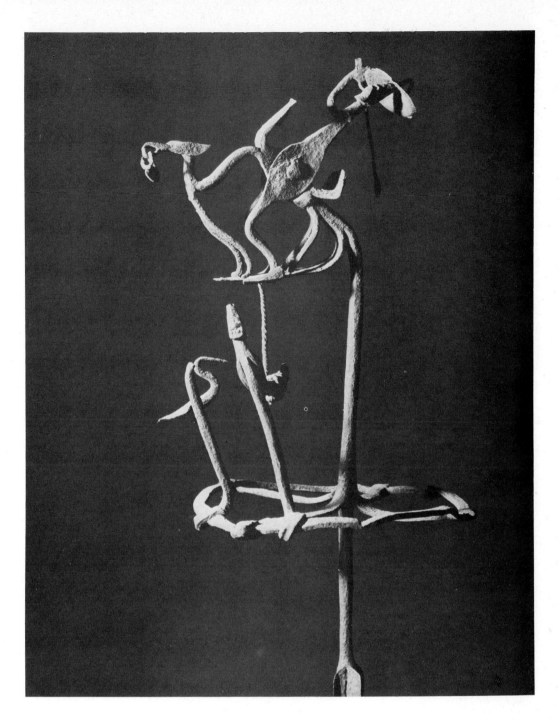

Wrought iron pole top in the form of an armed horseman from Nigeria. h. of figure 22½ in. (57 cm.). Museum für Völkerkunde, Munich.

colonialist activities, and it is only in comparatively recent times that it has begun to recover its former vigour. Twentieth-century productions show that the links with the primitive past are as strong as ever. An antelope head-dress from the Upper Volta region on the southern edge of the Sahara reveals an interesting combination of influences; it perpetuates the animal forms of hunter art but is worn by the agricultural Kurumba in mourning and sowing rituals; moreover the geometric decorative pattern reflects the anti-pictorial influence of Islamic art. After the masterpieces of Yoruba art, Nigerian artists continue to show a bold and imaginative use of metal in their wrought ironwork.

The art of primitive man is intuitive and anti-rational; its major preoccupations relate to creative forces which Western culture, with its emphasis on rationalism and technology, has tended to ignore. The history of human culture has always been that of a conflict between the rational and the non-rational, and it is significant that in the present century, Western artists have begun to turn again to the art of the primitive cultures, finding in them a source of inspiration which seems lacking in their own environment. For the world of primitive man embodies in its beliefs and aspirations the very timelessness which men have sought throughout the ages in their art and their religions.

The Ancient World

So long as man was restricted to a nomadic way of life, his possibilities of social development were limited. The introduction of agriculture, and its advancement beyond the level of mere subsistence were a prerequisite for the emergence of the so-called mature cultures. As we have said, these first appeared in the Middle East, and the geographical configuration of the area was undoubtedly a contributing factor in their creation. The ancient Middle East, stretching from Egypt and Anatolia in the west to the Iranian plateau in the east, is marked by two great river systems – the Nile in Egypt and the Tigris and Euphrates in Mesopotamia. Nomadic herdsmen settling in these areas learned to channel the flood waters and irrigate the land. This in itself demanded a certain level of social organisation, and soon led to the cultivation of grain on a large scale. Grain surpluses meant the possibility of commercial interchange with outlying areas, and the basis for the earliest political unit – the city state – was born.

Egypt and Mesopotamia, then, were the main centres of early Middle Eastern culture. To a certain extent they followed a similar course, developing writing, for instance, at about the same time. In other ways, however, they were markedly different. Though Egypt always suffered a certain conflict between the northern and southern parts, known as Lower and Upper Egypt respectively, this conflict was always kept in check by the strongly centralised government under the pharaoh, an absolute ruler with divine powers. Moreover Ancient Egypt remained relatively isolated through its geographical situation, and Egyptian art and culture were remarkably consistent over a period of some three thousand years.

Mesopotamia, on the other hand, remained a collection of regional states, with local theocratic rulers, and there was considerable interchange with the outlying areas of Iran, Syria-Palestine and Anatolia.

The art of the earliest mature cultures, like that of primitive man, was primarily functional in a sense which modern civilisation has tended to replace by a non-functional concept of beauty. While it already had both a commemorative and a decorative function, it still retained a strong sense of mystery. Statues and temples served as a means of intercession between man and the higher beings whom he believed controlled his destiny.

The First Mesopotamian Civilisation

Mesopotamian civilisation began with the Sumerians, in the second half of the fourth millennium BC. Probably coming from the Iranian highlands, the Sumerians quickly integrated with the local population, and after forming agricultural communities began to undertake the irrigation works necessitated by the uneven flow of the Tigris and Euphrates rivers. Such large scale works required a strong central power, which took a theocratic form. The focus of the Sumerian city states was the temple, and the ruler held both religious and political power.

Building and worship were thus the two main preoccupations of the Sumerians, a fact which is amply demonstrated by the first site of Sumerian art, Uruk, between the two great rivers in lower Mesopotamia. Here a great ziggurat of mud bricks raised the White Temple of the sky god Anu above the flat surrounding countryside. Temples such as this were filled with statues of worshippers. The pose of the earliest examples is characteristic, the arms held on the chest in an attitude of prayer and the eyes fixed firmly on the god – an effect emphasised where the eyes are made of shell with pupils of lapis lazuli.

One of the typical forms of Mesopotamian art as a whole is the decoration of the cylindrical seals which were used instead of an ordinary stamp or die. The wax impressions of cylinder seals from Uruk show lively scenes of Sumerian life betraying the same preoccupations as we have already noted – building and religion. The representations of buildings are important, for they show the actual appearance of structures of which only the foundations now exist. Here we have a prime example of a purely functional object being turned into a vehicle for decorative embellishment. Later cylinder seals bore inscriptions in the

Golden head of a bull decorating the front of a lyre from Ur. Early Dynastic II Period. 2600–2400 BC. Gold on a wood core. h. 11$\frac{5}{8}$ in. (29·5 cm.). Iraq Museum, Baghdad.

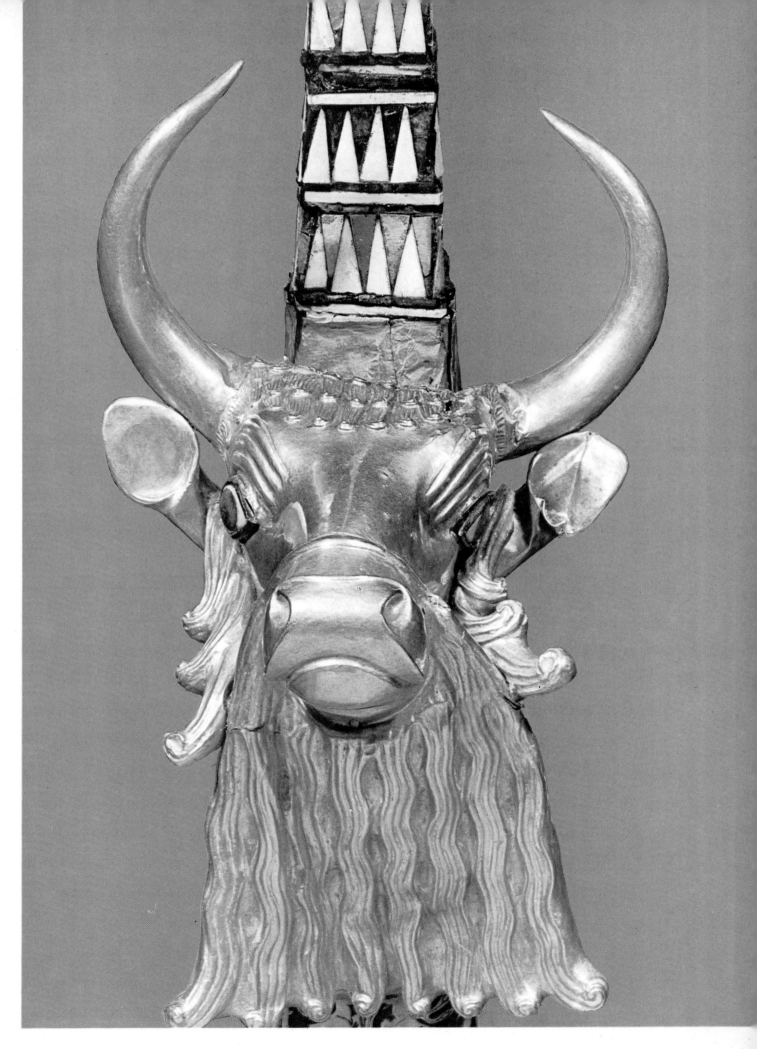

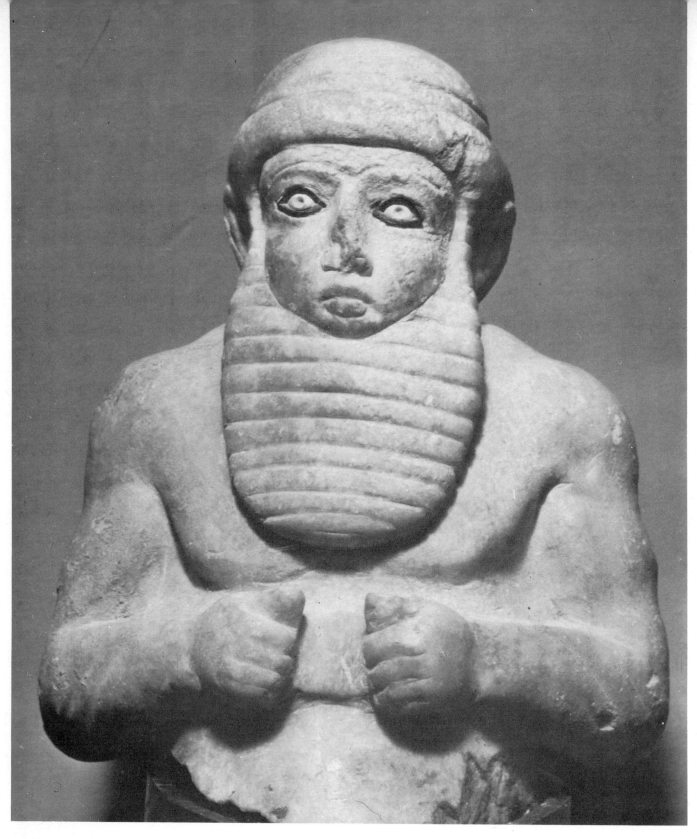

Statuette of a bearded
man from Uruk.
Predynastic period. *c.*
3200–3000 BC. Alabaster.
7⅛ in. (18 cm.). Iraq
Museum, Baghdad.

newly invented cuneiform writing.

The importance of Uruk dates from the first period of Sumerian civilisation, known as the Predynastic (c. 3200–3000 BC). After a period of uncertainty between 3000 and 2700 BC Sumerian culture rose to new heights in the periods designated as Early Dynastic I and II. By now the Sumerian gods had a less obsessive hold over the minds of the people; Sumerian man embarked on the conquest of foreign lands and his art took on a new and secular magnificence. A lavish and skilful use of pre-cious metals characterises the objects found in the royal tombs at Ur, of which the famous bull's head lyre is a splendid exam-ple. The aggressive opulence of the head well symbolises the new spirit of the age.

The Semitic Era

After 2350 BC, the Sumerians came under the domination of Semitic rulers, the first of whom were the Akkadians (c. 2350–2150 BC). Under the Akkadians, Sumerian art

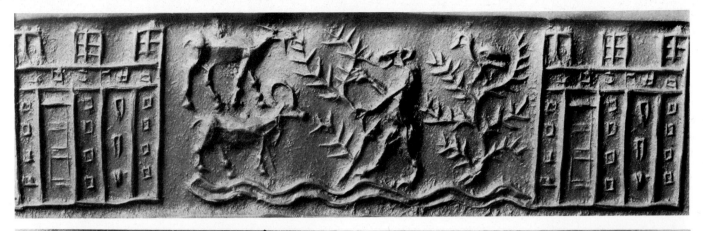

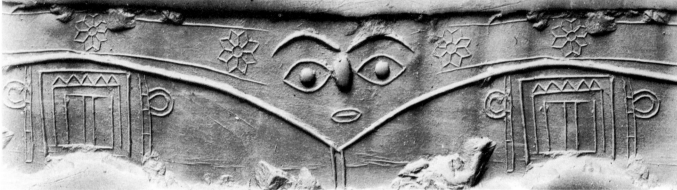

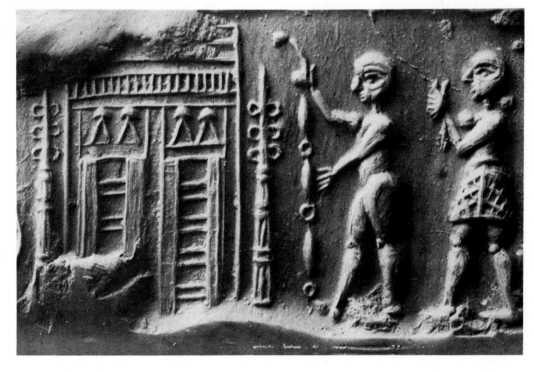

Predynastic cylinder seal impressions from Uruk. Iraq Museum, Baghdad: *a)* animals and a mythological figure before the walls of a temple; *b)* the all-seeing eyes of the god; *c)* offerings brought by land and water to a shrine.

reached its apogee, particularly in sculpture and cylinder seals. The stylised figures of worshippers which were typical of earlier Sumerian sculpture gave way to a new luxuriance of detail, of which the bronze head 32 from Nineveh is a particularly fine example. Possibly representing Sargon, the first of the Akkadian kings, its obvious dignity and power express a new ideal of kingship. 33 The stele of Naram-Sin, with its clear triangular composition and powerful upward movement towards the oversized figure of the king, has a formal sophistica-

tion and elegance which make it a masterpiece of Akkadian art.

After the splendour of the Akkadian period, Mesopotamian art for the next 1000 years was relatively undistinguished, reflecting the political instability brought about by a series of Semitic invaders – the Amorites, the Kassites and finally the Assyrians.

The Assyrians first emerged in northern Mesopotamia during the second half of the second millennium BC, but their major artistic activity occurred in the Neo-Assyr-

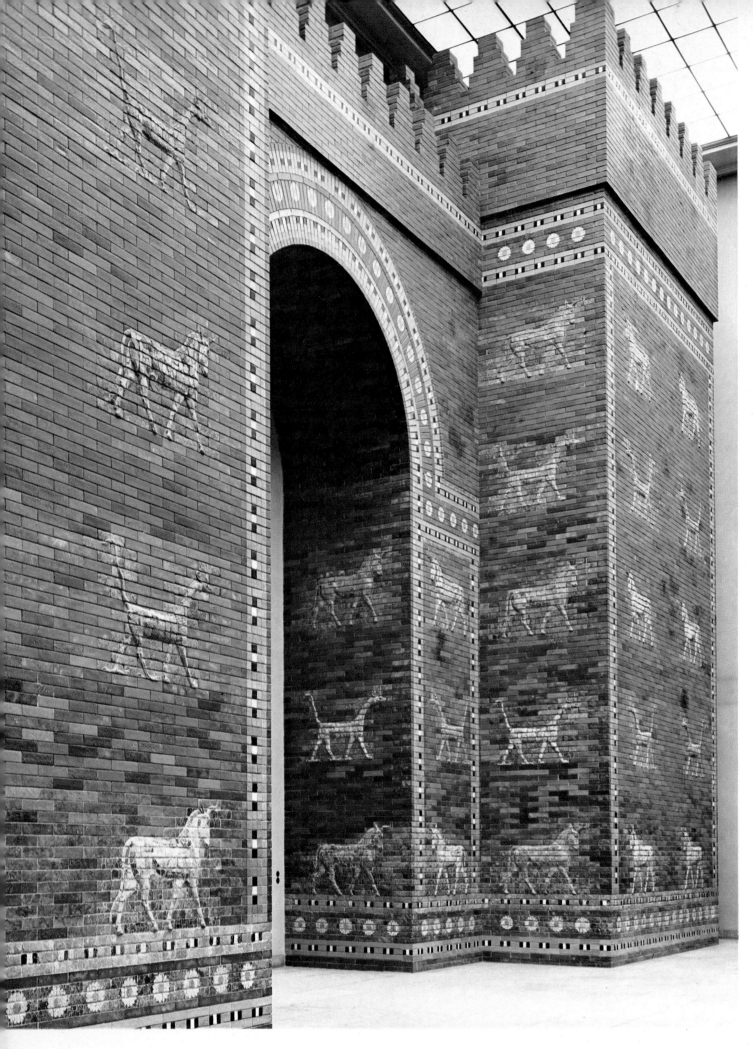

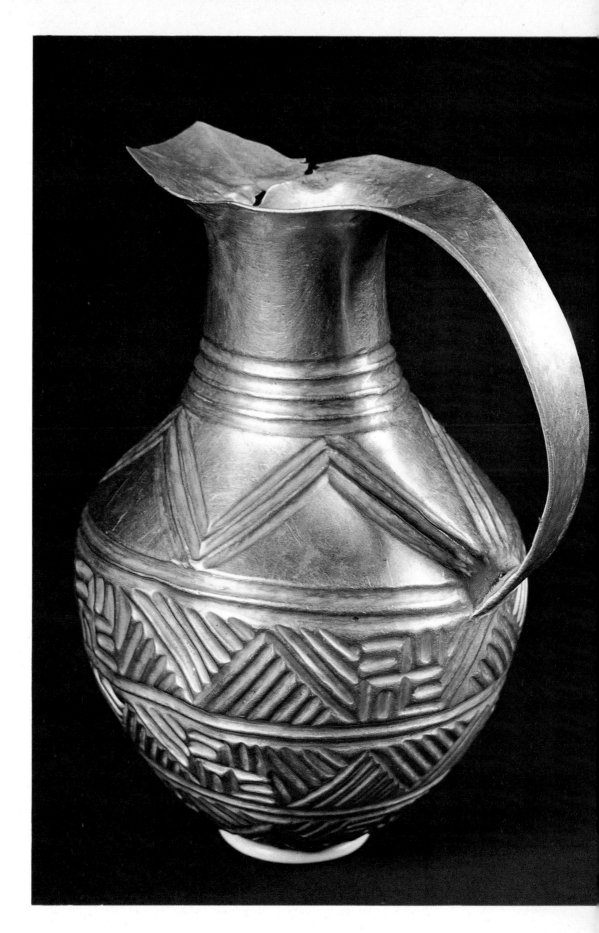

The Ishtar Gate, Babylon.
Reign of Nebuchadnezzar
II (604–562 BC). Glazed
brick. h. 47 ft. (14·30 m.).
Staatliche Museen, Berlin.

Jug from Alaca Hüyük. *c.*
2400–2200 BC. Gold. h.
6 in. (15·3 cm.).
Archaeological Museum,
Ankara.

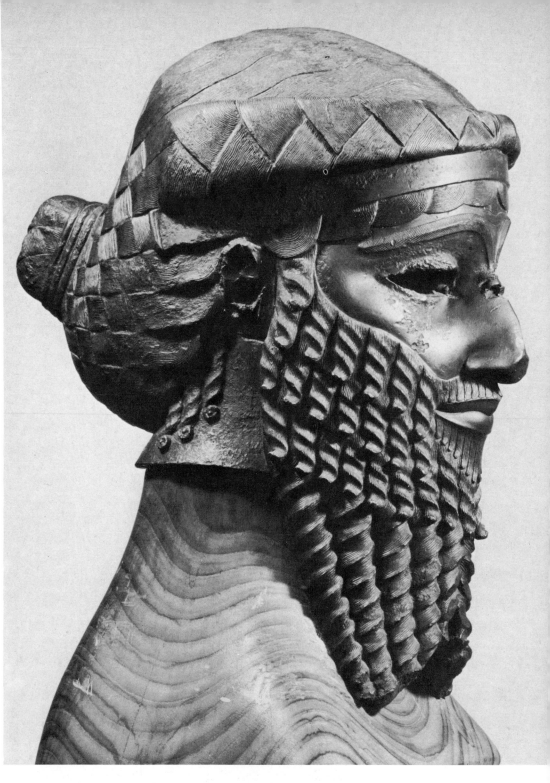

Bronze head from
Nineveh. *c.* 2350–2150
BC. h. 14⅜ in. (36·6 cm.).
Iraq Museum, Baghdad.

ian period (c. 1000–612 BC), which saw
the last flowering of the Sumerian artistic
traditions of two millennia. It was an art
of imperial prestige, attached to the palaces
of a series of successful and conquering
kings. In relief sculptures and seal carvings,
scenes of struggle with winged monsters
reflect a religious preoccupation with the
conflict between good and evil – a transcen-
dental parallel to the imperialistic struggles
36 of the time. The spirit of the age is typified
by the winged bulls which flanked the
entrance to the palace of Assurnasirpal II
(883–859 BC) at Nimrud, where they were
intended to ward off evil influences. Monu-
mental in scale, yet minutely detailed, they
represent the apogee of Assyrian relief

carving and are the very personification of
imperial power. Relief carvings are also
found in the palace of Assurbanipal
(668–626) at Nineveh. Here violent scenes
of war alternate with hunting scenes exe- 37
cuted in low relief in a finer style; the subtle
modelling of the fleeing animals suggests
a delicacy of feeling on the part of the artist
which contrasts with the baroque scenes
of violence found elsewhere.

The destruction of Nineveh by the
Medes and Babylonians in 612 BC brought
an end to Assyrian power, leaving Baby-
lonia as the last centre of Mesopotamian
culture. Though the Greeks held it in
reverence as the home of all wisdom, the
Babylonia of the first millennium BC

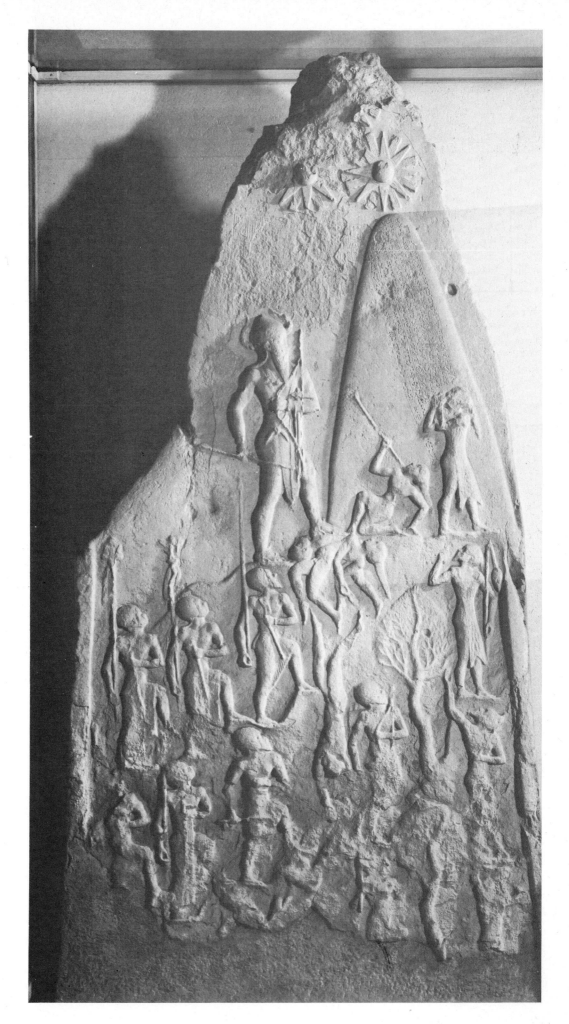

Stele of Naram-Sin, King of Akkad. *c.* 2300 BC. Red sandstone. 78¾ in. (200 cm.). Louvre, Paris. Naram-Sin, wearing the horned helmet of divinity, stands alone before a stylised mountain, one foot resting on slain enemies.

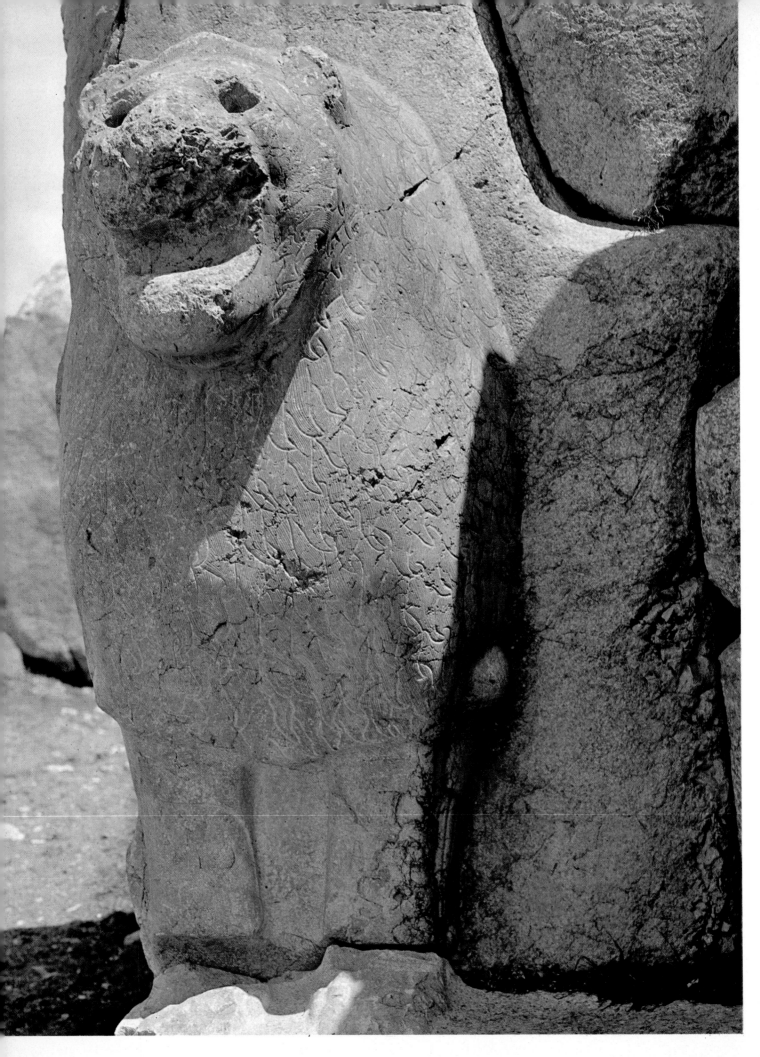

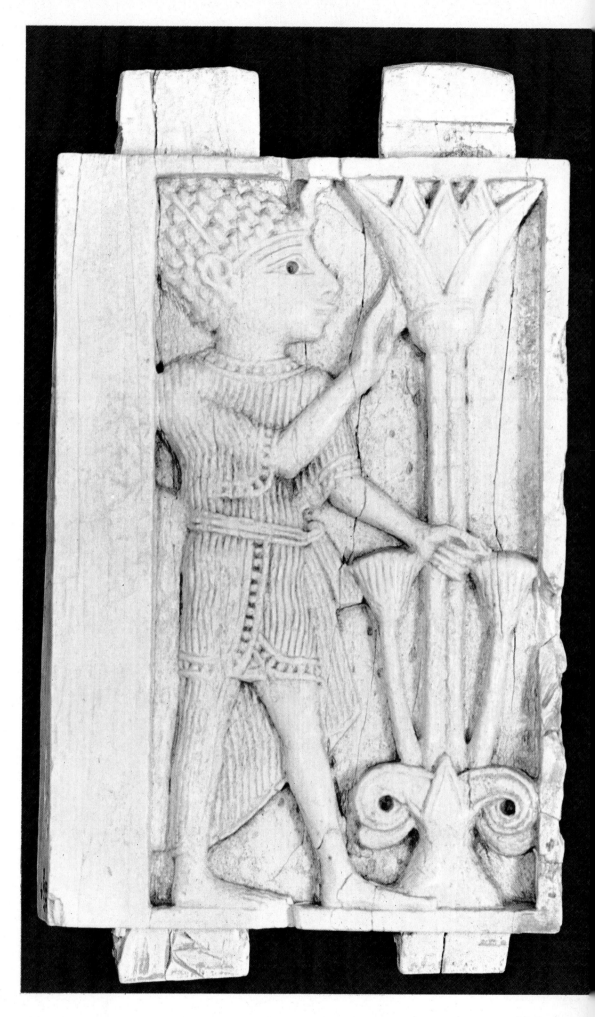

The Lion Gate, Hattusas
(detail). Hittite Imperial
period. 14th century BC.

Ivory panel from Nimrud.
Syrian. 9th–8th century
BC. h. *c.* 4 in. (10 cm.).
British Museum, London.

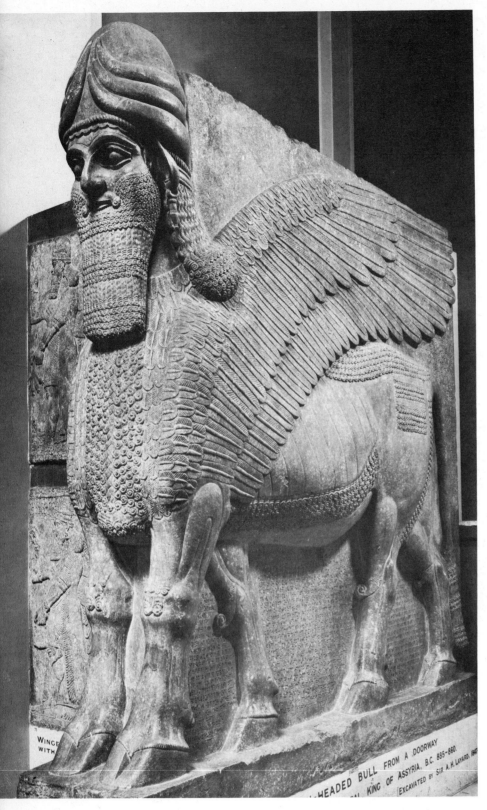

Winged human-headed bull from Nimrud. Period of Assurnasirpal II. Alabaster. h. 10 ft. 4 in. (3·14 m.). British Museum, London.

and cultural influence moved first to Persia and then to the cradle of Western civilisation – Greece.

Anatolia, Syria and Palestine, Iran

While the main centre of ancient civilisation in western Asia was in the great river system of Mesopotamia, important cultural centres also developed in the highlands stretching from Anatolia to Iran, and in the area covered by Syria and Palestine. Archaeological finds in Anatolia include the fertility goddesses of a neolithic culture and the first examples of western Asian pottery, painted with spirals or geometric patterns. Geometric patterns are also found in the technically advanced metal work of the Bronze Age people of Alaca Hüyük in 31 northern Anatolia. These are the characteristic motifs of early civilisation which were to spread from Anatolia westwards to Europe.

The first Anatolian civilisation to match the cultural centres of Mesopotamia was that of the Hittites, who arrived in the area gradually and during the second half of the second millennium BC possessed one of the strongest empires in the ancient world. The great achievement of the Hittites was to combine the decorative art of sculpture with the technology of architecture, for it was they who first adorned their walls and palaces with reliefs and figures in a manner later to be adopted by the other Middle Eastern cultures. The figures flanking the Lion Gate at the Hittite capital 34 of Hattusas are among the finest sculptures of the Hittite empire, and prefigure the great guardian beasts of the Assyrians.

Little is known of the history of Syria and Palestine before the third millennium BC, during which period they came under the direct rule of a succession of Mesopotamian kings. In the first half of the second millennium, while Mesopotamian culture declined, Syrian art flourished, reworking Mesopotamian motifs and often surpassing its models, especially in the field of seal carving. Syrian sculpture of the period is 37 uneven in quality, but the sculptured head, (possibly) that of King Yarim-Lim of Alakh, shows a considerable maturity of style based on Sumerian traditions.

The invasion of western Asia by the so-called 'Sea Peoples' around 1200 BC seriously disrupted Syrian culture and destroyed the Hittite Empire. In northern Syria at least, the traditions of Hittite art were absorbed by a newly arrived Semitic people, the Aramaeans. The early part of the first millennium saw a flowering of Syrian architecture in which relief carving

produced little that was new, preferring to preserve and imitate the Sumerian and Assyrian traditions. The Chaldean dynasty pursued an imperialistic policy which was reflected in the monumental architecture produced under Nebuchadnezzar II – the 30 Ishtar Gate, the royal palace with its famous 'hanging gardens', and the huge ziggurat which was the biblical 'Tower of Babel'. But despite this outward show, Mesopotamian art was already in a decline which accelerated as the centre of power

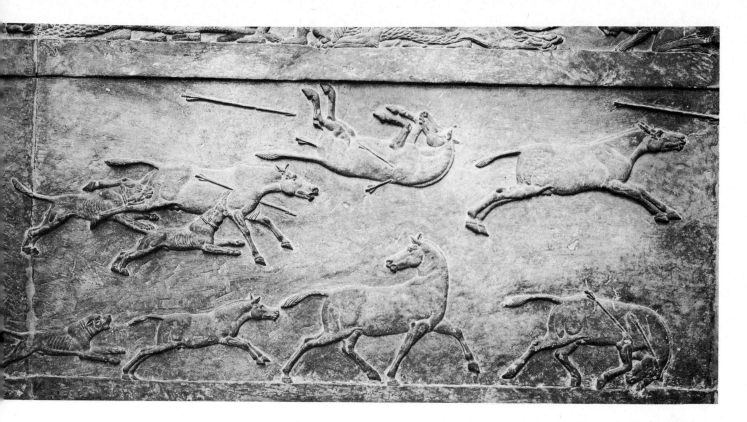

Wild asses hunted with mastiffs. Detail of a relief from the North Palace of Assurbanipal at Nineveh. 668–626 BC. h. 21 in. (53 cm.). British Museum, London.

far right
Yarim-Lim (?) of Alakh. *c.* 1750 BC. h. 6½ in. (16 cm.). Hatay Museum.

and sculptured figures clearly follow the Hittite style. The guardian lions flanking a gate at Malataya in northern Syria are obviously direct descendants of those at Hattusas, the bulky form and incised surface decoration being clearly derived from the earlier model.

Another important branch of North Syrian art during this period was that of ivory carving. This genre had developed in Phoenicia, farther to the south, before becoming widely popular at the beginning of the first millennium. The Phoenicians were traders in luxury goods, and their art reflects their commercial preoccupations. Trading links with Egypt led to a lively cultural interchange, which extended through Palestine and as far as northern Syria. An ivory panel from Nimrud – one of many exported over a large area – shows Egyptian influence in the youth's costume and the tree formed by a giant lotus flower.

From the middle of the 6th century to 330 BC, the Persian dynasty of the Achaemenians ruled western Asia and Egypt as one vast empire. Achaemenian art has an opulence and monumental grandeur in keeping with the culture's political aspirations, but in content it was no more than a synthesis of the empire's different constituents. Thus we find the sphinx from Egypt, winged human-headed bulls from Assyria, and glazed tiles from Babylonia. The multi-coloured halls of the Persian palaces have one unique feature, however, in the use of the foreparts of animals as capitals to the columns. The result is a bizarre and striking expression of imperial grandeur.

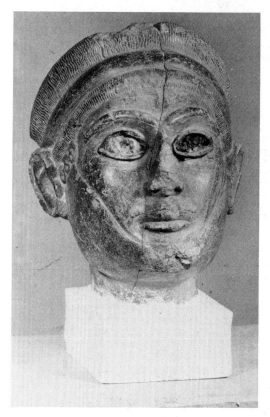

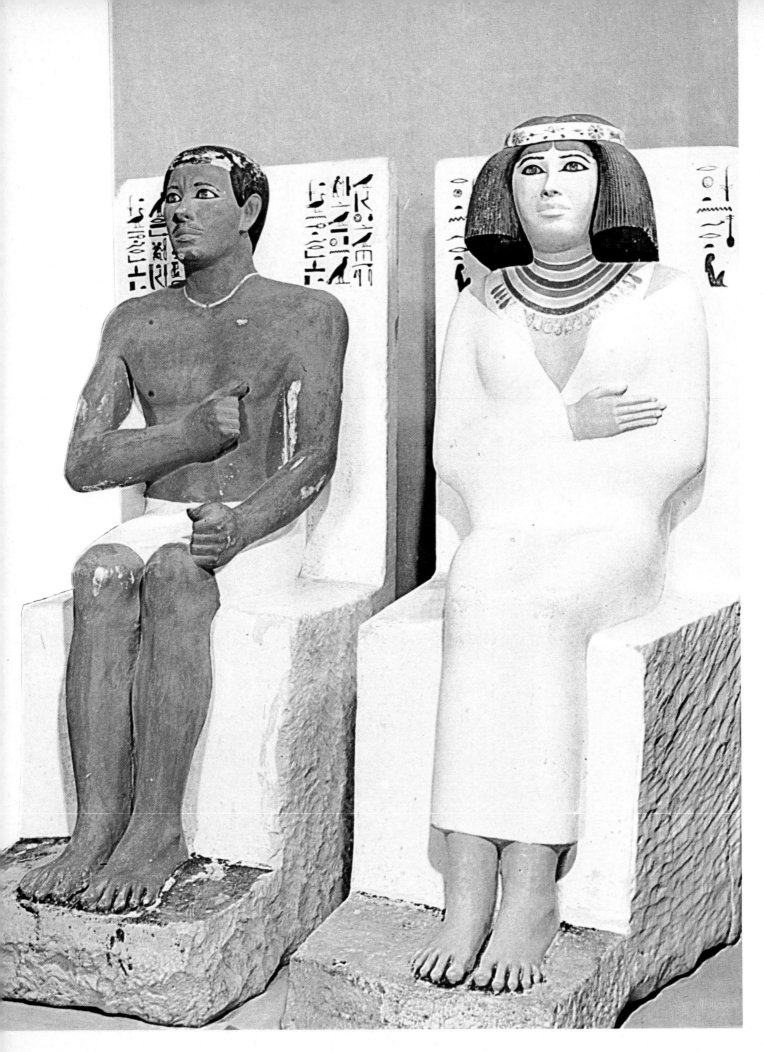

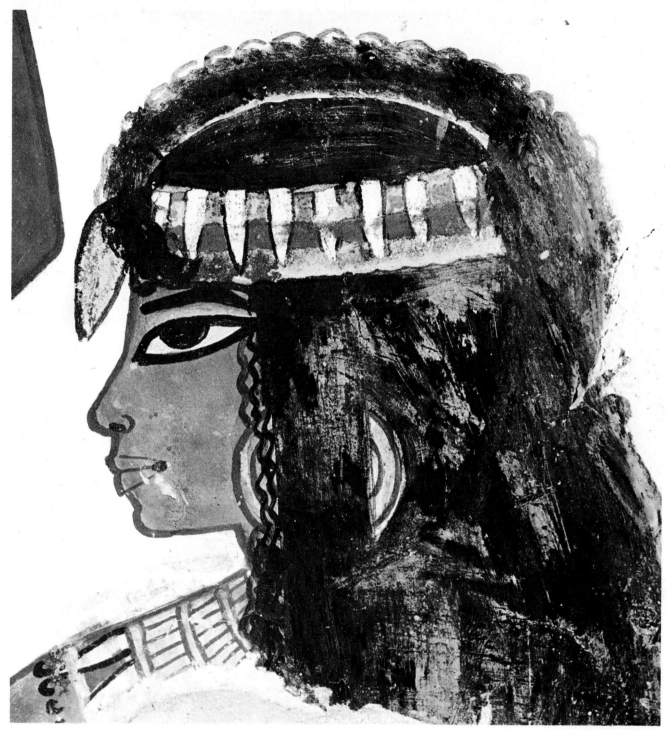

Rahotep and his wife
Nofret. Fourth Dynasty.
47¼ in. (120 cm.). Cairo
Museum.

Head of a girl with a lotus
bud in her hair. Tomb of
Menna,
Sheikh-abd-el-Qrnah,
Thebes. Mid-Eighteenth
Dynasty. Reign of
Tuthmosis IV (c.
1425–1415 BC.). Painting
on plaster.

Egypt

The Egyptian ruler, the pharaoh, was
regarded by himself and his people as a
living god, possessed of absolute power and
without equal in heaven or on earth. The
title was hereditary, and the importance of
family ties is reflected in the customary
division of ancient Egyptian history into
thirty-one dynasties. These in turn are
divided into four main periods – the Old,
Middle and New Kingdoms and the Late
Period – each separated from the next by
a period of confusion and violence.

Since the pharaoh was himself a god,
religious mystery is in a sense absent from
Egyptian art. It is, rather, commemorative
and monumental. For the first time specific
historical incidents are depicted. Monu-
ments, portrait statues, tombs, commemor-
ative temples abound. Such heavenly gods
as were believed to exist are shown openly
and boldly, in converse with their earthly
counterparts. There is a marked contrast
with the awe-struck worshippers of
Sumerian art, whose ruler was no more
than the earthly interpreter of the wishes
of an unseen god.

Two works will suffice to show the un-
compromising spirit of the Old Kingdom,
which was an age of supreme confidence
and stability. The statue of the 3rd dynasty
pharaoh Zoser is one of the first examples 41

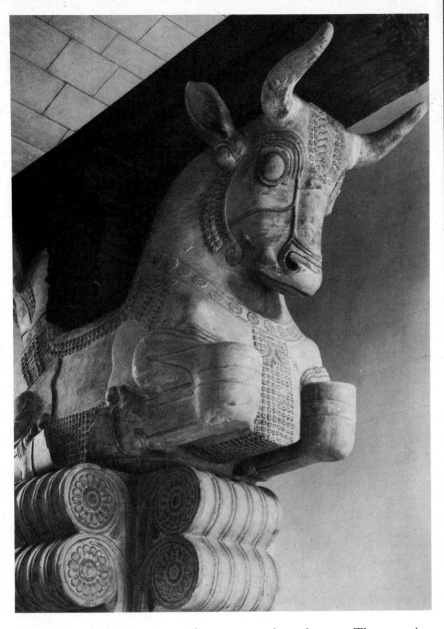

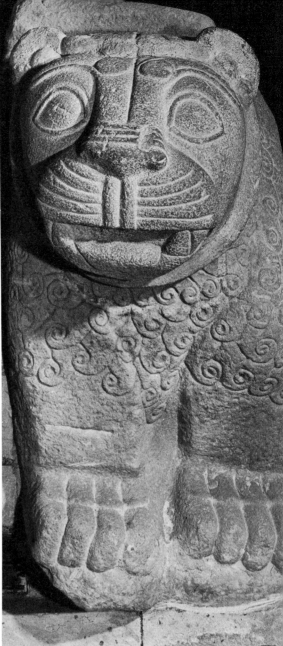

Double-bull capital. From the throne-room of the palace of Darius at Susa. 464–358 BC. Louvre, Paris.

above right
Lion Gate from Malataya. 9th century BC. Basalt. h. 51½ in. (131 cm.). Archaeological Museum, Ankara.

of monumental sculpture. The massive body, merging with the throne, and the heavy, expressionistic rendering of the head combine to create an impression of super-human power. The art of the 4th dynasty (2600–2480 BC) shows a more abstract approach, which culminates in the great 41 pyramids of Giza, built by the pharaohs Cheops, Chephren and Mycerinus. Their vast scale and simplicity of form make them one of the enduring wonders of the world, and ever since their construction they have remained a symbol of Egyptian civilisation. Despite their naturalistic colouring, which is characteristic of Egyptian statuary, the 38 figures of Rahotep and his wife, from the same period have an abstract formality and stiffness which contrast markedly with the figure of Zoser – even though the pose is identical.

The Old Kingdom ended in more than a century of social unrest in which the power of the pharaohs was challenged by local chieftains. When order was re-established in the Middle Kingdom the bound-

less confidence of the Old Kingdom had been lost, and replaced by an awareness of imperfection. The pharaoh was now more of a king, less of a god, and the art of the period is similarly on a more human scale. Lively relief carvings are a typical example.

The Middle Kingdom was followed by a further period of anarchy, which brought with it a new awareness of foreign cultures. Interchange with western Asia increased, and although little direct influence appears in Egyptian art there is a new sense of freedom, a greater humanity and a more historical, rather than a monumental approach. New Kingdom art began with the reign of Queen Hatshepsut (1501–1480 BC), when it was distinguished by an elegance and grace which must to some extent have reflected the queen's own femininity, although in many of her obelisks and sta- 44 tues the queen is represented as a male figure with the cobra – symbol of earthly divinity – attached to its headdress.

The refinement shown by the artists of

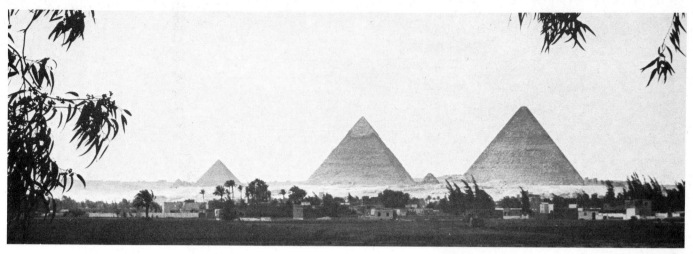

The pyramids of Giza from the east. Fourth Dynasty. On the right, the Great Pyramid of Cheops; centre, the pyramid of Chephren; left, the pyramid of Mycerinus, flanked by the small pyramids of three of his queens.

far right
King Zoser. Old Kingdom, Third Dynasty. *c.* 2650–2630 BC. Limestone. h. 55 in. (140 cm.). Egyptian Museum, Cairo.

over page
Two of the daughters of Akhenaton. Amarna period (*c.* 1370–1350 BC). Painting on plaster. h. of left figure 9 in. (23 cm.). Ashmolean Museum, Oxford.

Queen Hatshepsut's reign was continued and developed under her successors, even extending to the massive building programme undertaken between 1448 and 44 1377 BC. The papyrus-bundle columns of the court of Amenhotep III in the great temple of Amon, built during his reign at Luxor, are among the most refined and beautiful objects of Egyptian architecture. The plant column is a characteristic Egyptian form – here the shaft represents a bundle of bound plant stems and is topped by a cluster of papyrus buds.

An important feature of New Kingdom art is the development of painting. Lively narrative scenes, on illustrated papyri, painted sarcophagi and tombs, embodied the new spirit of emancipation in a way that the more traditional technique of painted relief carvings could not match. A 39 portrait of a young girl taken from scenes of agricultural activity decorating a tomb near Thebes has considerable delicacy and charm, despite its bold outlines which are typical of the genre.

Egyptian culture underwent a revolutionary change under the 'heretical' pharaoh Amenhotep IV, who replaced the official religion centred on the Theban god Amon by the cult of the sun god Atuen. This overthrowing of established traditions was marked by a change in artistic styles which is chiefly revealed in the appearance of portraiture as such for the first time. Though as stylised in their own way as earlier works, the portrait sculptures of the period show a new concern for reproducing the actual physical features of the person 44 represented. Statues of Amenhotep IV, who took the name of Akhenaton, 'the instrument of Aton', exaggerate his facial features to an almost grotesque degree. The portrait head of his wife Nefertiti is one of the best known works of Egyptian art. 45 A statuette, less famous, shows the same graceful realism in the face, while the rendering of the body contributes an intimate, almost domestic simplicity. A similar impression is conveyed by the painting of 42 Akhenaton's two daughters, from the

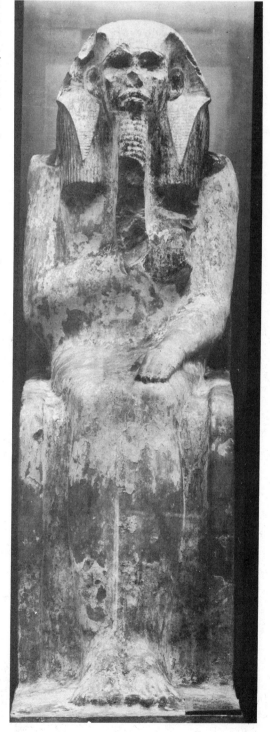

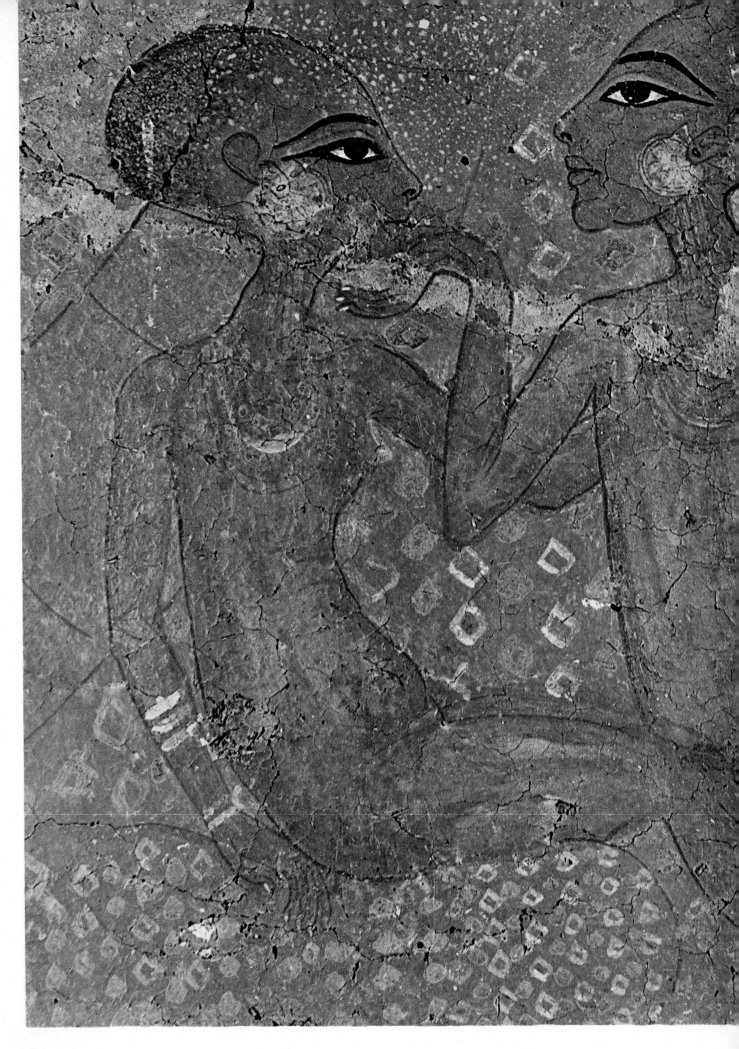

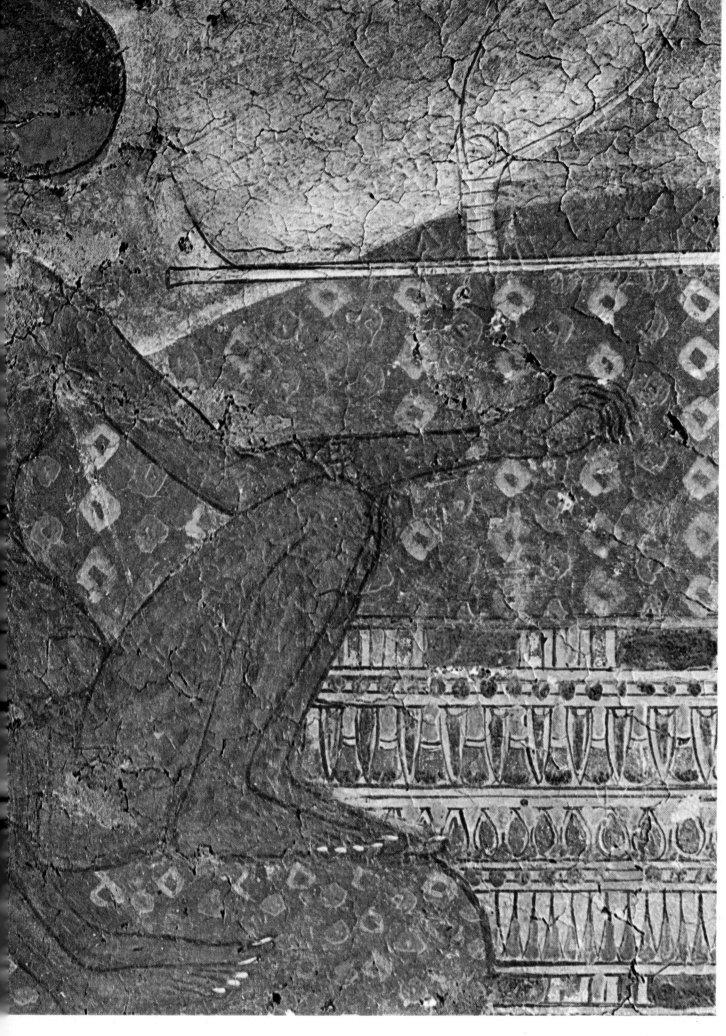

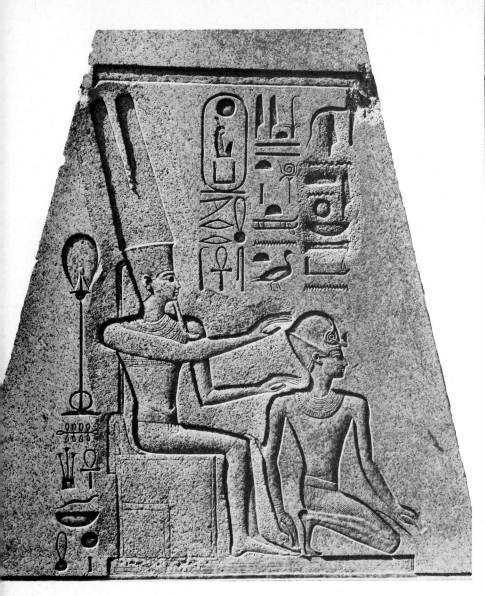

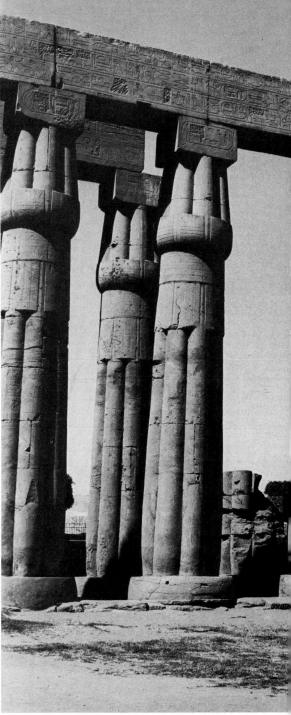

The god Amun-Rē and the Queen, from an obelisk of Queen Hatshepsut, Karnak. New Kingdom, Eighteenth Dynasty. *c.* 1501–1480 BC.

Amenhotep IV, later known as King Akhenaton. New Kingdom, Eighteenth Dynasty. *c.* 1375 BC. Sandstone. More than twice life-size. Original site, Karnak. Now in the Egyptian Museum, Cairo.

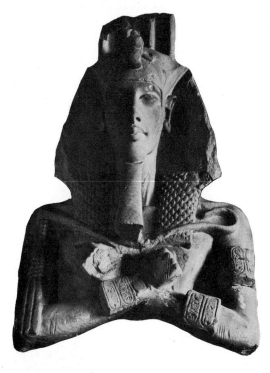

palace at his capital of Amarna. Like the statuette of Nefertiti, the figures show the elongated skull, full hips and slender legs which were a characteristic exaggeration of the Amarna style.

Although the end of the New Kingdom was marked by the splendour of such works as the funerary ornaments in the tomb of Tutankhamen, and the vast rock-carved temple of Abu-Simbel created in Nubia by Ramesses II, the transition to the Late Period was another time of crisis after which Egyptian art steadily declined. Successive domination by alien rulers – the Nubians, Assyrians and Persians – had little influence on the increasingly sterile reproduction of outworn styles and traditions.

The art of the mature cultures shows

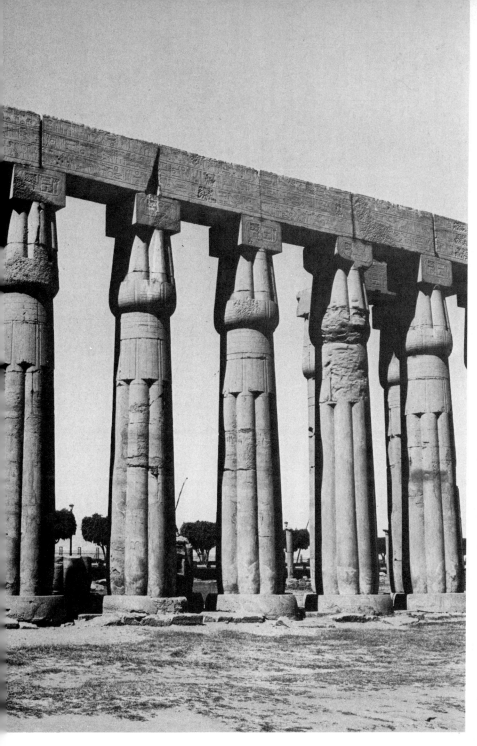

Court of Amenhotep III,
Temple of Amon, Luxor.
Eighteenth Dynasty. *c.*
1400–1360 BC.

Statuette of Queen
Nefertiti. New Kingdom,
Eighteenth Dynasty
(Amarna period). *c.*
1370–1350 BC. h. $15\frac{3}{4}$ in.
(40 cm.). Staatliche
Museen, Berlin.

a gradual progression away from the preoccupations of primitive man. Initially imbued with the primitive belief in the magical efficiency of the image, its increasing concern is with the accomplishments of men rather than gods, reflecting the advance in political organization made by these cultures. While religion always had, and always will have a place in art, there was a move first towards the heroic and monumental, and then towards the human and simply commemorative – all themes which will have an increasing validity as we turn our attention to the roots of Western culture.

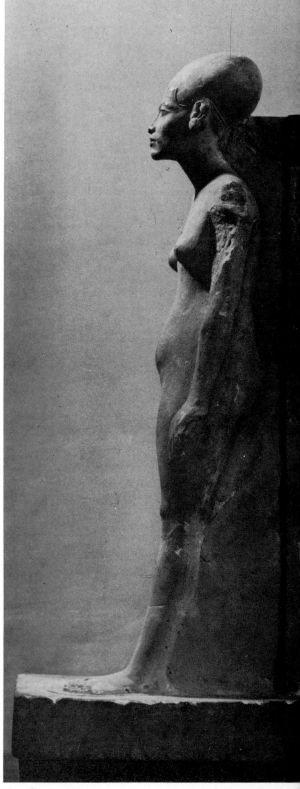

The Classical Heritage

By the Classical world we mean, broadly speaking, the cultures of ancient Greece and Rome. But the term is not only descriptive, it is evocative of a whole cultural tradition which has not ceased to inspire thinkers and artists, and which has formed the very basis of Western civilisation.

The beginnings of Greek civilisation can be traced to Bronze Age Crete, where the key figure is the legendary King Minos, whose great palace at Knossos, excavated in this century, is the most fertile source of early Cretan art. Simultaneously with the development of the Minoan cities, the Myceneans were laying the first seeds of Greek culture on the mainland. The Cretans were their artistic mentors, but soon became their political subjects as Mycenean power spread throughout the Mediterranean. The art of these early cultures still displays some of the sense of mystery and magic which can be traced back to the mind of primitive man. With the rise of Greek civilisation proper, however, we find a change of mood.

After the dark ages which followed the collapse of the Mycenean culture, Greek power began to reassert itself in the form of city states. The Olympian religion and the Greek epics were the twin inspirations for an art which while initially concerned with heroic and religious themes, looked increasingly to the human figure in the belief that perfection of the human form symbolised and implied the perfection of a universal order. After the ideal forms achieved by the art of 5th century Athens the gods themselves were reduced to a more human, domestic scale. The Greek myths which portray the gods as susceptible to the same weaknesses as ordinary mortals seem to reflect this gradual 'popularisation' of those beings whom man had always imagined to exist outside himself and had hitherto held in awe and often in terror.

The Romans wholeheartedly adopted the Greek cultural tradition. In art they both copied individual works and adapted the Greek forms and conventions to suit their own purposes. The reduction of Roman religion to the level of superstition and social formality reflected the increasing sophistication of Roman life and the entirely worldly preoccupations of citizenship and empire. The primitive sense of a central mystery in life had been lost, and the foundations laid of a humanistic tradition which was to last until our own time. At the end of the second millennium AD it would appear that we are only now reaching the end of an era which has been simultaneously Christian and neo-Classical.

The Bronze Age Cultures: Crete and Mycenae

It was not until the end of the 19th century that archaeological finds in the Aegean established a historical basis for the heroic age portrayed in Greek art and literature, and pointed to the Bronze Age cultures of Crete and Mycenae as the forerunners of Greek civilisation. The Minoan culture centred on Knossos flourished from about 2000 to 1400 BC and its artists excelled in colourful wall-paintings, lively decorated pottery, gem engraving and metalwork. The Greek legend of the Minotaur emphasises the mythical significance of the bull in Cretan culture, and it is a frequent motif in Minoan art. It appears on one pair of gold cups found in a tomb at Vaphio in

opposite
Palace style jar from Knossos. *c.* 1450 BC. Pottery. h. 3 ft. 3 in. (1·0 m.). Heraklion Museum, Crete.

Cup from Vaphio. *c.* 1500 BC. Gold. h. 3½ in. (9 cm.). National Museum, Athens.

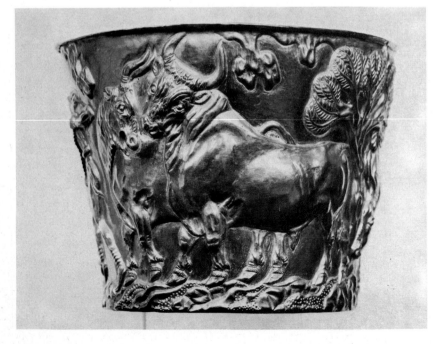

46

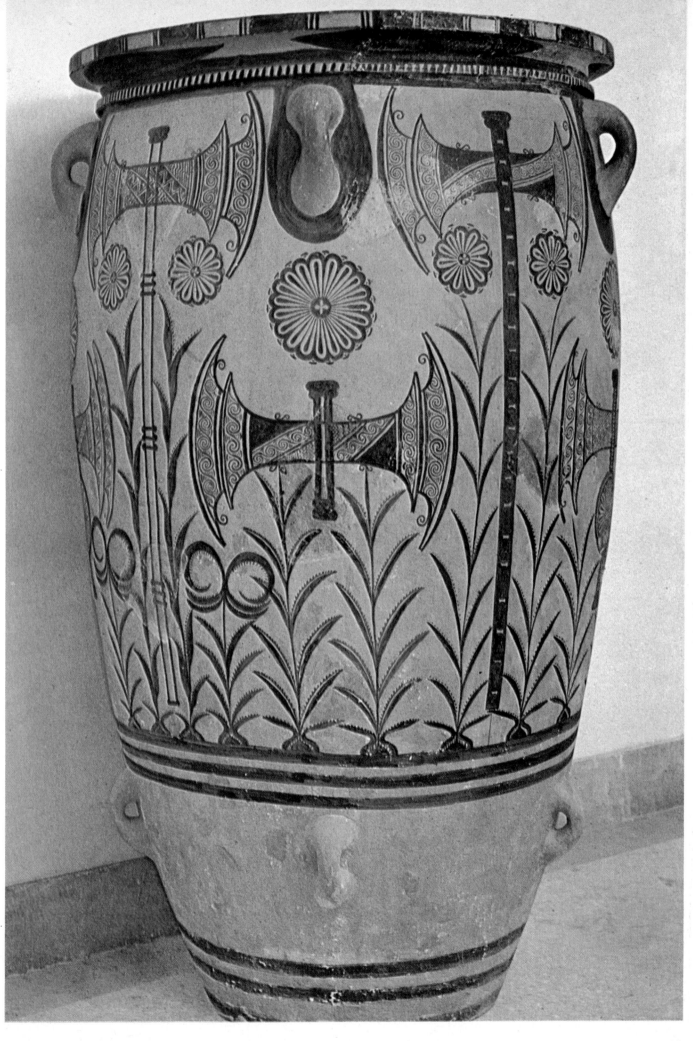

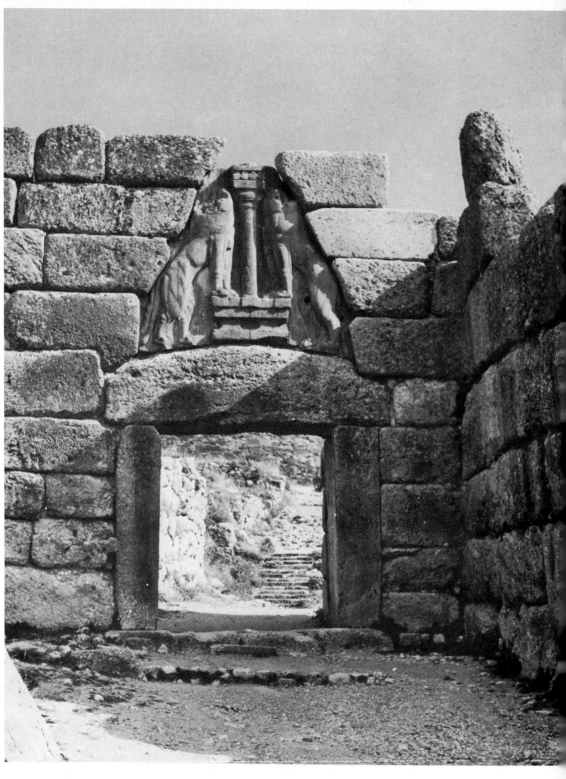

The Lion Gate, Mycenae.
14th century BC.

the Peloponnese which is a remarkable example of Cretan metalwork. Superbly expressive of violent action, the repoussé relief shows a scene in which a bull has charged a hunter and huntress, hurling one of them into the air. This piece dates from a time when Cretan art was concerned with the realistic representation of natural forms. Slightly later in date, storage jars 47 are executed in the so-called 'Palace style' of Knossos, in which naturalism has given way to more formal decorative patterns.

By about 1400 BC, Crete had been conquered by the Myceneans, the first Greek-speaking people to arrive on the Greek mainland. The Myceneans employed Cretan artists in all branches of the arts, for they recognised their artistic skills as superior to their own. They did however produce the first Greek examples of monumental sculpture allied to architecture, in the walls of their great citadels at Mycenae and elsewhere, constructed of cut stones so huge that the later Greeks believed them to have been built by giants, the Cyclops. The most famous example is the Lion Gate 48 at Mycenae, the lintel of which is surmounted by a relief of two lions.

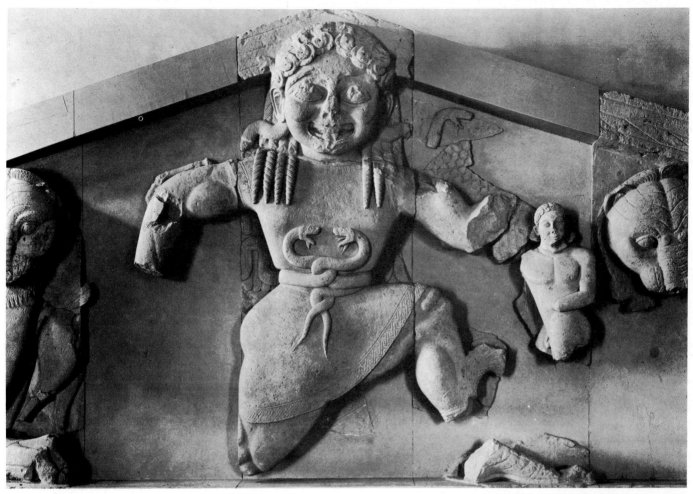

Medusa and her son
Chryasor. Early 6th
century BC. Marble. h.
10¼ ft (3·15 m.). Museum
of Corfu, Greece. The
central group of the vast
pediment of the Temple of
Artemis at Corcyra.

far right
The Kore of Auxerre. *c.*
640 BC. Limestone. h.
25½ in. (65 cm.). Louvre,
Paris.

Early Greek Art

When another Greek-speaking people, the
Dorians, invaded Greece from the north,
the Mycenean culture collapsed. During
the ensuing dark ages the major art forms
declined, but at the same time the founda-
tions of true Greek art were laid. By the
8th century BC, with the emergence of the
Greek city states, foreign influences from
western Asia and Egypt had combined with
an indigenous taste for geometric
decoration to produce a characteristic
Greek style, known as 'geometric'. At first,
even sculptures of the human figure were
reduced to a geometric simplicity of form,
but this gradually gave way to a greater
realism. The Daedalic style of 7th-century
Greece – named after the mythical
Daedalus of Crete whom legend held to
be the first Greek sculptor – shows a
balance between the two, as in a limestone
figure of a girl where the triangular form
of the face and simple body shape, as well
as the engraved decoration of the dress,
show traces of the geometric style, while
the treatment of the hair clearly owes much
to Egyptian influence.

Figure sculpture at this time was
dominated by the ideal concepts of the male
nude *kouros* and the draped female *kore*,
a particularly charming example of which
comes from the 6th century. Though a

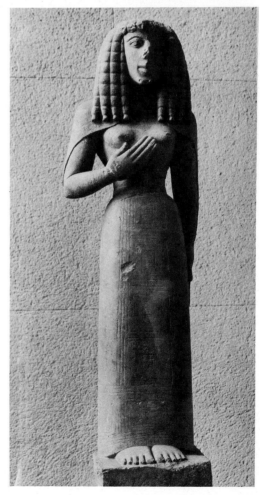

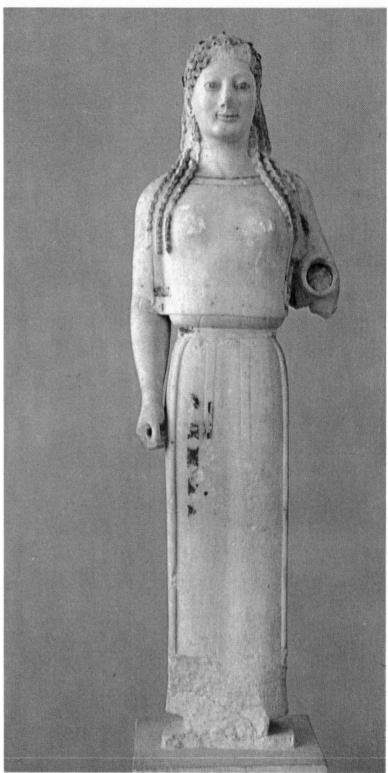

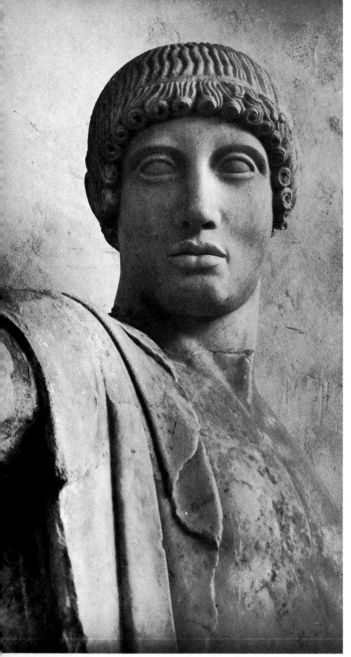

right
Kore No. 679 (The 'Peplos Kore'). *c.* 530 BC. Marble. h. 4 ft. (1·21 m.). Acropolis Museum, Athens.

Head of Apollo. Olympia Museum, Greece.

opposite
Exekias. Attic black-figure vase. *c.* 530 BC. Pottery. h. 16¼ in. (41 cm.). British Museum, London.

hundred years later than the previous example, the figure still has a stylised simplicity, but the modelling is softer and more subtle, and the face in particular has a new liveliness and grace.

The development of the standard form of Greek temple – a rectangular building surrounded by a colonnade – gave particular impetus to the development of Greek sculpture, for the triangular pediment at the end of the temple both cried out for decoration and imposed severe formal restraints on the latter's composition. In the

earliest surviving example of such sculpture the figure of Medusa is represented on one knee, to represent a running motion within the confined space of the pediment. In the original she is flanked by two heraldic beasts, while the corners of the pediment are taken up by smaller human figures.

The 6th century BC also saw the fullest development of the black-figure style of painted pottery which had been developed by the Corinthians out of the early geometric styles. The rich red clay of the pottery is decorated with figures painted as

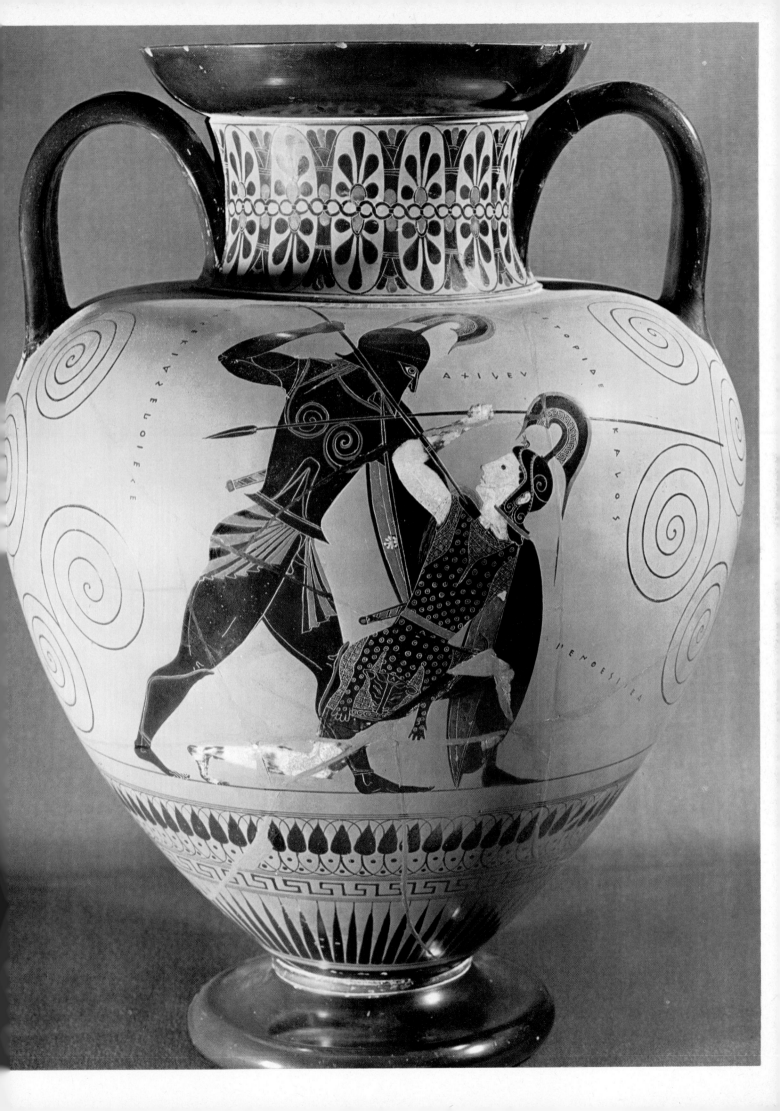

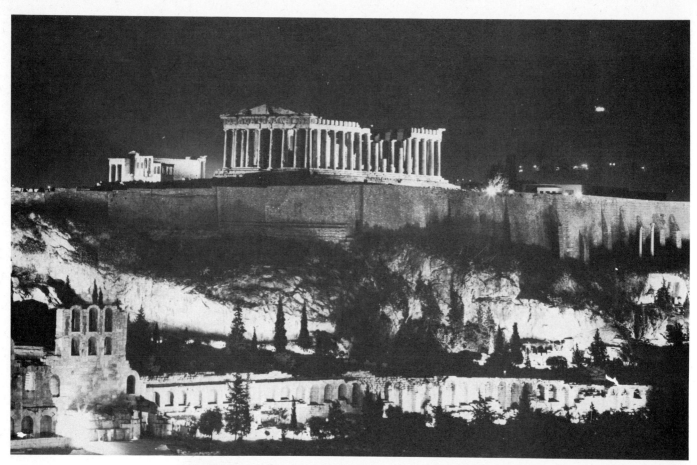

The Parthenon, Athens.
447–432 BC. Marble.

Head of Hermes. *c.* 340
BC. h. (of statue) 7 ft.
(2·13 m.). Olympia
Museum, Greece.

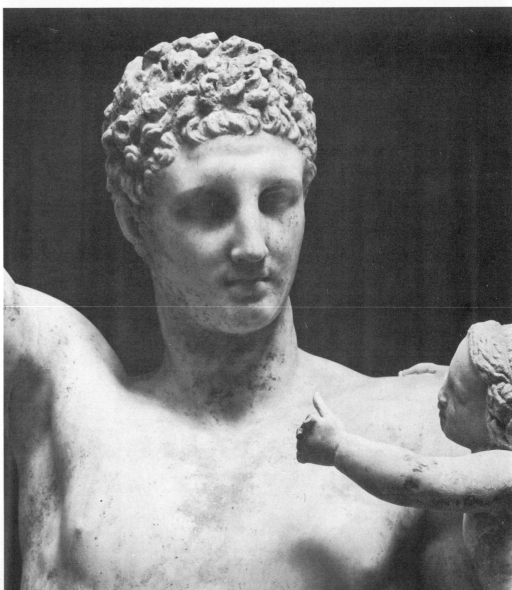

black silhouettes with some incised internal details, and the use of additional colours, particularly purple and white. Repetitive decorative patterns round the top and bottom of the vessels clearly show the inheritance of the geometric style. One of the finest surviving examples of the 51 black-figure technique applied to a vase depicts Achilles slaying Penthesilea, queen of the Amazons.

The City States

At the beginning of the 5th century BC, Athens emerged as the leader of the Greek city-states against the attempted invasions of the Persians, and Greece entered on a period of unprecedented prosperity and cultural achievement. Greek sculpture in particular underwent a revolution exemplified by the abandonment of the ritual poses of the *kouros* and *kore*, which still retained something of the magical flavour of ancient cult images. Sculpture now 50 became concerned with the expression of an ideal of human and divine beauty. The new spirit is well symbolised by the statue of Apollo from the west pediment of the Temple of Zeus at Olympia. With its commanding pose, the right arm flung out and the head turned to follow it with a remote expression, this outstanding figure sets a new standard for Greek art which was not to be surpassed for the next hundred years. 54 A similar spirit is found in the figure of Zeus by an unknown master-sculptor of the period, which is one of the few original Greek bronzes to have survived – bronze statues were always liable to be melted down for other purposes. Like the Apollo, it combines a monumental calm with a suggestion of great physical power.

The Athens of Pericles concentrates and epitomises the achievements of 5th-century Greek art. The great building programme undertaken on the Acropolis in Athens in- 52 cluded the Parthenon, the Doric temple which housed the image of the city's patron goddess, Athena, and which is one of the enduring monuments of world architecture. The famous sculptures from the frieze of the Parthenon, many of which were brought to England by Lord Elgin in the 19th century, probably owe something to the hand of the famous 5th-century sculptor Pheidias, who with his fellow-sculptor Polykleitos best represented the ideals of 5th-century art.

With the victory of Sparta and her allies in the Peloponnesian War (431–404 BC), the might of the Greek city states was broken, and the grand manner of Greek art, inspired by the greatness of Athens and the Olympian religion, gave way to a more human scale of conception. The work of the 4th-century sculptor Praxiteles

far right
The Capitoline Venus. Roman period. Marble. h. 6 ft. 4 in. (1·93 m.). Capitoline Museum, Rome. A Roman copy of a Greek original made about the middle of the 4th century BC.

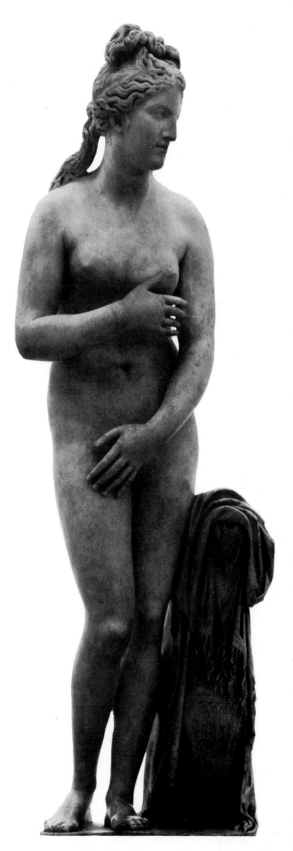

53

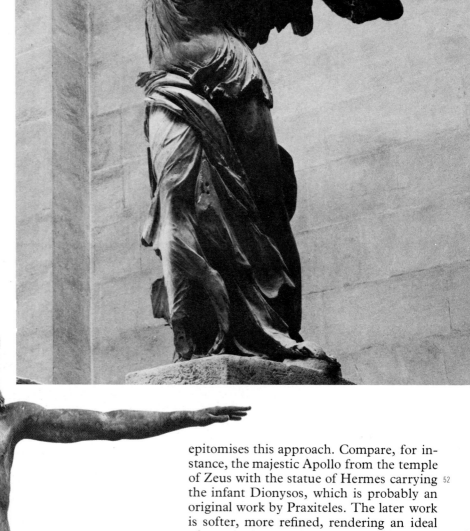

The Victory of Samothrace. Early 2nd century BC. Marble. h. 8 ft. (2·45 m.). Louvre, Paris. Statue of Victory alighting on the prow of a ship.

Statue of Zeus or Poseidon from Cape Artemision. *c.* 460 BC. Bronze. h. 6 ft. 10 in. (2·09 m.). National Museum, Athens.

epitomises this approach. Compare, for instance, the majestic Apollo from the temple of Zeus with the statue of Hermes carrying 52 the infant Dionysos, which is probably an original work by Praxiteles. The later work is softer, more refined, rendering an ideal of purely human beauty and lacking the athletic vigour of the Apollo. It was in the same period that the female nude became an important subject in sculpture, as we can see from a Roman copy of a famous 53 figure of Aphrodite from the period. Compared with the graceful *Peplos Kore*, this is a more 'worldly' creation from every point of view – a fact emphasised by the coyness of the pose.

The Hellenistic Period

The Hellenistic period begins with the conquests of Alexander the Great (356–323 BC) and the spread of Greek influence over a far wider area than hitherto. It was marked by a mingling of Greek and oriental ideas, and a new conception of art. Whereas Greek art had previously been intended to instruct and inspire by an ideal example,

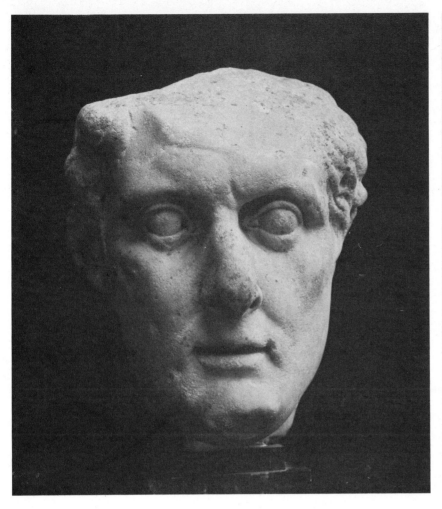

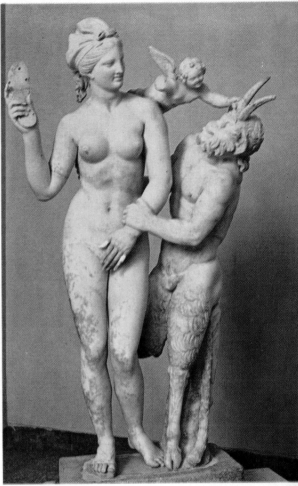

Ptolemy I. *c.* 280 BC.
Marble. h. 10¼ in. (26
cm.). Ny Carlsberg
Glyptotek, Copenhagen.
Ptolemy I was founder of
the dynasty of kings who
ruled Egypt from 323 to
330 BC.

above right
Aphrodite, Pan and Eros.
c. 100 BC. Marble.
h. 4 ft. 4 in. (1·32 m.).
National Museum, Athens.

we now find it being used as a source of pleasure and amusement. For the first time in history we find the concept of a 'work of art' as something of value in itself, without reference to its function. Greek artists became more mobile and travelled widely, producing works to decorate courts and the homes of rich patrons. A typical example 55 is the group made for a Syrian merchant on the island of Delos. Groups of satyrs and maenads were a common theme of Hellenistic decorative sculpture and this particular example has a playfulness which is almost Rococo in flavour.

Hellenistic figure sculpture in general showed a move away from the stylised poses of the previous age with animated groups such as the famous *Death of Laocoön* revealing an interest in human emotions and drama. Single figures of the period rarely have the distinction of those from the time of Polykleitos or Praxiteles, but 54 the winged Victory of Samothrace is an exceptional example. A new and dramatic use of drapery, combined with the sweep of the wings, give this figure a remarkable sense of power and movement.

The new interest in rendering subjects of human drama was matched by a greater realism, with many figures clearly portraying the imperfections of a human original. The growth of portraiture was an important facet of this trend – once again we are witnessing a progression from the idealised and the heroic towards the purely commemorative in art. The portrait head of Ptolemy has a vividness which suggests a 55 far greater faithfulness to the original subject than had been achieved before.

The Etruscans

Just as Hellenistic domination of the Mediterranean world gave way to Roman domination in the 3rd and 2nd centuries BC, so Hellenistic art shades into Roman art. In the 1st century BC, the Romans wholeheartedly adopted the themes and techniques of Greek art, but they had already had long experience of these indirectly, through the Etruscans, whose own art owed much to Greek example. The development of a distinctive Etruscan culture began in the 8th century with the Villanovans. The latter were skilled metalworkers and potters and the geometric decoration of their work is clearly related to the Greek geometric style, which may have been absorbed through a Greek colony established in southern Italy about 750 BC. The human figure is not seen at this early stage in Etruscan art, first appearing in the monumental sculpture of the 7th century when the increased prosperity of the Etruscan ruling class led to a demand

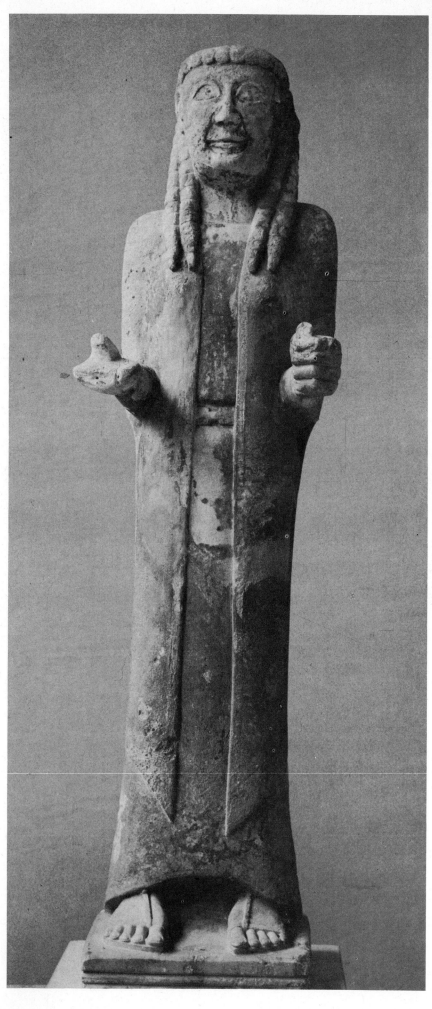

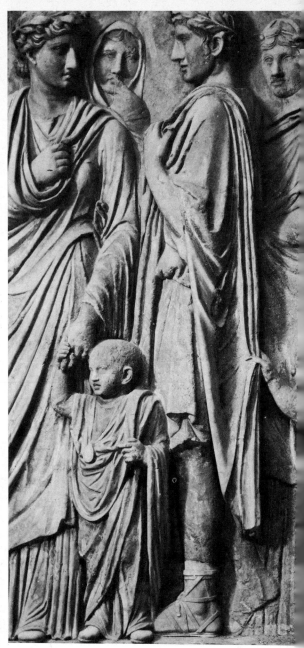

for luxury objects in precious metals and lavishly decorated tombs. The Etruscan figure sculpture of the 6th century shows the same mixture of influences from Egypt and western Asia as Greek sculpture of the period and is clearly derived from the latter. Some examples bear direct compari- 56 son with figures in the Daedalic style. The progression from the early geometric style to more rounded human forms has been taken a little further, but the treatment of the face and hair and the formal stiffness of the body show a practically identical approach.

The Etruscans excelled in the art of terra-cotta modelling, a technique which they had learned from the Corinthians, which often shows the extent to which by the 5th century BC Etruscan art, while adopting the conventions and mythology of the Greeks, had nevertheless developed a distinctive flavour of its own. The cast of the face in this particular example in 58 particular shows an oriental influence which had disappeared from Greek art by

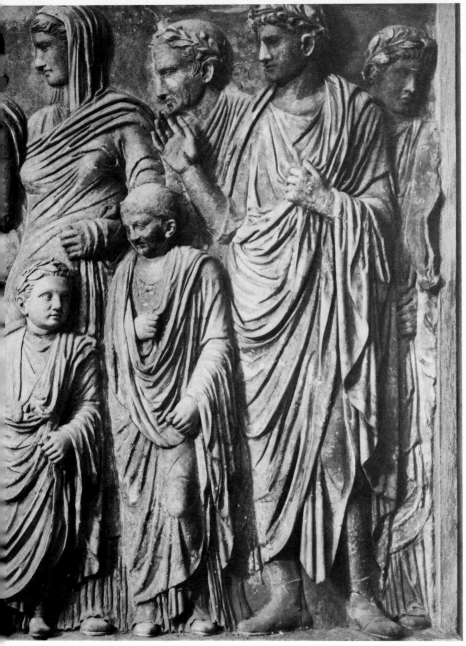

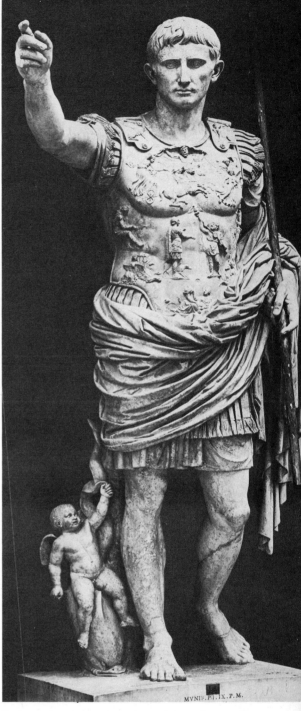

the 5th century and is almost Byzantine
in character. The Etruscans also learned
the art of vase-painting from the Greeks,
and the 4th century saw the production
of some impressive works in the red-figure
style – a reversal of the black-figure style
in which the figures themselves are left in
the natural colour of the clay while the
background and details are filled in in
black. One example, depicting the sack of
Troy, is crammed with lively detail.

The Roman
Contribution

By their adoption of Greek art, the Romans
assured its survival and its diffusion over
a far wider area than would otherwise have
been possible. The Roman conquests of the
2nd and 1st centuries BC resulted in a flood
of works of art into Italy, taken from the
conquered cities. The demand for Greek
works in particular became widespread and

Rome was a magnet for artists from all
over the Hellenistic world. Having made
their own contributions and modifications
to the Greek styles, the Romans then
spread it throughout the area of the Roman
empire.

The Roman contribution to Classical art
shows a continuance of two trends which
have already been noted – an increasing
humanisation and secularisation of art, and
an ever more intensive concern with the
commemorative role of representational
works, particularly sculpture.

The two trends are combined in the
characteristic Roman art form of com-
memorative relief sculpture. Here was a
medium which lent itself admirably to the

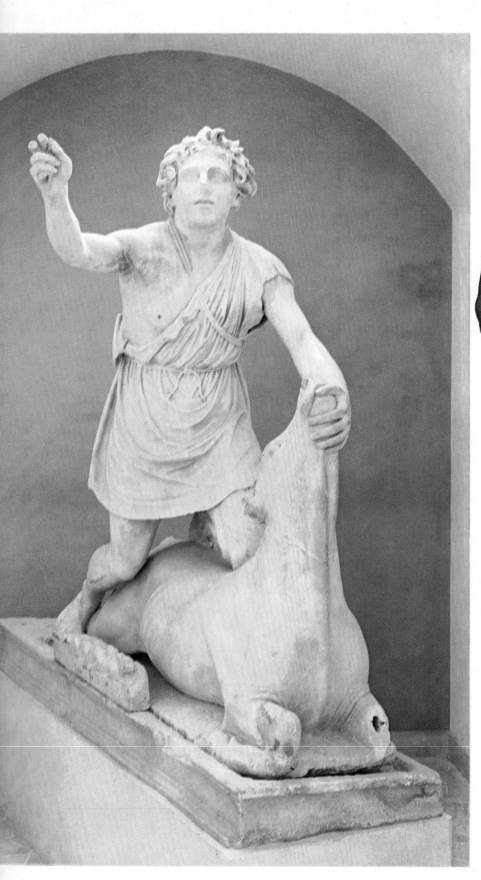

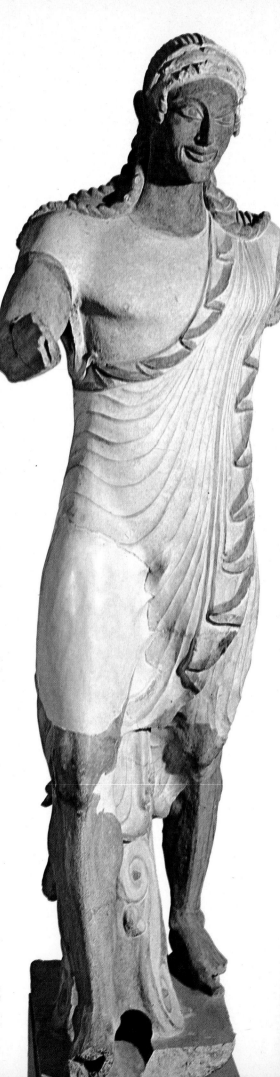

Kritios of Athens. *Mithras Slaying the Bull. c.* 2nd century AD. Marble. h. 5 ft. 7 in. (1·70 m.). Ostia Museum, Rome.

The Apollo of Veii. *c.* 500 BC. Terracotta. h. 5 ft. 9 in. (1·75 m.). Villa Giulia Museum, Rome.

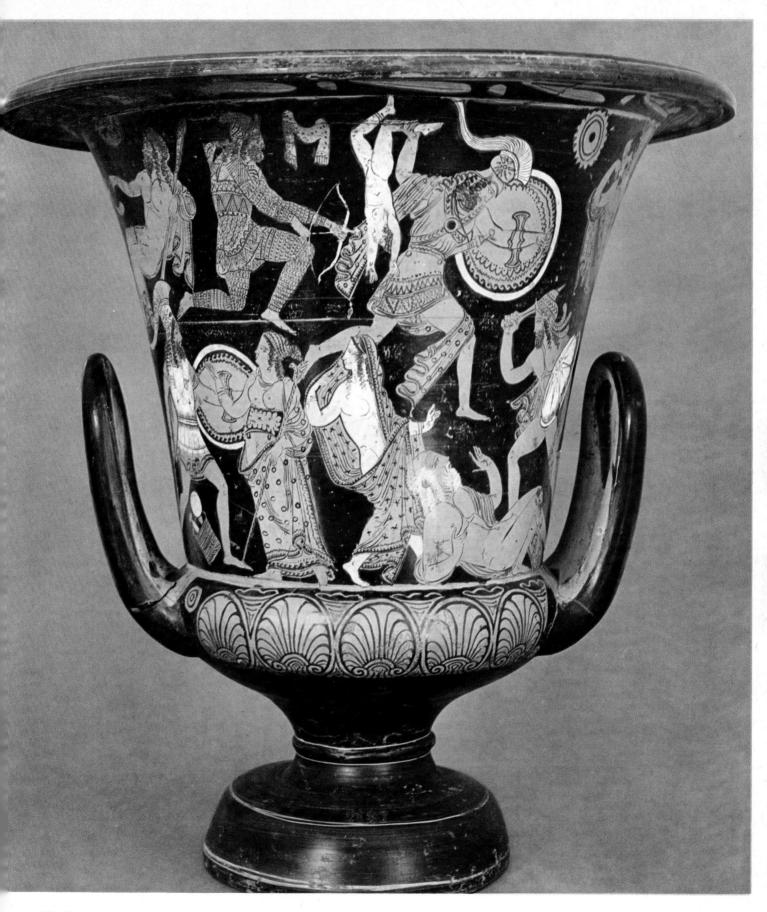

The Nazzano painter.
Calyx crater. *c.* 400–350
BC. Pottery. h. 22½ in. (51
cm.). Villa Giulia Museum,
Rome.

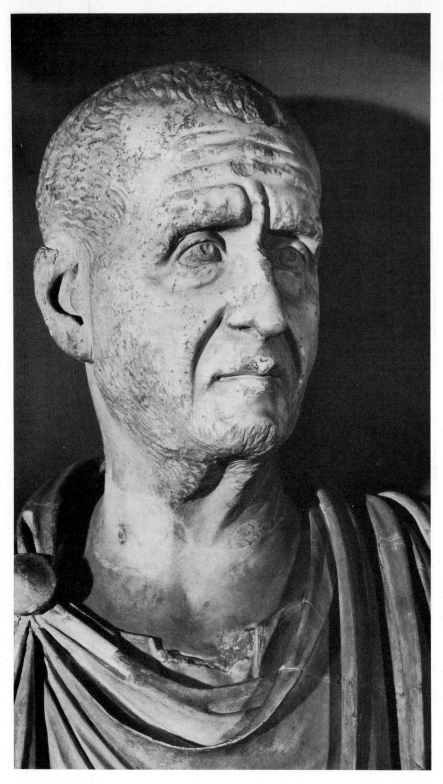

Head of Trajan Decius. c.
250 AD. Marble. h. 13 in.
(33 cm.). Capitoline
Museum, Rome. Portrait
of an emperor who
reigned from 249 to 251.

opposite
The Melfi Sarcophagus.
Late 2nd century AD.
Marble. h. 5 ft. 5 in. (1·65
m.). Melfi.

celebration of the historical achievements
in which the Romans took a justifiable
pride. The great monumental altar in
Rome, the *Ara Pacis*, built at the beginning
of the imperial age, typifies this new kind
of commemorative art. The processional
frieze combines a concern for realistic por-
traiture with a suitably Roman sense of
civic dignity and pride.

Portraiture was in fact an important part
of Roman commemorative art. Portraits of
the emperor in particular – coins, busts and
statues – were used as a means of uphold-
ing Roman values at home and spreading

them to the furthest corners of the empire.
The well-known statue of Augustus is a
superb example of imperial propa-
ganda – the emperor depicted as the suc-
cessful warrior, stern and composed, his
right arm raised in a gesture of supreme
authority. Such an idealised rendering suits
the confident spirit of the Augustan age,
but later emperors did not necessarily care
to appear so remote. By the 3rd century
AD, when the Roman empire was on the
decline, portraiture had become very differ-
ent, seeking to reveal the inner aspirations
and sufferings of the subject in a way which
symbolised the tensions and confusions of
the time. The head of Trajan Decius
is one of the finest portraits in this
later style.

While Roman public art adapted the
Greek conventions to suit the purposes of
imperial propaganda, it was in the sculp-
tures and paintings with which the wealthy
Romans decorated their homes that the
Greek traditions were most faithfully
upheld. Copies of Greek sculpture, paint-
ings and furniture were widely used. In-
deed, Roman wall paintings thought to
have been copied from Greek originals are
the only record of a Greek art form which
would otherwise have been lost to us en-
tirely, as is the case with pictures from a
house in Pompeii which are on typically
classical themes and were probably inspired
by a Greek original painted in the 4th or
3rd century BC. Scenes from Greek myth-
ology were a popular subject for this type
of decorative painting, which are very soon
thought to have reached a fairly advanced
level of technique in the rendering of light
effects and the modelling of the human
body.

In imperial times, the conventional man-
ner of burial for wealthy Romans was in
stone sarcophagi, and this gave rise to a
typically Roman art form which combined
both the public and the private manners.
Elaborately carved sarcophagi were pro-
duced throughout the Roman empire, some
decorated with Classical and mythological
scenes, and others with scenes of Roman
civil and military life more in the manner
of the commemorative reliefs. The Melfi
Sarcophagus belongs to the latter category,
and shows the less 'Classical' technique and
greater realism of the faces which charac-
terise Roman art of the 2nd century AD.

The Classical period shows a gradual
'de-mystification' of the themes and tech-
niques of artistic creation. The rise of
Christianity in Roman times clearly repre-
sents a reassertion of the 'mystical' element
in life, but the new tradition which it estab-
lished could never entirely displace the
Classical tradition, and the two were to
remain uneasy companions, sometimes
complimentary, at others contradictory, for
the next two thousand years.

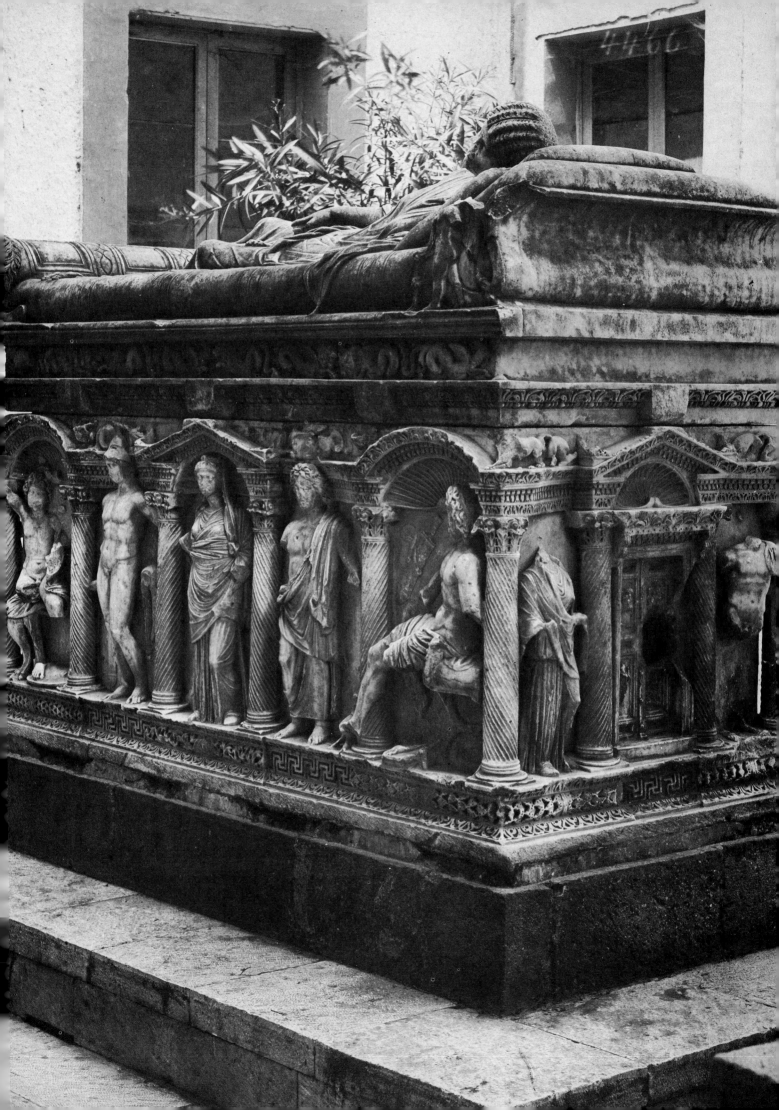

Early Christianity and the Byzantine World

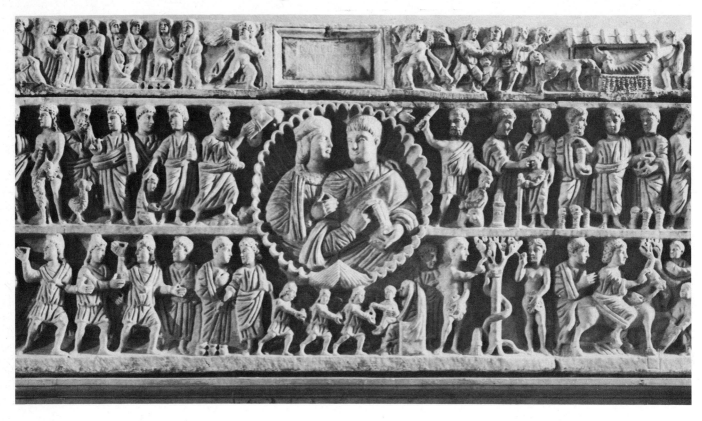

Sarcophagus of Adelphia.
4th century. Marble.
Syracuse.

Under the Roman empire, religion had become inextricably linked with imperialism. The official religion of Rome glorified the values embodied in its own form of political organisation, raising its rulers to the status of gods. That side of religion which did not relate to imperialistic propaganda was a compound of superstition and witchcraft. The mystical element in religion, which upholds the possibility of individual progress on a non-worldly plane – in Christian terminology, of salvation – was absent from a system in which such gods as were thought to exist were there only to be bullied, coaxed, bribed or placated.

Whatever its later manifestations, Christianity in its original form would appear to have been an attempt to reintroduce this mystical element into the life of the Roman world. Since Christianity could not hope to supplant the entire Classical tradition at one blow, it was inevitable that the earliest Christian art should wholeheartedly adopt the Classical artistic heritage, despite its pagan associations. Indeed, not only did Christian artists of the 4th and 5th centuries AD make extensive use of Roman

artistic techniques such as mosaic, but pagan themes often appeared in the decoration of Christian churches.

Initially, Christian art was relatively uniform throughout the area of the Roman empire, but gradually there was a divergence of artistic methods between East and West which paralleled the doctrinal split between the church of Rome and the church of Byzantium. While in the West Christian art perpetuated a modified Classical tradition mingled with local forms such as the Celtic art of the British Isles, in the East there was a development of the western Asian influences which had made a contribution to Greek art at an early stage. In both quarters the concern to avoid the associations of pagan 'graven images' led to the exclusion of statuary from churches and the rejection of highly representational painting in favour of works which aimed to transmit an aura of sanctity. In the Byzantine world the 8th-century revolution of the iconoclasts, who sought to ban all figurative art from churches, was followed by the adoption of 'iconography' in which the images of saints and martyrs

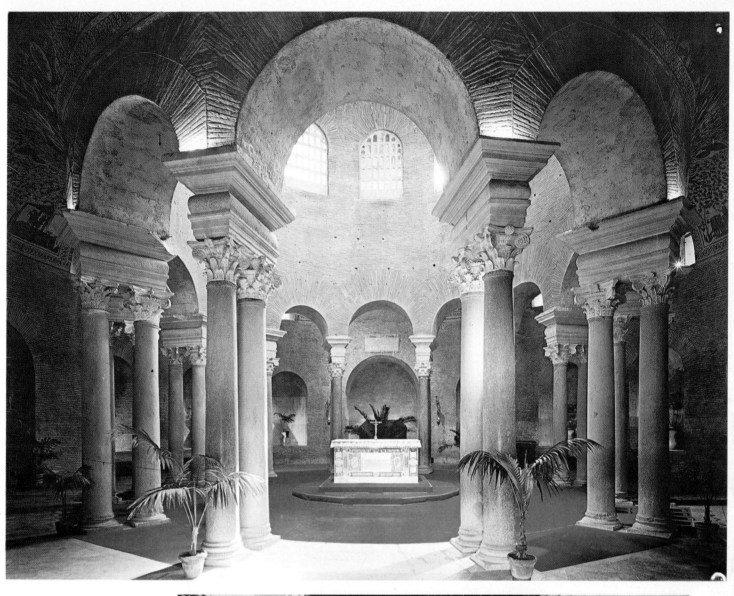

Interior of Sta Costanza,
Rome. 4th century.

The Sanctuary of the
Nativity. 4th century.
Bethlehem.

63

conformed to a rigid tradition and were always depicted with the same set of stylised facial characteristics.

Covering a relatively brief period in historical terms, Early Christian art was nevertheless the starting point of a new tradition, and as such it has a vital richness and splendour which subsequent Christian ages with their different preoccupations would never entirely reproduce.

Christianity and the Romans

In its beginnings, Christianity was naturally subjected to considerable pressures by the all-embracing system of the Roman state. So long as it did not have official sanction its manifestations were necessarily private, and the first examples of Christian art reflect its status. They were paintings on the walls of private places of worship, and in the catacombs where the Christians buried their dead. Carved sarcophagi in the Roman manner were one medium which the early artists could conveniently make use of, and surviving examples show a more or less continuous progression from Roman and pagan to Christian themes, as in one example decorated with carvings of biblical subjects; although the technique is perhaps slightly cruder than on the Ludovisi Battle Sarcophagus from a century earlier, they are obviously closely related.

The real impetus to the development of Christian art came with the establishment of Christianity as the official religion of the Roman empire under the Emperor Constantine in the 4th century AD. Now Christian art could assume a public character, and public places of worship could be erected, designed and decorated to meet the needs of the new cult. The temples of the previous age had been designed to meet a pattern of small-scale ritual and individual sacrifice to the pagan gods. The new Christian churches had to accommodate large congregations facing a sanctified area at one end. The customary form was that of an oblong building with a central nave separated from side aisles by a colonnade and lit by a clerestory from above. The basilica of the Sanctuary of the Nativity in Bethlehem is one of the earliest surviving examples of this type of building. The colonnade of Roman Corinthian columns dates from the time of Constantine, though the octagon which originally covered the sanctuary was replaced by three trefoil apses in the 6th century. The Classical style of the architecture scarcely needs emphasising.

Where the sanctified area marked a place of particular religious significance – as in the Sanctuary of the Ascension on the Mount of Olives or the Holy Sepulchre itself – a large rotunda or octagon was erected in which pilgrims could assemble with their attention focused on a central point. Since many Roman mausoleums had

opposite
Presbyterium of S. Vitale. 546–548. Ravenna.

The ambo of the Christian basilica at Leptis Magna. 5th century. Homs, Tripolitania.

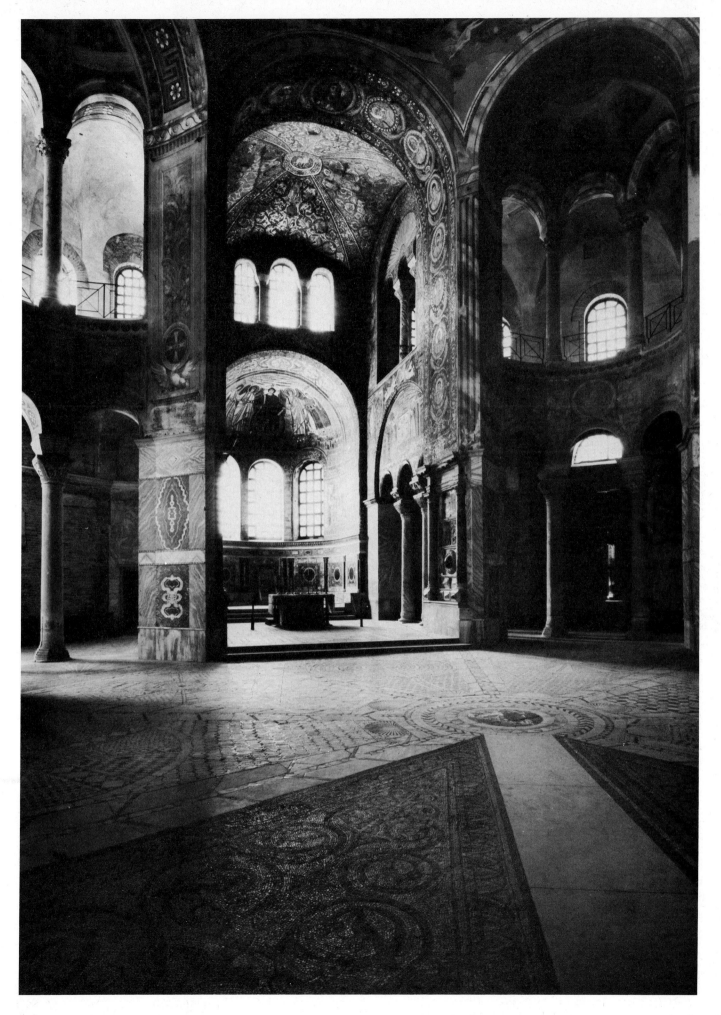

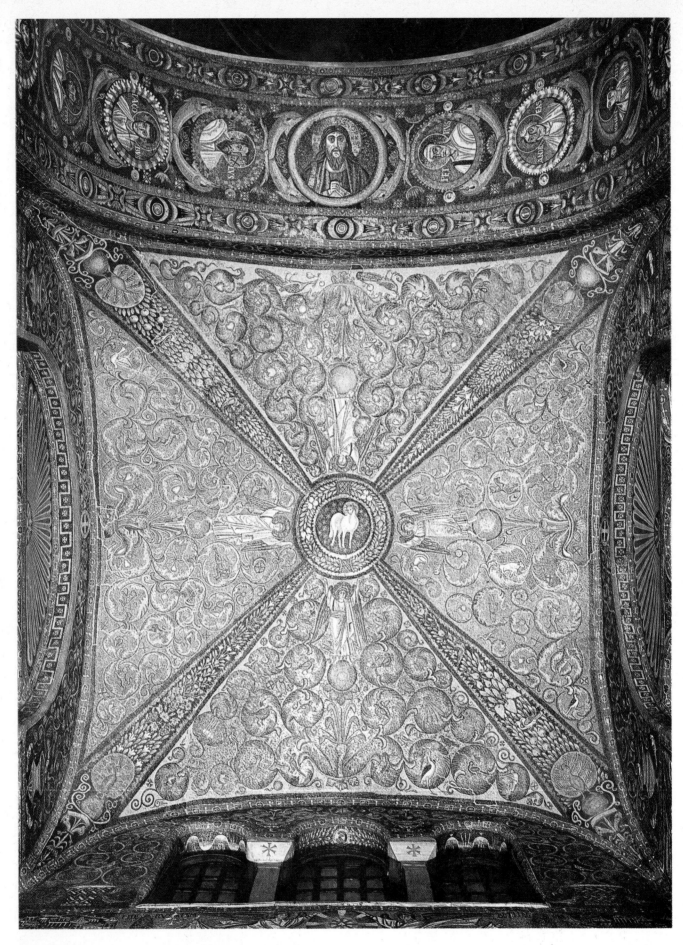

The vault of the
presbyterium of S. Vitale.
546–548. Ravenna.

opposite
Capital from Hagia
Sophia. 6th century.
Marble. Constantinople.

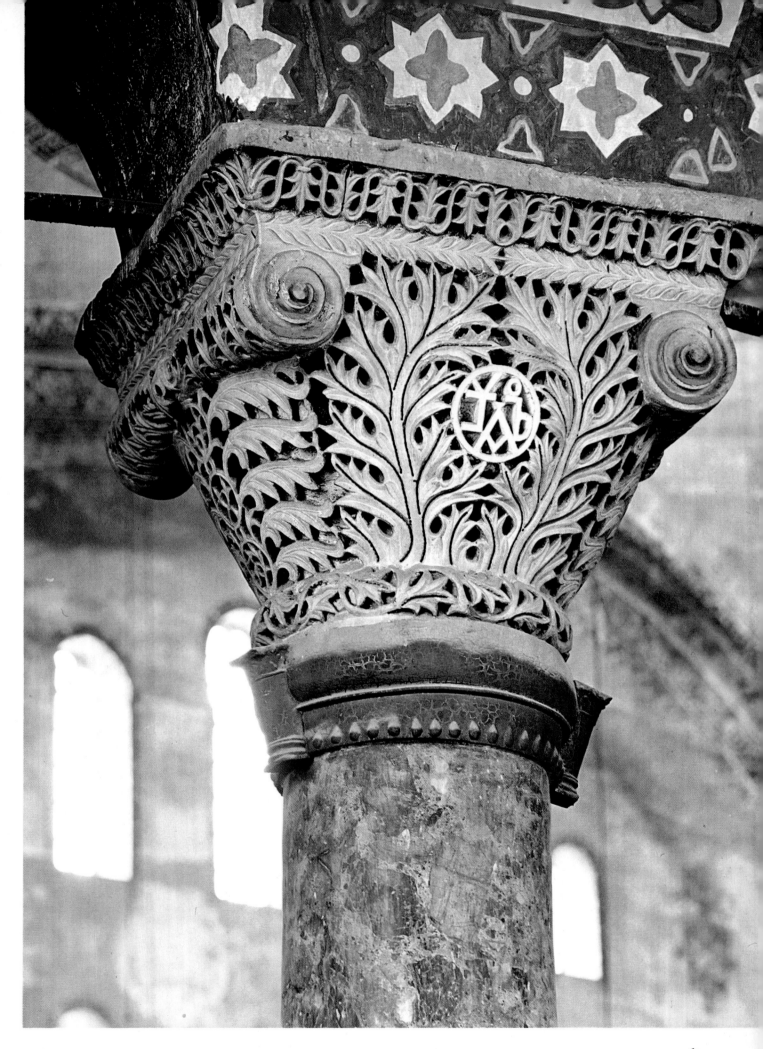

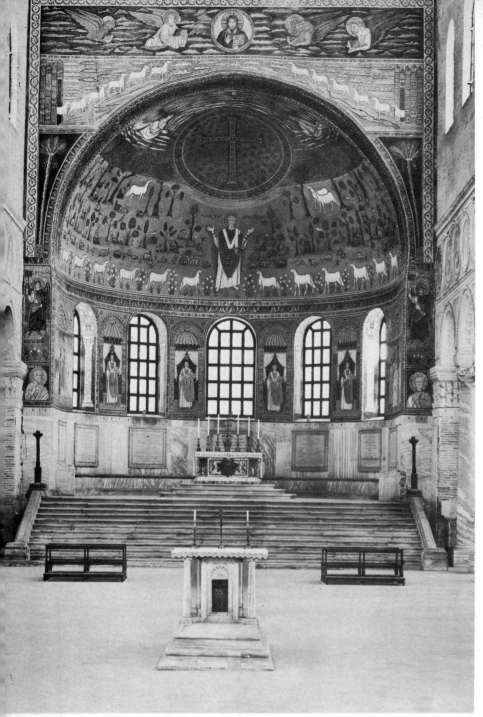

The apse, S. Apollinare in Classe. 6th century. Ravenna.

itself adapted from a Roman civilian basilica on the same site, but the ambo – a kind of pulpit used for readings and sermons – was constructed with capitals and slabs of marble from pagan monuments. 64

Early Byzantine Art

The creation of a new imperial capital at Constantinople brought a new focus of power and cultural influence to eastern Europe, whose essence is summed up in a word – Byzantium.

Nothing gives a better impression of the splendour of early Byzantine art than the famous mosaics of Ravenna. As the western centre of the Byzantine empire, Ravenna was the meeting place of East and West in the 5th and 6th centuries AD. In the churches of Ravenna, the mosaic technique beloved of the Romans was extended to cover walls and ceilings as well as floors, while the Asian influence which had long formed a separate tradition in Greek art appeared in the stylistic treatment of the subjects. The typically 'Byzantine' faces which appear in these mosaics seem to echo the large-eyed staring masks of Mesopotamia, reviving some of the sense of mystery found in the art of the ancient Mesopotamian cultures. The church of S. Vitale is the fullest expression of Byzantine art in Ravenna. The interior facings up to eye-65 level are a riot of multicoloured, patterned marble, while the floors and upper parts of the walls, as well as the ceilings, are covered in mosaics on Christian and Byzantine imperial themes. The mosaics themselves show a tremendous richness of detail and colour as compared with their Roman predecessors, which is partially due to the use of semi-translucent glass tesserae backed with gold and other colours. The illustration of the vault of the presbyterium 66 of S. Vitale gives an idea of the sumptous overall effect. Elsewhere one finds the haughty faces of the Byzantine rulers – the Emperor Justinian and his Empress Theodora appear in S. Vitale – and also charming narrative scenes of prophets, saints and martyrs. In the church of S. Apollinare in Classe, the souls of the faithful are 68 depicted as sheep rising from earth to receive Christ's blessing and finally resting with the saint in the garden of paradise.

Byzantine churches showed a departure from the pattern of a rectangular basilica – their characteristic feature was the dome, which instead of being placed on a solid-walled drum as in Roman buildings, was supported by a series of arches, so that the interior of the building appeared as a cross within a square. While demanding complex architectural solutions, this arrangement gave the typical Byzantine church a new spaciousness, the soaring

been constructed on a similar plan, such buildings were often taken over and consecrated for the purposes of Christian worship. One notable example is the circular mauso-63 leum of Constantina, one of the daughters of Constantine, in Rome. The slender Classical columns supporting the arches, and the overhead windows, contribute an airy lightness to the building, which is decorated with mosaics on both pagan and Christian themes.

The early Christian basilicas remained flexible in design, changing in layout according to local needs and customs – the position of the altar, for example, varied considerably. But the use of Classical motifs and the adoption of existing buildings and materials was a constant feature. In the case of the Christian basilica at Leptis Magna, not only was the building

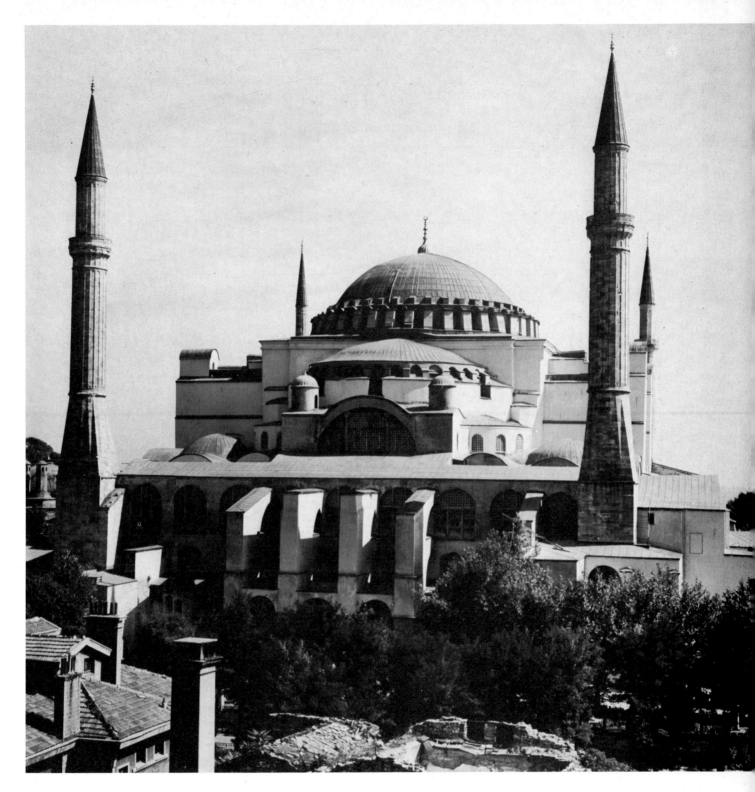

Hagia Sophia. 532–537. Constantinople.

dome symbolising the mystical aspirations 69 of man. The supreme example is the Hagia Sophia in Constantinople, which was built on the orders of the Emperor Justinian, not only as a place of worship but also as a monument to Byzantine imperial power. It clearly follows the cross-in-square plan; half domes at either end of the main dome extend the interior vaulting throughout the length of the building. The interior decoration matches the splendour of the architectural form. The dome is faced with mosaics on the inside and the 67 capitals of the colonnades are elaborately carved with acanthus leaves and scrolls.

Christianity and the West

While the Byzantine empire had imposed a firm tradition on the Christian art of the East by about the 6th century AD, in the West the situation was more fluid. The barbarian tribes which invaded the western part of the Roman empire and settled in Europe had far fewer artistic traditions of their own, especially when it came to architecture. As a result we find the Roman style of architecture continuing in a relatively

Xpiꝰꞅ autem

Christ Blessing. c. 781.
From an Evangelistary
commissioned from the
scribe Godescalc at the
court school of
Charlemagne.
Bibliothèque Nationale,
Paris.

71

unmodified form, while the minor decorative arts are full of stylised natural forms and abstract geometric patterns which seem to echo the world of primitive man. A sarcophagus of Pyrenean marble, now in Toulouse Museum, has a well established Roman ancestry and the carved decoration still uses Classical motifs, such as the embryonic columns at each corner and the vine-scroll decoration, but the use of the latter as an overall pattern suggests a more primitive inspiration.

In the British Isles, the decorative art of the Celts had been preserved and refined to a level of considerable sophistication, and this became linked with the early Christian tradition in the monastic movement founded by St Columba in Ireland in the 6th century, which was to spread rapidly over Western Europe. Celtic scroll-work and interlaced patterns appear on brooches, sword scabbards, chalices and illuminated manuscripts. The monastic movement of St Columba was noted for its intellectual achievements – Latin and Irish manuscripts were copied and the monks, who included poets and historians,

opposite top
Sarcophagus of Pyrenean marble. 7th century. Toulouse Museum.

opposite bottom left
The Ardagh Chalice. 8th century. Bronze and enamel. National Museum, Dublin, Ireland.

right
Initial from the Catach of St Columba. 6th century. Royal Irish Academy, Ireland.

also wrote lives of the saints, including that of St Columba himself. At first the ascetic influence of the latter prevented any lavish illustration of the manuscripts, and there were only a few embellished initial capitals, though these have a remarkably fresh and lively graphic quality. But later manuscripts do not show such restraint. The famous Book of Kells is one of the most magnificent examples of illustrated manuscript work from any culture. The title page is a swirling mass of coloured scroll-work in which the favourite Celtic motifs – the familiar snake and spiral – are developed with incredible intricacy. Man's taste for decorative embellishment is nowhere better demonstrated than here.

The western centre for Christian art in the 8th–9th centuries was the court of Charlemagne at Aachen. Fired by the examples of Rome, Ravenna and Byzantium, Charlemagne wished to create a cultural centre of comparable magnificence. Artists, thinkers and craftsmen flocked to his court from all corners of Europe and western Asia, and in this cosmopolitan atmosphere the Roman, European and Byzantine traditions met. The palace chapel at Aachen, built to an octagonal plan, is lavishly decorated with mosaics and marble facings which are faintly reminiscent of the Byzantine manner, but its conception is basically Roman. The central octagon is a simple, solid construction, suggestive of the early Christian sanctuaries rather than the soaring vaulted interiors of the Byzantine churches, and there are Roman capitals to the colonnades.

Charlemagne also created an official workshop at his court for the reproduction of manuscripts, and numerous masterpieces of the illustrator's art were produced. The first was the evangelistary of the scribe Godescalc. The pose of the figure on the leaf illustrated, the realistic drapery and the use of naturalistic plant forms can be traced back to early Roman Christian art. The iconographic stylisation of the face shows Byzantine influence, however, and the border is decorated with a Celtic interlace pattern derived from Irish manuscripts brought to the Frankish kingdom in the 7th century. West and East had at last met in the Holy Roman Empire.

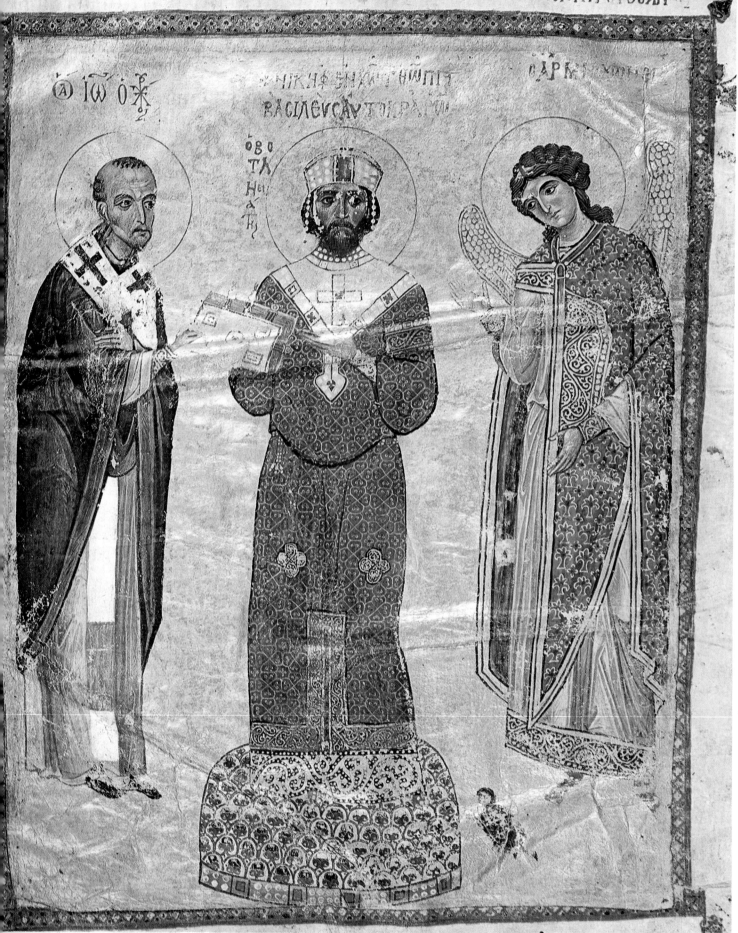

74

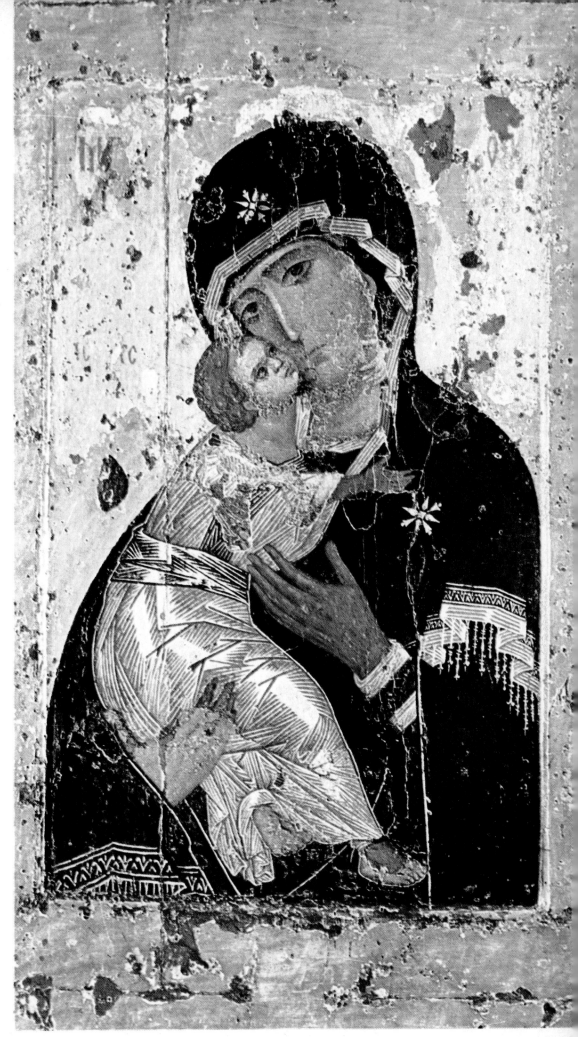

*The Emperor Nicephorus
III Botaniates. c.* 1078.
Miniature from a famous
manuscript of the
Homilies of St John
Chrysostom. Bibliothèque
Nationale, Paris (MS.
Coislin 79, fo. 2 v.).

The Virgin of Vladimir. c.
1125. Paint on panel. The
Tretyakov Gallery,
Moscow.

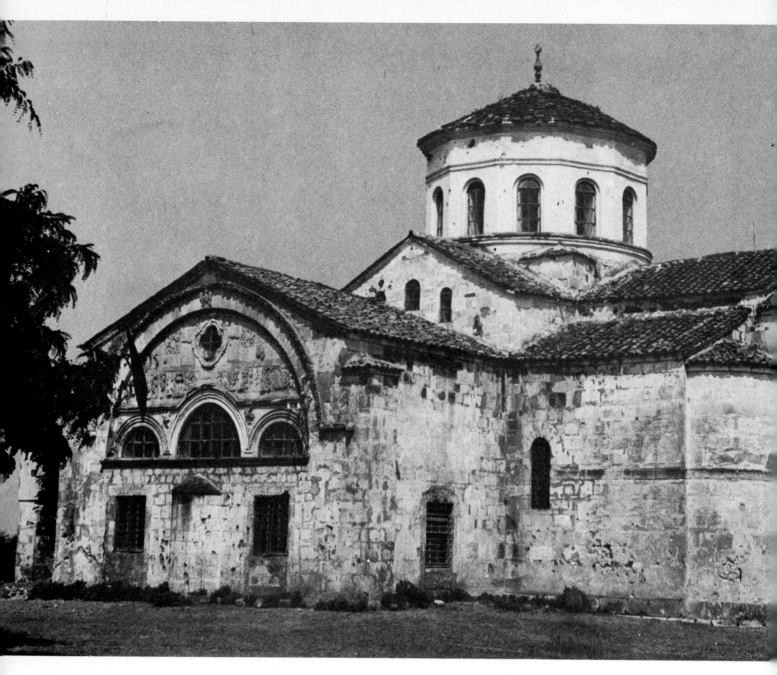

Sta Sophia, Trebizond.
Before 1260.

The Byzantine Revival

After the iconoclastic disputes of the 8th century, which naturally had a disruptive effect on Byzantine art, the 9th century saw a brilliant resurgence of Byzantine power and cultural influence which was to continue into the 12th and 13th centuries and spread as far afield as the Caucasus and Sicily. The church of Sta Sophia at Trebizond on the south-east shore of the Black Sea shows the characteristic domed cross-in-square plan of the Byzantine church, modified in this instance by the addition of projecting porches on the north, west and south sides – the latter being shown in the illustration. In Venice, a city which maintained close relations with Byzantium throughout the period of its expansion, the famous cathedral of San Marco was inspired by the church of the Holy Apostles in Constantinople. Filled with an unearthly light which falls from the five great domes, the soaring vaults of the interior are faced with glittering mosaics and the walls with green patterned marble which seems to reflect the rippling waters of the lagoon outside. Detail fades before an overwhelming impression of almost barbaric oriental splendour.

Roger II, the Norman king of Sicily from 1130 to 1154, maintained relations with both the Western and Byzantine empires, and these two influences, together with that derived from the earlier Muslim invasions, resulted in a complex intermingling of styles in Sicilian art. The mosaic of the Three Fathers of the Church is unmistakably Byzantine, however, with its statuesque poses and elongated faces, which show the stereotyped portraiture of iconography, as we shall shortly see.

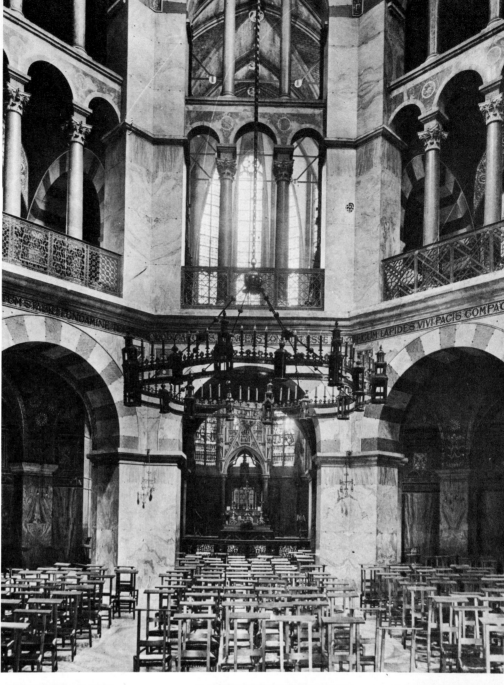

The Palace Chapel,
Aachen. Late 8th century.

The interior of S. Marco,
Venice. 12th century.

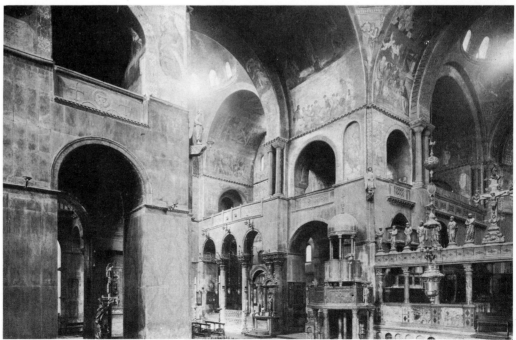

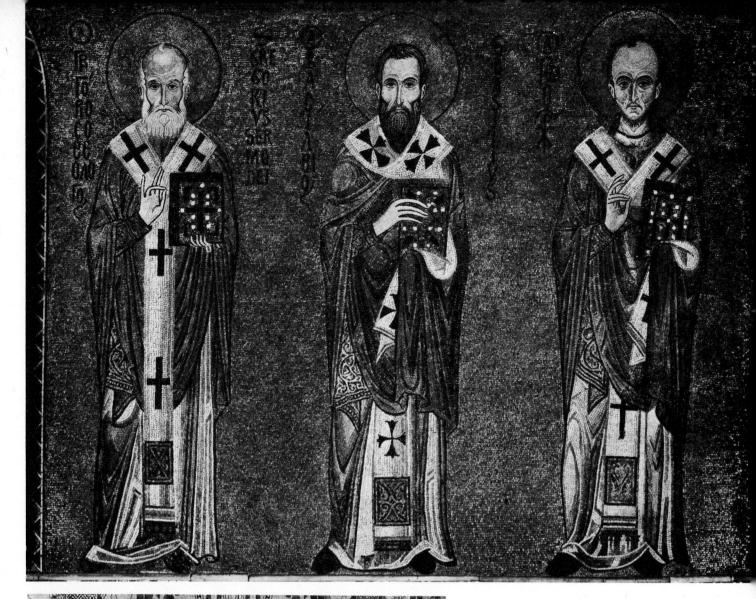

The court studios of the revived Byzantine empire produced a wealth of pictorial art which included both imperial portraiture and illustrated manuscripts on religious themes. The two are combined in a miniature from a manuscript of the Homilies of St John Chrysostom. The careful composition of the figures and brilliant use of colours mark this as a masterpiece of Byzantine illustration, and the rich semi-geometric pattern of the Emperor's robe suggests Islamic influence.

Facets of Byzantine Art

Like most of the established religions of the high cultures, Christianity derives its authority from the traditions contained in a book which is held to be sacred by its followers. And the concern for religious orthodoxy led to a wide range of artistic conventions governing the depiction of incidents from that book. In the art of the eastern Christian church, in particular, these conventions are developed into a systematic iconography, in which even the facial characteristics of saints are established by tradition.

The Stavelot Triptych. *c.*
1150. Copper, silver gilt,
champlevé enamels. 12½ ×
25 in. (31 × 63 cm.).
Pierpont Morgan Library,
New York.

opposite top
The three Fathers of the
Church. 12th century.
Mosaic. Capella Palatina,
Palermo, Sicily. St
Gregory, St Basil and St
John Chrysostom are
represented with the facial
traits established by
traditional iconography.

opposite bottom left
The Shroud of St Victor.
8th century. Byzantine
silk. Sens Cathedral,
France.

This crystallisation of a whole religious tradition in each portrait of a sacred figure meant that the portrait itself assumed a kind of sacred aura, becoming an object of devotion. Icons – iconographic portraits of Christ, the Virgin and the saints – became an important part of the artistic and devotional apparatus of the eastern church. The *Virgin of Vladimir* is an outstanding example of this art. The softer treatment of the subject and the feeling of compassion and tenderness which the painter has instilled into the picture show a move away from the traditional Byzantine mould. Executed in Constantinople and subsequently taken to Russia, this particular work established a whole new style for Russian icons.

The lavishness and splendour of Byzantine art reflect a culture in which religion and imperialism had once more become intimately entwined. The sumptuous decoration of Byzantine churches was matched by a proliferation of luxury artifacts of the kind with which rulers like to surround themselves. Thus we find richly embroidered textiles, such as the shroud of St Victor, in which Byzantine art shows its western Asian origins. The 'Gilgamesh motif' of the lion-conquering hero goes back to early Mesopotamian culture, before being identified with Samson in the Bible. Ivory carving has always been a luxury craft, and in Byzantine art it takes the place of sculpture, which the early Christian attitude towards idolatry rendered unacceptable. Byzantine caskets made of wood and covered with ivory plaques depicted scenes from the story of Adam and Eve. The bands of rosettes are characteristic of the period, and the individual scenes are charmingly labelled with the participants' names in a kind of comic-strip style. Portable reliquaries executed in ivory or precious metals and decorated with gems and enamel work were another typical product of the Byzantine taste for opulence. The

The monastery of Lavra,
on Mount Athos, Greece.
903.

small enamel triptychs in the centre of the altar-piece were probably made in Constantinople to hold relics of the True Cross. The enamel medallions in the two leaves are probably of Western origin, and their realistic scenes, with a suggestion of perspective and a naturalistic use of drapery, contrast with the formally posed, two-dimensional figures of the centre panels, exemplifying the contrast between the Classical and Byzantine traditions.

From the beginning, Byzantine religious art had overtly imperial associations, but the traditions which it established were strong enough to survive the end of Byzantine power. The eastern church has remained a repository of the Byzantine heritage, which even at a fairly early stage was conserved in an unchanging form in monastic centres of which Mount Athos is probably the most famous. The centres of innovation in Christian art in medieval times were firmly fixed in Europe, where the Roman church was pursuing its own particular brand of imperialism.

Islam

Some six hundred years after the birth of Christ, a new religion arose in the Middle East which was to give its name to a new empire and a whole civilisation. Its founder, Mohammed, was not only a mystic and religious teacher, he was also a statesman and administrator, and from the beginning there was no division between the Islamic religion and Islamic secular life.

Bronze ewer with engraved design from Syria. Mid-8th century. h. 16⅛ in. (41 cm.). Museum of Islamic art, Cairo.

Mohammedans believed in the all-embracing power of the one god, whose prophet was Mohammed and whose influence was revealed in every facet of human existence. In the half century which followed Mohammed's death in 632 AD, the Islamic armies spread out from Arabia, imposing the Muslim way of life as much by conquest as conversion. By 750 AD they controlled a vast area stretching from Spain to the borders of China and including North Africa, Egypt, Syria, Persia, part of northern India and western Turkestan.

This sudden expansion was matched by a cultural explosion of unparalleled richness and creativity. Moreover it was one which owed relatively little to the prevailing cultural modes of the time. We have seen how both Byzantine and western early Christian art eschewed the use of religious statuary, but nevertheless retained painted images of saints and martyrs. In Islam, however, the interdiction against religious portraiture was complete and as a result Islamic art contains an important non-figurative element. It is an art of abstract geometric patterns, calligraphy, stylised animal and plant forms, concerned with colour and contrast and the overall effect of patterns and motifs repeated a hundredfold. And the materials and mediums used reflect these preoccupations – painted ceramic tiles and pottery, inlaid metalwork, carpets and manuscript paintings. Islamic architecture, with its brilliantly coloured tile-work and fantastically complex detail, has a unique radiance and an other-worldliness which not even the great Christian monuments of the Middle Ages could surpass.

The Early Dynasties and the Seljuks

Islamic history is best viewed in terms of the various dynasties which held power successively in Arabia and the different parts of the Muslim empire, each contributing their portion to the rich cultural mixture which is revealed in Islamic art. After the death of Mohammed, the Umayyads, of the Prophet's tribe of Kuraish, emerged as the first Islamic

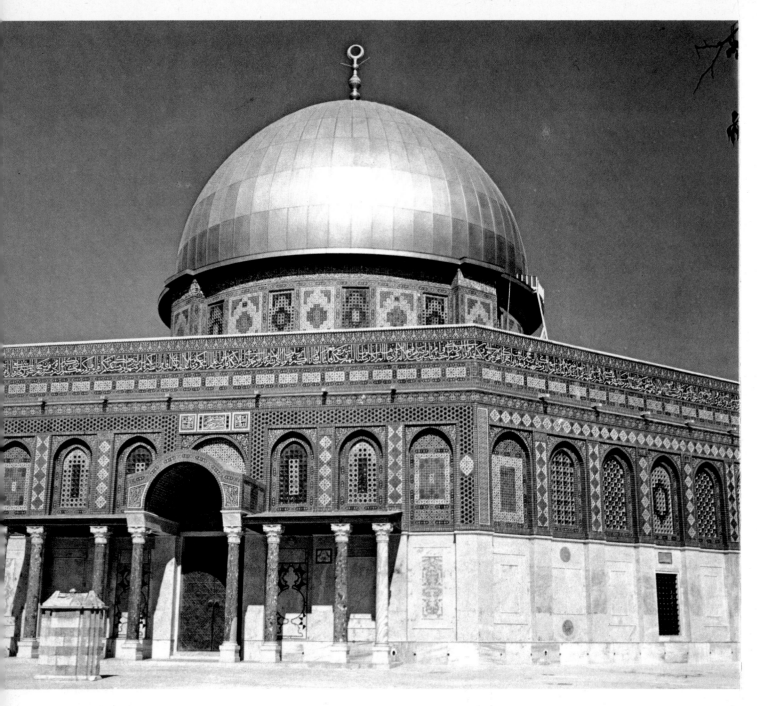

The Dome of the Rock,
Jerusalem. Built by Abd
al-Malik in 691.

opposite
Ceramic vase from
Damascus, Syria. Late
13th century.
Lustre-painted decoration.
h. *c.* 12 in. (30·5 cm.).
Collection of the Marquis
de Ganay, Paris.

dynasty between 661 and 750. The Umayyads established their capital at Damascus, where they came into direct contact with the classical traditions of the area's former rulers. The first monument of Islamic architecture, the Dome of the Rock in Jerusalem, is still rooted in the Roman world. Its form – an octagon with a domed rotunda in the centre – is that of the early Christian sanctuaries, while the Classical pillars of the porch are repeated in the interior. More typically Islamic elements such as the tile facings of the exterior were in fact added at a later date.

Another influence which is visible in the first manifestations of Islamic art is that of the older Asian traditions which also contributed to Hellenistic culture. The earliest Islamic metalwork dates from Umayyad times and combines a variety of

traditions. The incised decoration and the relief work on the handle echo the art of the Sassanian empire in Persia (211–651 AD), while the cockerel which forms the spout is in the style of late Hellenistic animal sculpture which was found throughout the Middle East.

The replacement of the Umayyad dynasty by the Abbasids and the creation of a new Islamic capital – Baghdad – marked a shift of the centre of Islamic culture towards the east and the beginning of a divergence between its eastern and western sectors. Nothing of Abbasid Baghdad now remains, but its marvels are legendary. The Abbasids were great builders and they excelled in the arts of decorative plasterwork and lustre-painted pottery. Removed from the centres of late Classical art, Islamic art increasingly

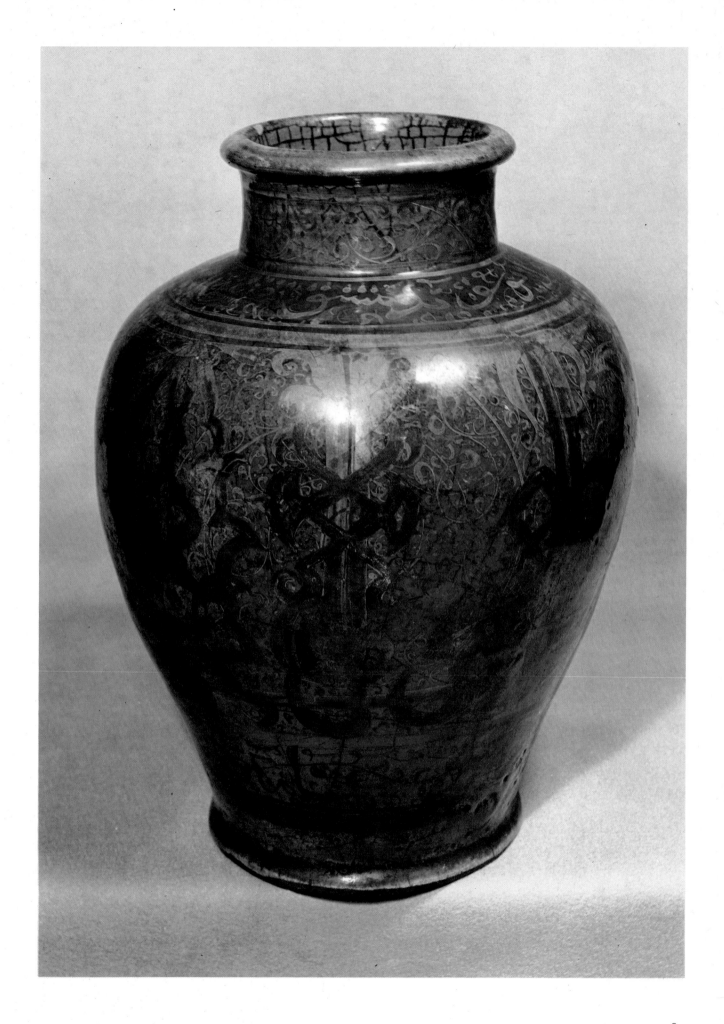

Patterned Buyid silk.
Persia. 10th century.
Museum of Art, Cleveland,
Ohio. h. 19½ in. (49·5
cm.). w. 18⅝ in. (47·4
cm.).

Mihrab from the
Mausoleum of Sayyidah
Rukhaiyah. 1154–1160.
Wood. h. 82¾ × 43¾ in.
(210 × 111 cm.).
Museum of Islamic Art,
Cairo.

reflected the influence of Middle Eastern and eventually Central Asian traditions. Under the Buyid dynasty, who succeeded the Abbasids at Baghdad, the Sassanian tradition predominated, particularly in their precious metal work and sumptuous patterned silks, which combine both 84 calligraphic and stylised representational elements. In typically Islamic fashion, the various elements are reduced to a more or less abstract repetitive pattern.

Simultaneously with the rule of the Buyids in Baghdad, Egypt under the Fatimids – a North African Berber dynasty – became the major cultural centre of western Islam. Fatimid art had two contrasting, almost contradictory modes. On the one hand it produced a multitude of figurative works in mediums as diverse as painting, wood and ivory carving, glass and textiles, and on the other hand it developed a style of abstract ornamentation which was to become one of the fundamental forms of Islamic art. The rock crystal ewer made 85 for the Fatimid Caliph Al-Azis Billah, belongs to the former category and is a masterpiece of its kind. The Mihrabs from the Mausoleum of Sayyiddah Rukhaiyah shows one of the first examples of the Islamic infinite pattern, in which different linear patterns are superimposed on one another to create interlinked geometric forms. While abstract in themselves, these stars, polygons and triangles combine in a surging, scintillating movement which on a superficial level recalls the illusionistic effects of 'op art' and on a deeper one seems to suggest the complex interrelations and pulsating life forms of nature itself. The effect is to be seen to admirable effect in the decoration of the Karatay Madrasah. 89

In the middle of the 11th century, the Seljuk Turks, one of a group of Turkish peoples who had migrated into Iran, wrested the central power from the Buyids. From now on the Turkish peoples were to represent an important influence in the development of eastern Islamic culture. The Seljuks were great builders, and their mosques attained a monumental scale, but most notably it was in Seljuk Iran that pottery became a major Islamic art form. A wave of creative experimentation with different glazes, different shapes and styles, produced a wealth of ceramic ware on which the decoration ranged from painted figurative designs to moulded relief patterns. The figurative style can be seen in those Iranian ceramic bowls, in which both the richness of the translucent blue glaze over the black painted design and the skill with which the figures of sphinx or harpy are fitted into the shape of the bowl make them masterpieces of the potter's art.

The Seljuks conquered Anatolia towards the end of the 11th century, but Seljuk culture in Anatolia did not reach its peak

Rock crystal ewer from
Cairo, Egypt. 10th century.
Inscribed with the name of
the Fatimid Caliph Al-Azis
Billah (975–996). h. $7\frac{1}{16}$
in. (18 cm.). Tesoro di S.
Marco, Venice.

وبرُوزد زمانه که أندز حانه ازبعد سه دَور بِدید آید و بحه ازسِبید بخیرد و زردخورد وطعمه اوباشد

أندر صورت سیمرغ

سیمرغ اندزدار محیط باشد اندزجزیزهَا بندکی خط استوا و مردم بدان جای نشسند و هوای خوش دارد

The Phoenix. Painting from *Manafi al-Hayawan (The Usefulness of Animals)* by Abu Sa'id Ubaud Allah ibn Bakhtishu. Maragha, Iran. Between 1294 and 1299. 13½ × 9¾ in. (33·5 × 24·5 cm.). Pierpont Morgan Library, New York.

opposite
Isfandiyar Slaying Arjasp in the Brazen Palace. Painting from a copy of Firdusi's *Shah-nameh,* made for Baysunghur Mirza in Herat, AH 830 (1430 AD). Page size 15 × 10¼ in. (38 × 26 cm.). Gulestan Palace Library, Teheran.

The Congregational
Mosque in Aleppo, Syria.
12th–13th centuries. The
minaret dates from 1090.

until the 13th century, when the Mongols were already flooding into the Islamic world from the East. The Seljuks filled their capital at Konya with lavishly conceived palaces and mosques in which glazed brick and faience decoration were used on a monumental scale, inspiring Islamic architecture for centuries to come. The dome of the Karatay Madrasah or theological school in Konya is decorated with a 'sunburst' design in glazed ceramic, which is a sophisticated example of the infinite pattern mentioned earlier. Close inspection reveals a series of semi-circular and asymmetric internal rhythms of astounding complexity.

Woodcarving was another major art form in Seljuk Anatolia, and the illustration of 89 the carved lectern shows a combination of calligraphy with arabesques of naturalistic plant forms. The latter are a characteristic motif of Islamic decoration, probably derived from the vine-leaf scrolls and other naturalistic patterns of late Classical art.

Egypt – the Ayyubids and Mamluks

The breakdown of centralised Seljuk rule in Iran in the mid-12th century led to increasing independence in the western parts of the Islamic empire. Both Egypt and Syria came under the rule of the Ayyubid dynasty, whose founder was Salah al-din Ayyub (Saladin) (1138–1193). The Ayyubid period saw a great flowering of architecture, of which the Congregational 88 Mosque in Aleppo is a fine example. Conforming to the traditional plan of the Islamic mosque, it was begun during the Seljuk period, and the tall stone minaret dates from that time. With its strong cubic outlines and fine marble pavements in the central court it shows a new simplicity both in form and decoration.

The Ayyubids were succeeded in Egypt by the Mamluks, who inherited the

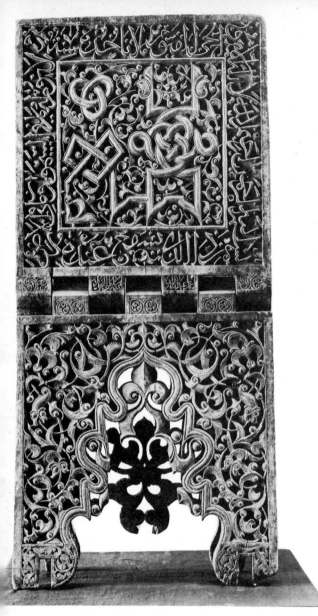

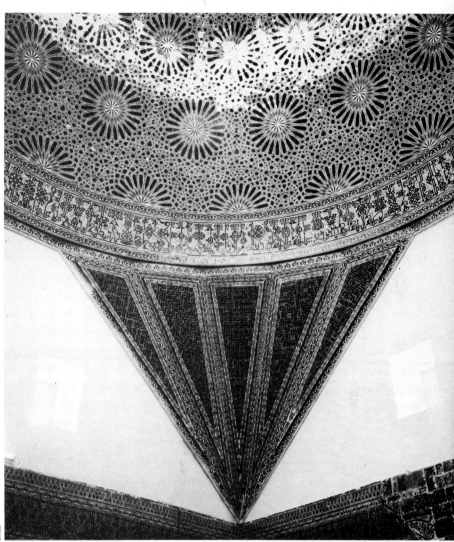

Carved wooden lectern (*rahle*) from Turkey. 13th century. Signed by Abd al-Wahid ibn Sulayman. w. 19¾ in. (50 cm.). h. 45½ in. (115·5 cm.). Staatliche Museen, Berlin.

above right
Interior of the dome of the Madrasah of Celaleddin Karatay, Konya, Turkey. 1251.

Seljuk and Ayyubid traditions and combined them with North African elements. The architecture of the time was generally monumental in scale, with great simplicity of form, following the trend shown in the Mosque at Aleppo. The decorative arts, by contrast, showed a great richness which is best revealed in their treatment of the technique of inlaid metalwork which they inherited from the Ayyubids. The *kursi*, or cupboard for a Koran, with its silver inlays and its perforated arabesques, combined with calligraphy demonstrates the mastery which Egyptian artists had achieved in this technique in the 14th century.

The Eastern Invaders – Chingiz Khan and Tamerlane

The invasion of the eastern part of the Muslim world by the Mongols under Chingiz Khan in the early 13th century gave Islam its first taste of Far Eastern culture. The Mongols built monumentally, largely in the Seljuk tradition, at their successive capitals of Tabriz and Sultaniya. Their brilliant use of plasterwork decoration also followed the established motifs, though these were employed with an unprecedented richness and skill. It was in the field of painting, however, that the Mongols made their most decisive impact on Islamic culture. The brilliant phoenix from a Mongol manuscript from Maragha, Iran clearly shows a Far Eastern derivation. Both the subject matter, the serpentine forms of the bird's plumage and the stylised representation of plants, flowers, water, etc., are largely inspired by Chinese painting. The Mongols also excelled in representative painting of an intense if stylised realism.

The Mongol period came to an end with another invasion from the East, by Timur or Tamerlane, from Kesh, to the south of Samarkand. Timur invaded Iran and Iraq in the late 14th century, and under his rule and that of his successors, the centres of Islamic culture were Herat, Shiraz and Timur's own capital of Samarkand. In

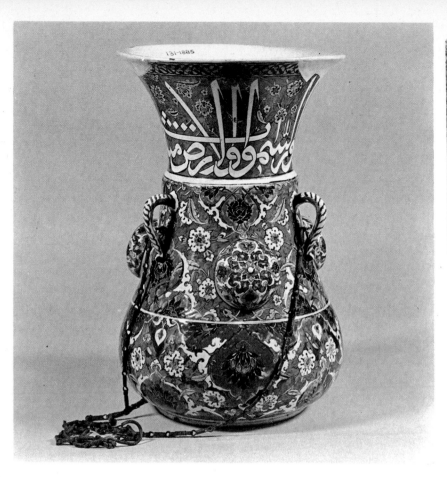

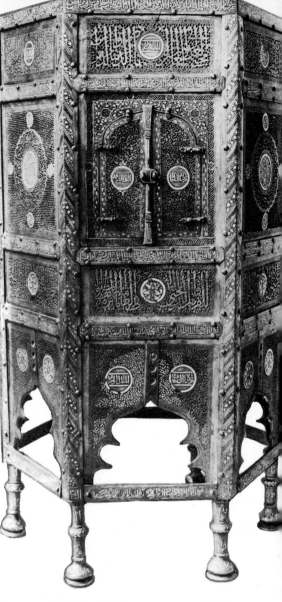

Ceramic mosque lamp
from Istanbul. Isnik,
Turkey. c. 1557. h. 19 in.
(48·2 cm.). Victoria and
Albert Museum, London.

above right
Kursi (cupboard for a
Koran) from Cairo. Made
for Sultan Kalaun in AH
728 (1327–1328 AD).
diam. $15\frac{3}{8}$ in. (39 cm.). h.
$27\frac{1}{2}$ in. (70 cm.). Museum
of Islamic Art, Cairo.

opposite
*Majnun before Layla's
Tent.* Painting from a copy
of Jami's *Haft Aurang
(Seven Thrones),* copied
from the library of Abu'l
Fath Sultan Ibrahim Mirza,
cousin of Shah Ismail II,
between 1556 and 1565
in Meshhed. Page size
$13\frac{1}{2} \times 9\frac{1}{4}$ in. (34·2 × 23·2
cm.). Freer Gallery of Art,
Washington.

architecture and painting in particular, the
Timurid period represents the finest
expression of the traditions and styles of
92 eastern Islamic art. Timur's tomb at
Samarkand, the Gur-i Amir, shows the
traditional forms of Islamic architecture,
with its large bulbous dome set over a
square chamber. The exterior, including
the dome, is covered with a lavish decora-
tive scheme of glazed brick and tilework.
The major centre of painting in the
Timurid period was Herat, where the styles
created by Mongol artists were elaborated
and developed. The 'classical' Herat style
of the 14th-15th centuries combined a new
concept of space, whereby the different
levels of perspective were arranged above
one another on the page, with an almost
abstract use of patterned decorative ele-
ments and a stylised realism in figurative
work. The illustrations from the copy of
87 Firdusi's *Shah-nameh* made for the biblio-
phile Prince Baysunghur represent the
most brilliant expression of this style. The
example shown is distinguished by its
subtle use of colour, the bold arrangement
of the different perspective planes and an
almost brocade-like rendering of the typi-
cally Islamic calligraphic and leaf-scroll
decoration.

The Ottoman Turks

Concurrently with the invasions in the
East, a new force was emerging in the west-
ern part of the Islamic empire – the

Ottoman Turks. Their conquest of Con-
stantinople in the mid-15th century gave
western Islam a new capital in what had
once been the centre of the Byzantine
world. One of the most notable achieve-
ments of the Ottomans was their creation
of the domed mosque, in which the prayer
hall was enlarged into a great vaulted
chamber very much in the manner of the
Byzantine churches such as the Hagia
Sophia – which the Ottomans did in fact
use as a mosque. The Selimiyeh Cami mos- 93
que at Edirne in Turkey is the most perfect
example of this kind of building. The suc-
cession of half-domes leading up to the
main dome produces a vast, vaulted inter-
ior, while the upward thrust of the building
as seen from the exterior is emphasised by
the four great minarets. The Ottoman mos-
ques are also notable for their interior
decoration. Vast areas of polychrome
glazed tiles with floral or semi-abstract
designs serve to dissolve away the solid
mass of walls and columns so that the whole
building seems to float in a dazzling, ether-
eal light. The magnificence of Ottoman tile
decoration can be appreciated from the

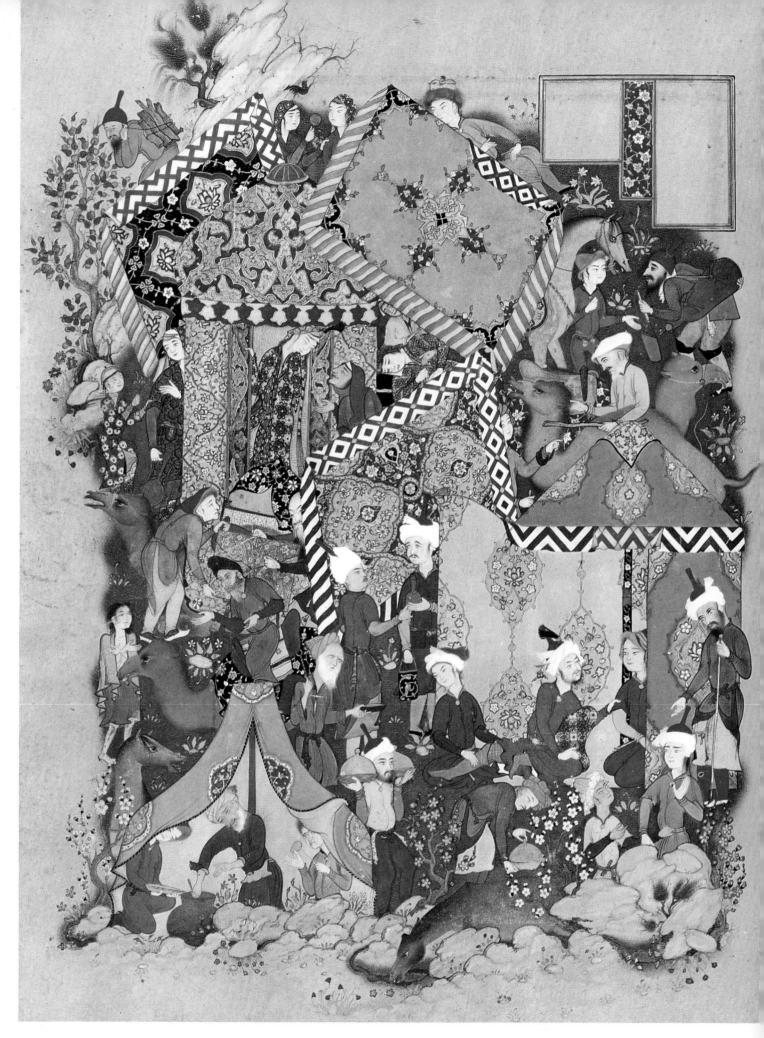

Gur-i Amir, Timur's
Mausoleum, Samarkand.
1405.

abstract and floral designs, forming an infinitely repeating pattern contained within a border.

The Persian Element–
Safavid Iran

While the Arabic element in Islamic art is clearly recognisable as being centred on a concept of linear abstraction which derived from the Arabs' interest in mathematics and astronomy, the Persian element is in a sense the opposite. Its main characteristic is a poetical lyricism which finds its most sublime expression in the work of the Persian mystical poets and comes through in the graphic arts as an unprecedented richness of colour and style. In the 16th and 17th centuries, the Persian element predominated in eastern Muslim culture with the rule of the Safavid dynasty in Iran.

Persian painting at this time continued 91 in the traditions of the Timurid period, but its vivid colouring and exquisite detail give it an entirely different, almost Oriental atmosphere, inviting comparison with the work of Baysunghur's workshop in Teheran. It has many of the features of the Timurid painting – the arrangement of the different planes of perspective, their division by bands of ornament which in the earlier example were the battlements of a castle and here form the fringes of the baldachins. But the later picture breathes a sheer delight in decorative patterns for their own sake, and there is a thoroughly modern feeling in the abstract arrangement of the different planes, with the painter entirely abandoning the formal constraint of the rectangular page.

The Persian taste for rich colours and the use of naturalistic forms in abstract patterns is best revealed in 16th and 17th-century Persian carpets – the supreme expression of a tradition which began with the simple knotted rugs of the Turkish nomads many centuries earlier. The original semi-abstract repeat patterns have been largely replaced by elaborate, richly coloured floral designs, often arranged around a central medallion. Designs give 94 the impression of a veritable garden full of exotic blooms, and indeed some of the most accomplished Iranian carpets of the Safavid period actually reproduce the layout of a formal Persian garden, complete with water-courses, flowers and trees.

Islamic Spain

The Iberian Peninsula, the most remote and westerly point of the Islamic empire, enjoyed from an early stage an indepen-

90 illustration of a ceramic mosque lamp. The combination of calligraphy and floral designs is found here as in certain Seljuk works.

If one were to single out a uniquely Turkish contribution to Islamic art forms, it would undoubtedly be that of the knotted rug. Brought by nomadic Turkish tribes into Anatolia from Central Asia, knotted rugs were originally an attempt to reproduce animal fur by adding long woollen threads to a flat woven fabric. Developed by the Seljuk Turks in Anatolia, the rug as a decorative art form was perfected by the Ottomans and later by the Persians of
96 the 16th century. The example illustrated contains a characteristic mixture of semi-

Selimiyeh Cami Mosque, Edirne, Turkey. Built by Sinan between 1567 and 1574.

dence and relative isolation from the comings and goings of western Asia which enabled it to develop the major themes of Islamic art to an unparalleled degree of sophistication. Two great monuments epitomise the achievements of the two main periods of Spanish Islam, the first created under the Spanish Umayyad dynasty (mid-18th century to early 11th century), and the second under the Nasrids (mid-13th to late 15th century), whose expulsion by Ferdinand and Isabella of Castile marked the end of Muslim rule.

In the Umayyad period, Cordoba was a major centre of Islamic culture, matched only by Baghdad, and its Great Mosque, begun by the first Spanish Umayyad prince

Abd al-Rahman I (756–788), is one of the most remarkable monuments of Islamic architecture. Originally built on the traditional open court plan of the Arab mosque, it shows the Islamic adaptation of late Classical styles which we have already seen in the Umayyad architecture of western Asia. It was enlarged considerably by the later Spanish Umayyads, notably al-Hakam II, who in the 10th century extended the prayer hall to include the magnificent Chapel of the Mihrab. The capitals of the double-story colonnades and the naturalistic motifs of the carved plasterwork decoration are clearly Classical in derivation, combining with marble and mosaic to create an effect of richness and tranquility

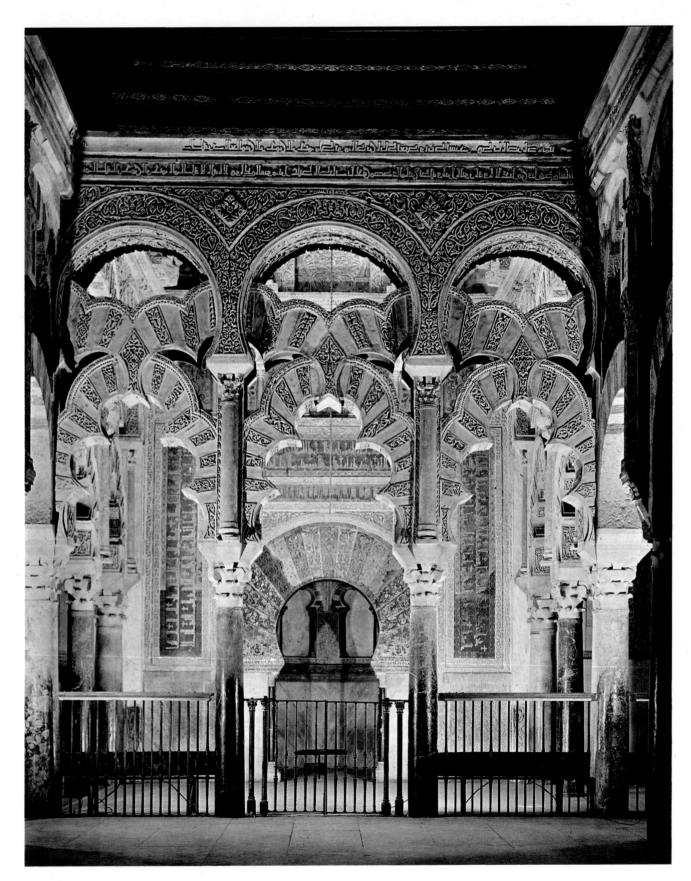

opposite
Rose ground vase carpet
(detail). Persian. Late 16th
or early 17th century.
Victoria and Albert
Museum, London.

Chapel of the Mihrab,
Umayyad Mosque,
Cordoba. Completed 965.

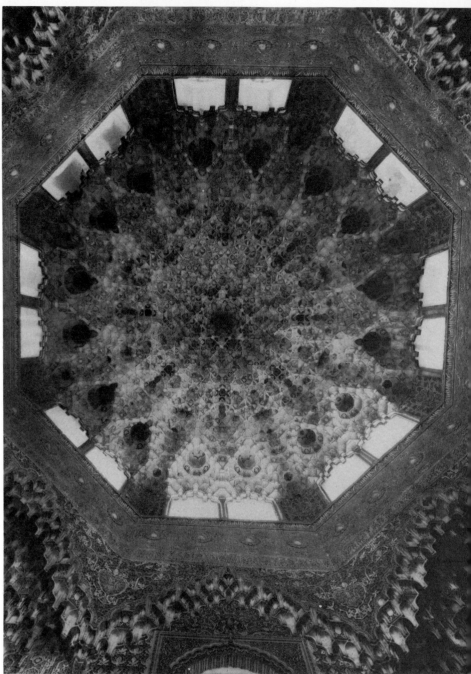

'Bird' Carpet from Turkey.
c. 1600. 14 ft. 7 in × 7
ft. 7 in. (4·27 × 2·14 m.).
Metropolitan Museum of
Art, New York (Ex
Collection of Joseph V.
McMullan).

above right
Stalactite cupola in the
Chamber of the Two
Sisters, Alhambra Palace.
14th century. Granada,
Spain.

which is unique in Islamic architecture.

While the Great Mosque of Cordoba clearly shows the Classical roots of western Islamic art, the famous palace of the Alhambra in Granada, built by the Nasrids in the 14th century, is a supreme distillation of the basic ideas and decorative motifs of Islamic architecture developed over several centuries. Its walls and ceilings are covered with a plasterwork coating which is carved in an incredibly intricate series of naturalistic and abstract designs. The treatment of the domed ceilings in particular shows the ultimate refinement of the Islamic technique of dematerialising solid masses through the hundredfold repetition of decorative motifs. In the cupola of the Chamber of the Two Sisters a complex use of *mukkarnas* or stalactites gives the effect of a fantastic honeycomb hanging in space,

and is also the most sophisticated application ever of the Arabic system of superimposed, infinitely repeating patterns.

The sumptuousness of the interior decoration of the Alhambra is matched by the painted ceramic ware which reached a new height of development in Granada at the same period, such as the so-called 'Alhambra vases' which represent the most ambitious works ever undertaken by Islamic potters. The form is unique, with its curious wing-shaped handles on the shoulders of the body, one of which has been broken off in this example. The scrollwork and animal motifs are painted in gold lustre heightened with cobalt blue, producing a surface sheen which once again serves to dematerialise the body of the vase.

In the art of Islam, man's passion for decoration is developed to a level of sophis-

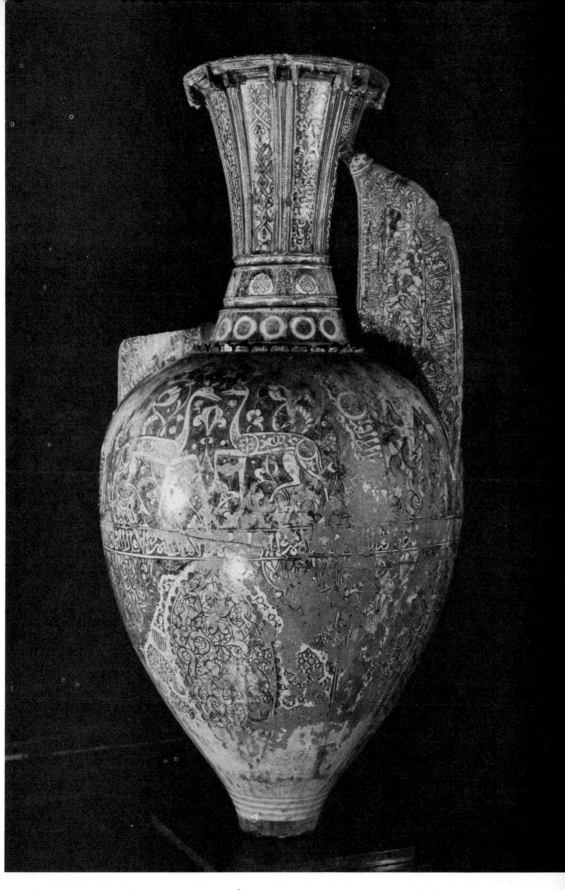

Ceramic vase with
lustre-painted decoration
from Malaga (?), Spain. h.
47¼ in. (120 cm.).
Alhambra, Granada.

tication unseen before or since. The
commemorative, human-representational
element is played down and portraiture is
largely absent, except in Islamic-Indian art
which will be discussed in the following
chapter. Islamic architecture and decora-
tive ornament in particular combine a bril-
liance of conception and execution which
are surely the supreme expression of man's
versatility and creative genius. For not only

does Islamic ornament have a decorative
function, it is also symbolic and interpreta-
tive. The Islamic technique of 'dematerial-
isation' is a graphic representation of the
interpenetration of different phenomena
which finds an echo both in the religious
belief that god is present in every facet
of existence and the picture of atomic
particles and interacting forces drawn by
modern science.

97

The Worlds of the Orient

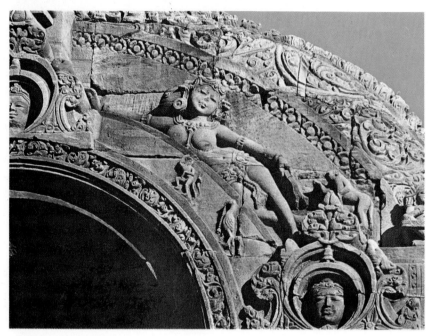

Torana of the Muktesvara temple, Bhuvanesvar (detail). 9th–10th centuries.

opposite
Head of Buddha. Amarāvatī school. *c.* 2nd century. Marble. h. 8¼ in. (21 cm.). Musée Guimet, Paris.

In many parts of the Orient, man's primitive roots have remained nearer the surface than in the over-sophisticated world of the industrialised West. But in India in particular they survived within a culture which itself reached a high level of sophistication. From its neolithic beginnings through to its absorption of Islamic influences in the Mughal art of the 16th and 17th centuries, Indian art has a unique record of uninterrupted development.

This is not to say that Indian art grew in isolation. Indeed the vast Indo-Ganges plain was a regular parade ground for invading armies – the Aryans, the Achaemenians, the Greeks under Alexander, the Sassanians and of course the Muslims all left their mark. Trade by both land and sea also brought inter-cultural contacts. But Indian art nevertheless has a consistency which may be ascribed to the overriding importance of religion in Indian life. The Indian religions of Vedism, Brahmanism and Buddhism embraced a whole gamut of religious attitudes, from polytheism to mystical pantheism. Both the temple and the human body were seen as microcosms of a greater whole, and the Indian artists' wholehearted celebration of the human form gives Indian religious art, and particularly sculpture, a uniquely sensual flavour.

While sharing its basically Oriental character, and its Buddhist religion, Chinese culture is in many ways the antithesis of Indian. Where Indian culture absorbed a variety of influences, Chinese civilisation, ever since its first flowering in the second and first millennia BC, was characterised by an isolationism which at first owed much to geographical remoteness but subsequently derived from the Chinese people's innate belief in their own cultural superiority. Where Indian culture was religious, anti-rational, devoid of a linear time-sense to an extent which renders the historian's task unusually difficult, Chinese culture tended to be secular, emphasising social obedience rather than submission to universal laws, and possessed of a strong sense of linear time and history. As we shall see, these differences are well illustrated by the art of India and China, and of the two other main centres of Far Eastern culture – Korea and Japan – both of which absorbed the examples and traditions of Chinese culture, adapting them to meet their own requirements and circumstances.

The Origins of Indian Art

The earliest manifestations of Indian civilisation show every resemblance to their counterparts in Western Asia and Europe. The Indus valley culture of the third and second millennia BC is comparable to the early mature cultures of the ancient Middle East. Archaeological sites reveal the existence of towns equipped with public buildings, baths, granaries and residential quarters. Sculptured figures such as the bust of a bearded man recall the art of 100 Mesopotamia – the features are Semitic and the hieratic pose is directly comparable with those of the early Sumerian temple figures.

During the second and first millennia BC, the Aryans laid the foundations of Hindu culture on the Indo-Ganges plain, developing the religions which were to become the prime source of inspiration for all Indian art. After the rise of the Maurya dynasty in the 4th century BC, its most famous ruler, the Emperor Asoka (c. 264–227 BC) established Buddhism throughout India and instituted a programme of civilisation and social reform. Great stone columns inscribed with moral codes were erected throughout his territory. Sometimes as much as 42 feet high, these columns were crowned with bell-shaped capitals surmounted by animal 101 forms – a motif directly adopted from the Achaemenians of Iran, who had conquered north-western India in the 6th–5th centuries BC.

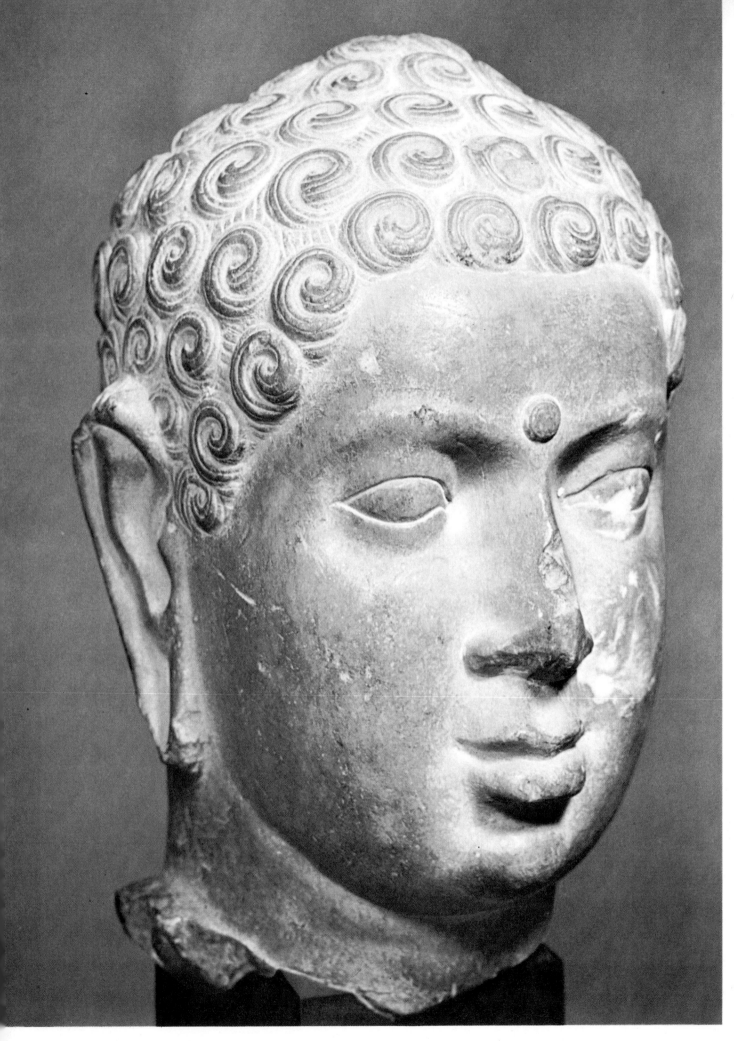

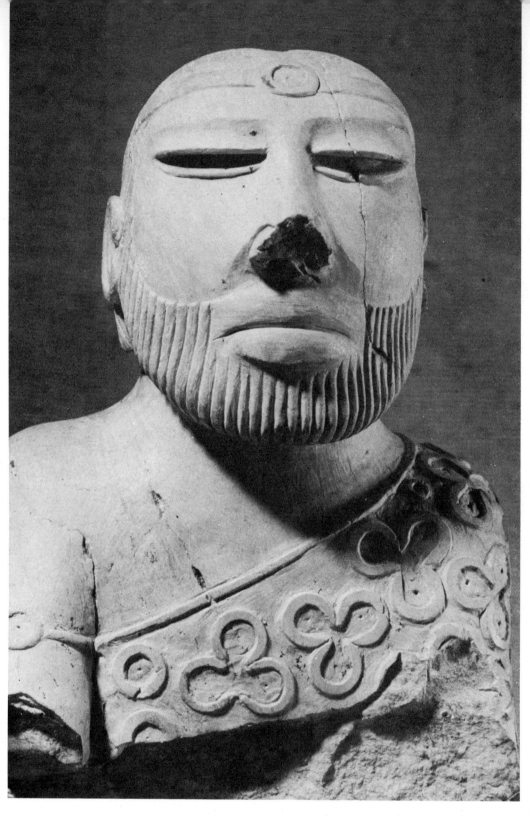

Bust of a man from
Mohenjo-daro. 3rd
millennium BC. Steatite. h.
6¾ in. (17 cm.). Museum
of Central Asiatic
Antiquities, New Delhi.

Whether in the rich pantheon of Vedic
gods and demi-gods or the Buddhist con-
cept of absorption into Nirvana, the Indian
religions show a firm belief in the inter-
penetration of human and divine phenom-
ena. Not for them the earnest Christian
interdictions against graven images – the
human form is to be depicted with a rich
sensuality which stands as a microcosmic
symbol of unearthly delights. The figure
of Buddha himself is used as a cult object,
portrayed according to a long-established
iconographic tradition which was being
formed in the centuries immediately before
and after the birth of Christ, when north-

western India was under Greek domin-
ation. The head of Buddha preaching, from
Lorujan Tanzai, belongs to the so-called
Greco-Buddhist school of Gandhāra and
clearly shows a mingling of Indian and
Hellenistic styles; the features are reminis-
cent of Greek images of Apollo, but the
face has an air of gentleness and detach-
ment which clearly derive from the Budd-
hist ethic. Another Buddha, of the Amarā-
vati school, has distinctly Dravidian
features, with a boyish, slightly doll-like
expression. The top-knot of the Gandhāra
Buddha is here stylised into a cranial protu-
berance – a misinterpretation which passed

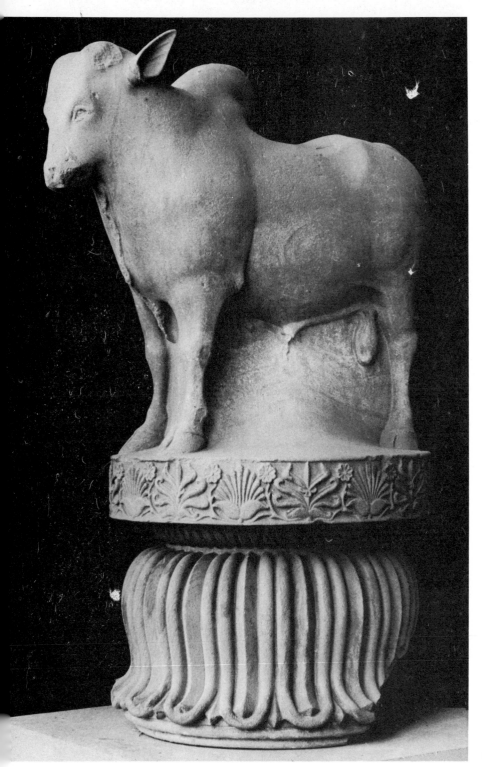

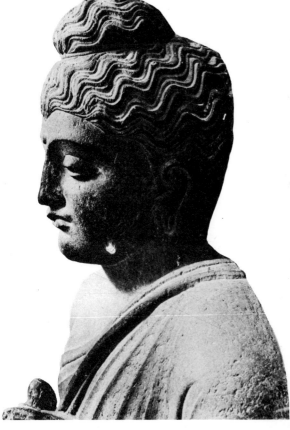

Capital from Rāmpurva. Maurya period. Polished sandstone. h. 6 ft. 6 in. (2 m.). Indian Museum, Calcutta.

above right
Buddha preaching. From Loriyan Tangai. Gandhāra school, *c.* 2nd century. Schist. h. 2 ft. 9½ in. (85 cm.). Indian Museum, Calcutta.

into Buddhist iconography – while in the centre of his forehead is the *ūrna* or coil of hair which is one of the signs of his sacred nature.

The Classical and Medieval Periods

Between the 4th and 8th centuries AD, Indian art and culture flowered under the Gupta dynasty, reaching unprecedented heights in every field from architecture to philosophy. Sculpture of the human figure

achieved a Classical serenity, and wall-paintings such as the famous frescoes at Ajantā were remarkable for their brilliant use of colour and their beauty of composition and form. Architecture took a major step forward with the appearance of the first free-standing structures built from durable materials.

The Temple of Lakshmana at Sīrpūr is 102 one of the earliest examples of the free-standing Hindu sanctuary, the most characteristic form of Indian architecture. Unlike the Buddhist *chaitya*, which provided a spacious, airy interior for communal worship, the Hindu sanctuary aimed

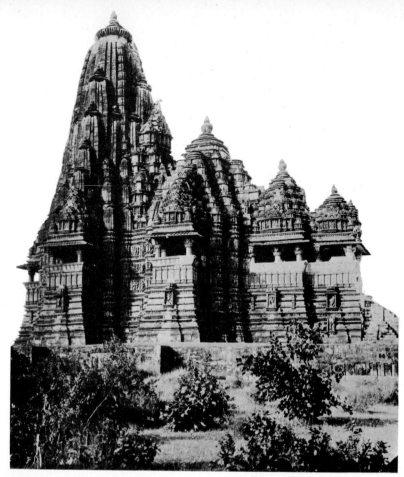

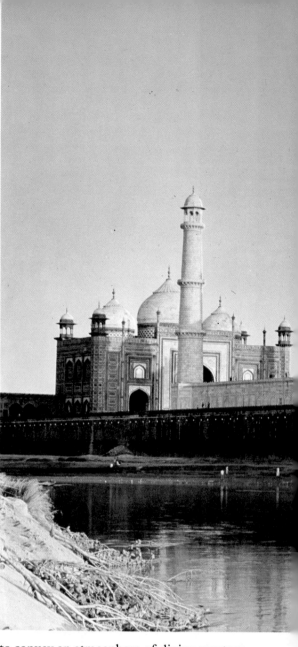

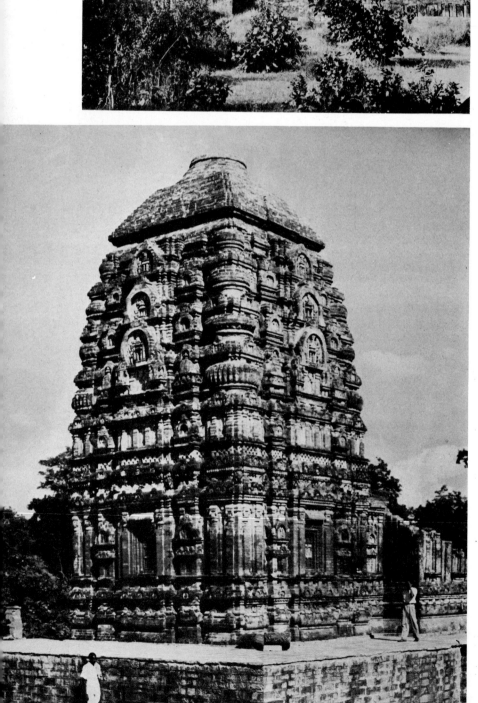

to convey an atmosphere of divine mystery. The temple as a whole was conceived as a microcosm, symbolising the Hindu concept of the universe. The *stūpa* or reliquary itself was the seat of the deity, the sacred mountain and pivot of the world; the wall around the sanctuary represented the mountain ranges bordering the earthly world; and the gates at the four cardinal points were as openings in the vault of heaven, through which contact between man and god was established.

During the medieval period, which stretches roughly from the 9th to the 16th century, Indian art enjoyed unprecedented patronage as a result of the competition between local centres of power. Hindu temples became increasingly complex, the main sanctuary sometimes sprouting subsidiary chapels and the whole building becoming 102 covered in a seemingly organic profusion of sculptural detail in which the human form plays an essential part. Originally no more than a simple columned portico, the *mandapa*, in the example illustrated, has 105 become a building in its own right; and the solid mass of the stonework has been

The Tāj Mahal at Agra,
India. *c.* 1635. Mausoleum
of Mumtaz Mahal, Shāh
Jahān's wife.

opposite top
Kandāriya Mahādeo,
Khajurāho. Beginning of
the 11th century.

opposite bottom
Temple of Lakshmana,
Sīrpūr. 6th–7th centuries.

dissolved away into a complex arrangement
of architectural and organic forms. These
98 temple carvings gave the Indian artists
ample scope to indulge their delight in the
human form, portraying it with a lack of
prudishness which comes from their accep-
tance of humanity in all its facets as an
organic part of a universal whole. The re-
clining female figure following the graceful
curve of the doorway in the detail of the
Muktesvara temple illustrated exudes an air
of languorous sensuality which is set off
by the crispness of the carved rosettes
above.

Mughal Art

In the 16th century, India came under the
sway of Muslim rulers, and the spark
seemed to go out of its indigenous art
forms. The Mughals brought with them
the artistic traditions of Islam, and these
combined with local styles to produce an
art of great richness and variety. Mosques,
tombs, citadels and palaces were built, all
with an elegance and simplicity which

differed from the native Indian style. In-
deed, one of the most famous monuments
of Islamic architecture is the Tāj Mahāl 102
at Agra, in northern India, built by the
Mughal ruler Shāh Jahān (1627–58) as a
mausoleum for his wife. The building is
designed in the purest Islamic tradition,
its most remarkable feature being the bril-
liant white exterior decorated with floral
relief patterns and polychrome *pietra dura*
inlay.

The Mughals brought new life to Indian
crafts such as wood and metalwork, and
introduced new techniques for the produc-
tion of jewellery and glassware. Metalwork
in particular flourished in the 16th and 17th
centuries, the elephant hook illustrated 104
being a particularly fine example with its
elaborate sculpted decoration and inlaid
shaft. But it was in the field of book and
manuscript illustration that the Mughals
made the greatest contribution to Indian
art. They brought Persian painters to their
courts to produce works celebrating their
wealth and influence, and the achievements
of the Persian schools were enriched by
a new interest in landscape and portraiture.

The Mandapa at
Srírangám. 15th–16th
centuries.

opposite
Ankusha, or elephant
hook. 17th century. Gilt
bronze with enamel inlay.
h. 26¾ in. (68 cm.).
Musée Guimet, Paris.

108 The painting illustrated here is a fine example of Mughal portraiture in the semi-official style reserved for minor nobles or local rulers. The sensitive rendering of the features gives a vivid impression of the subject's personality, despite the characteristic formality of the pose.

South-east Asia – the Khmers

From about the 1st century AD onwards Indian cultural influence spread throughout south-east Asia, resulting in the widespread adoption of the Sanskrit language and the religions of Buddhism and Brahmanism. Indigenous cultures developed the themes and styles of Indian art in their own manner, producing works which were by no means devoid of originality. The most striking transmutation of Indian traditions appears in the art of the Khmer empire, which lasted from the 6th to the 13th centuries.

The famous Khmer temple of Angkor 109 Wat is one of the most striking interpretations ever of the Hindu concept of the microcosmic temple mountain. The harmonious balance of the different parts emphasises the relationship between god and man, between the celestial and terrestrial planes. With its superb sculptured

Lacquer throne. Ch'ing dynasty, Ch'ien-lung period. 1736–1796. Wood core with carved red lacquer decoration. h. 4 ft. (122 cm.). Victoria and Albert Museum, London.

opposite
Seated court lady holding a mirror. T'ang period. 618 906 AD. Fired terracotta with coloured glazes. h. 12½ in. (31·8 cm.). Victoria and Albert Museum, London.

decoration and skilfully conceived internal rhythms, it is one of the masterpieces of world architecture.

The figure of Prajñāpāramitā represents the Buddhist element in Khmer art, dating from the time of the Buddhist king Jayavarman VII (1181–1219). The calm pose and reflective, gently smiling expression epitomize the spirituality of Buddhism, while the face, which is that of Jayavarman's wife, Jayarājadevī, shows the artist's gift for sensitive portraiture.

China – the Early Period and the T'ang Dynasty

The role of the nomadic Mongols in spreading the motifs of primitive art across Asia has already been mentioned, and many

of them are found in the art of the Shang period (c. 1500–1000 BC), which saw the creation of the first organised Chinese state. Ritual vessels of the Shang period in cast bronze combine a remarkably advanced technique with primitive ornamental motifs. The small figure of a man clings to an ancestor spirit in the form of a tiger for protection, and the whole surface of the vessel is covered with the decorative motifs of ancestor worship and Shamanism – stylised dragons, snakes, and the ubiquitous spiral.

Originally linked to the primitive world's preoccupations with fertility and the transmission of spiritual power through ancestral images, in Chinese culture ancestor worship soon lost its magical associations, becoming the basis for a strictly hierarchical society in which dynastic rule was an important feature. Gradually developing under the twin influences of Confucianism and Buddhism, Chinese culture

Painting by Hashim in an album made for Shāh Jahān. India, c. 1635. 15⅜ × 10¼ in. (38·8 × 25·8 cm.). Portrait of the Mullah Muhammad of Bijapur. Metropolitan Museum of Art, New York.

flowered under the cosmopolitan T'ang dynasty, producing masterpieces in architecture, wall-painting and ceramics, and the ceramic grave images which are the most characteristic products of T'ang art clearly reflect the heritage of early ancestor worship. Figures such as the court lady holding a mirror were buried with the dead as symbolic companions of their after-life. This charming and sophisticated depiction of a T'ang court lady is entirely secular, however, reflecting the demystification of a ritual which had once required human and animal sacrifice. The famous ceramic horses of the T'ang period, which represent a particular type of horse imported into the T'ang empire for polo and equestrian displays, belong to the same category.

106

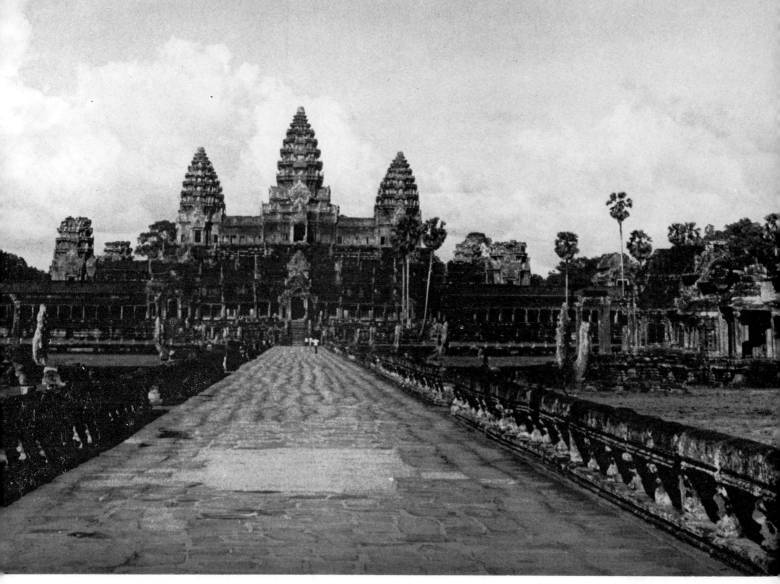

Angkor Wāt. First half of the 12th century.

opposite bottom right Prajñāpāramitā. Bayon style. End of the 12th century. Sandstone. h. 3 ft. 7½ in. (110 cm.). Musée Guimet.

The Sung Period and after

The development of the religious cults of Taoism and Zen Buddhism brought with them a new interest in natural phenomena which was reflected in the art of the Sung period (960–1279). The arts of painting and calligraphy were developed as contemplative rituals and the study of Taoism and landscape painting often went hand in hand. One of the most famous painter-monks was Huang Kung-wang, who used the traditional Sung style as the basis for his own, revolutionary work at a time when China had been incorporated into the Mongol empire. The illustration shows a 112 detail from one of his most famous scrolls, the Fu-ch'un, which clearly shows the contemplative nature of Chinese landscape painting. Drama is absent, and we are faced only with the calm majesty of water and mountains.

After casting out the Mongols from Chinese territory the Ming emperors (1368–1644) sought to restore the previous isolationism of Chinese culture in an atmosphere of imperial splendour to which the numerous artists employed in the imperial workshops made their own decorative contribution. The Sacred Way leading to the tomb of the Ming emperor Yung-Lo at Nan-k'ou is lined with monumental figures of warriors and animals, which amply illustrate the grandiloquent nature of Ming art and culture. The finely detailed elephant illustrated is characteris- 112 tically lying in an attitude of obeisance before some passing dignitary, real or imagined.

The Ch'ing emperors from Manchuria were the last dynasty to rule China, between 1644 and 1912. In their efforts to assimilate, and be assimilated by Chinese culture, the Ch'ing rulers fostered a new opulence in court ceremonial and artistic production, which is exemplified by the imperial lacquer throne. A supreme exam- 107 ple of the Chinese art of lacquer painting, it is decorated with good-luck symbols which are carved into the red surface.

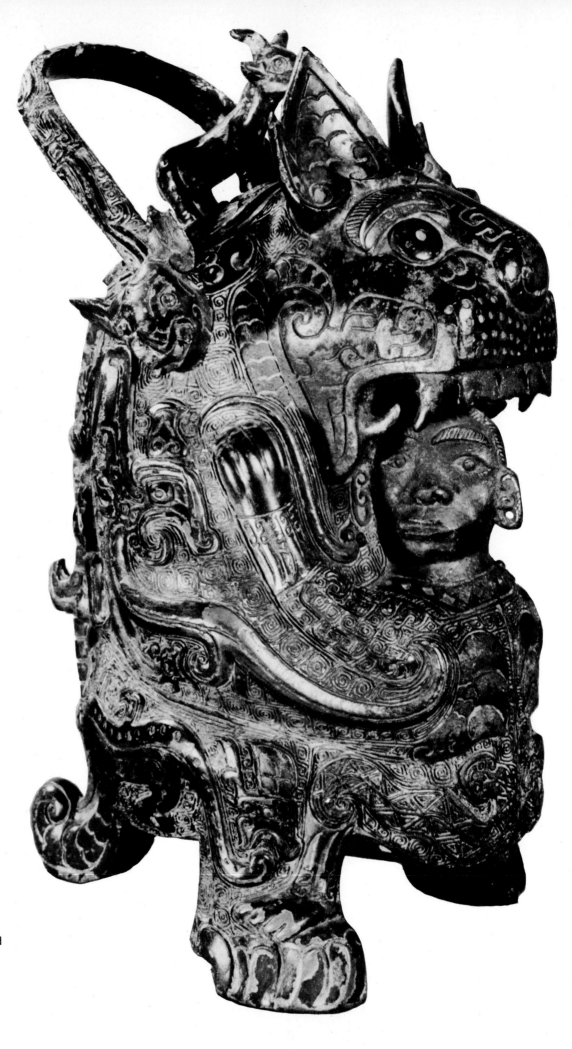

Ritual vessel of the *ho* or
yu type. Shang period.
14th–12th centuries BC.
Bronze with shiny black
patina. h. 13¾ in. (35
cm.). Musée Cernuschi,
Paris.

opposite
Bodhisattva Maitreya. Old
Silla or Paekche period.
Early 7th century. Gilt
bronze. h. 3 ft. 2¾ in. (91
cm.). Duksoo Palace
Museum, Seoul.

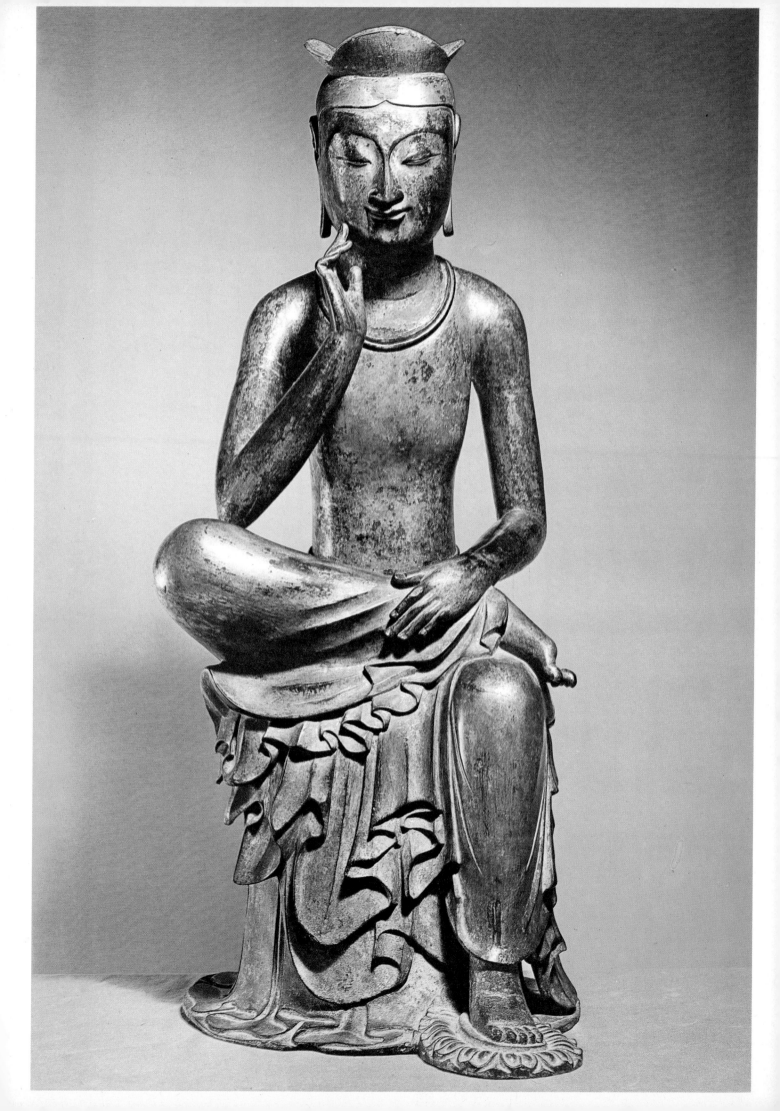

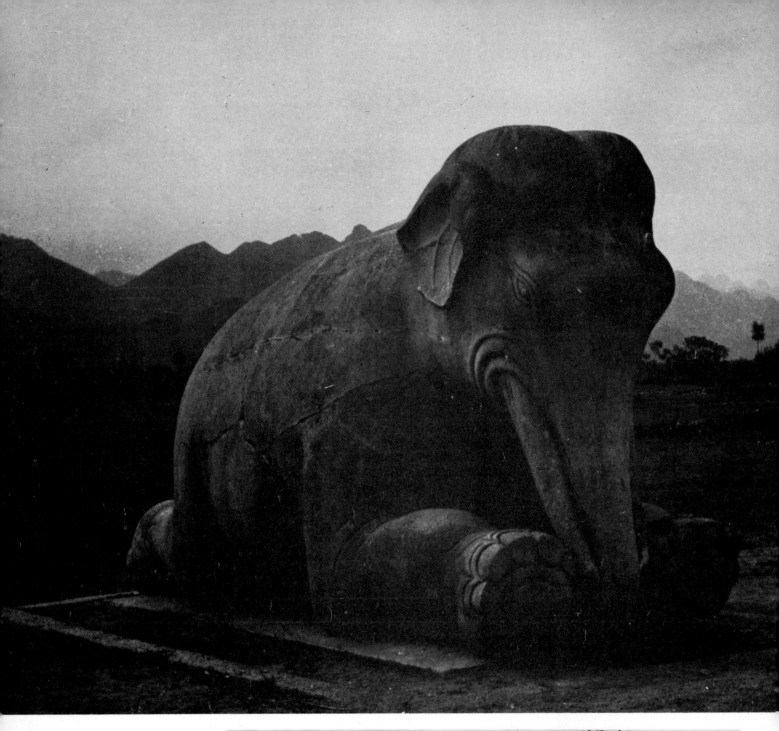

The Sacred Way leading to the tomb of the Emperor Yung-lo, Nan-k'ou. Ming dynasty. *c.* 1403–1424. Limestone figure of an elephant.

opposite bottom
Huang Kung-wang. The Fu–ch'un scroll (detail). Yüan period, dated 1350. Handscroll. Ink on paper. Whole size 13 in. × 20 ft. 10¾ in. (33 × 673 cm.). National Palace Museum, T'apei, Taiwan.

Korea – the Bridge between China and Japan

As the main bridgehead for the transmission of Chinese culture to Japan, Korea inevitably took its cue in artistic terms from China. Korean art shows the same interests, the same use of materials as that of both its neighbours. Ceramics, scroll-painting, the use of wood in architecture are all characteristic forms. Among the finest achievements of Korean art are the bronze Buddhist sculptures of the Paekche kingdom produced in the 4th to 7th centuries. Figures such as the Bodhisattva Maitreya were instrumental in transmitting Buddhism to Japan and had a decisive infl-

uence on Japanese art. The Bodhisattva Maitreya is depicted in a typically contemplative pose, enlivened by a certain native freshness which is particularly evident in the finely drawn face and the exquisite modelling of the drapery.

Japan – Religion and Conservatism

Perhaps even more conservative than that of pre-Communist China, Japanese culture shows a markedly similar pattern of development. The shamanistic and ancestor-worshipping cults of prehistory fused into the organised religion of Shintōism, forming the basis of a concept of imperial divinity which has lasted until modern times. Buddhism, introduced to Japan from the Korean kingdom of Paekche in 552 AD, flourished during the 8th century, when the establishment of a new Japanese capital at Nara gave ample scope for the development of Buddhist ritual as a manifestation of imperial opulence. The seated Buddha from the Nara period is an outstanding work, which shows the influence of Chinese sculpture of the early T'ang period. Now covered with a dark patina of lacquer, it was originally gilded, and combines the carefully stylised repose of all Buddhist art with an impression of opulence and power.

Like the Chinese, the Japanese combined an interest in the metaphysical implications of religions such as Buddhism with an entirely worldly interest in commemorative portraiture. The figure of the priest Ganjin exemplifies this double aspect of the Chinese and Japanese cultures, representing the Chinese monk Ganjin, who became blind in the course of his repeated attempts to reach Japan carrying the Buddhist faith, and finally founded a Buddhist temple at Nara. It is at once a highly religious work, imbued with a sense of the monk's devotion to his faith, and an extremely realistic piece of portraiture.

After a period of isolationism in the 9th and 10th centuries, renewed Japanese contacts with the Sung dynasty in China coincided with a new interest in painting and literature. The latter were combined in horizontal scrolls where text and illustrations blended in comic-strip style. The most remarkable examples of this art form are the satirical animal scrolls from the Kōzan-ji Temple in Kyōto. Drawn in a brilliantly fluid style they show animals engaged in human activities and were probably intended to satirise abuses in the Buddhist Church.

The introduction of Zen Buddhism from Sung China during the 13th century brought with it the same development of painting allied with monastic life which had

Yakushi Nyorai. Nara
period, *c.* 720. h. 8 ft. 4⅜
in. (2·55 m.). Yakushi-ji,
Nara. Detail of a triad in
which the Buddha of
healing is flanked by two
standing Bodhisattvas.

opposite
The Priest Ganjin. Nara
period. 8th century.
Painted dry lacquer.
h. 2 ft. 8½ in. (81·7 cm.).
Tōshōdai-ji, Nara.

華叟兒孫不知禪
狂雲面前誰說禪
三十年来肩上重
一人荷擔松源禪
前住大德一休純
頂相自賛諸謹拝書

The Animal Scrolls
(detail). Heian period.
12th century. Ink on
paper. h. 11⅞ in. (30·2
cm.). Kōzan-ji, Kyōto.

opposite
Bokusai (?). *Portrait of
Ikkyū Sōjun.* Muromachi
period, second half of the
15th century. Hanging
scroll. Ink and light colour
on paper. 6⅛ × 10½ in.
(16·2 × 26·7 cm.).
National Museum, Tokyo.

taken place in its country of origin. The
taste for realistic portraiture in a religious
context is found in the special category of
Zen paintings known as *chinzō*, which were
portraits of great spiritual masters used for
devotional purposes by their students. The
painting from the Muromachi period illus-
trated is probably a sketch for a larger por-
trait of the Zen monk Ikkyū, and as such
has an immediacy and intense realism
which is devoid of any attempt at idealisa-
tion yet admirably conveys a sense of pain-
fully acquired wisdom in the subject.

The Zen cult appealed strongly to the
members of the warrior caste of *samurai*,
who thus provide a link between the medi-
tative pattern of Japanese art and the no
less Japanese phenomenon of militarism.
Moreover the art of scroll painting adopted
from the Chinese was soon applied to the
screens which adorned the castles of the
Japanese warlords. Originally built in
wood, by the 16th to 17th centuries these
fortresses were being constructed in stone,
following the methods of the Europeans
who introduced firearms into Japan at this
time. Himeji Castle is a typical example
which has adopted the European principle
of a fortified keep while retaining the tradi-
tional form of Japanese architecture for its
execution.

The rise of a Japanese middle class in
the Edo period (1615–1867) – again named
after the location of the country's capital
– created a demand for new, less exclusive
art forms, among which the most popular
was that of wood-cuts. Used for the illust-
ration of popular stories and books describ-
ing life in the pleasure quarter of Yoshiwara
in Edo, the technique was invented by
Suzuki Harunobu (1725–70), who is
renowned for his pictures of elegant courte-
sans. Harunobu's *Woman with a Fan* sums

up a whole area of Japanese life and art
which when interpreted by later masters
such as Hokusai, Hiroshige and Utamaro
was to have an important influence on
the French painters of the late 19th
century.

The response of all the Oriental cultures
to Western influence in recent times has
followed much the same pattern. The
impact of European ideas and techniques
has tended to deaden the creative spark
of the native culture, leading on the one
hand to attempts at assimilation and on
the other to the production of stereotyped
images in response to a Western demand
for exotic artefacts and images. To the
Westerner, all that is Oriental is exotic, but
in fact the Indian and Chinese cultural cur-
rents show a marked division which seems
to echo the division between the primitive
and Western traditions. With its view of
man as an organic part of the cosmos,
Indian culture retains a primitive sense of
timelessness which is reflected in the lack
of formally commemorative art or the
portraiture of individuals. The archetypal
figures of gods may well be depicted, but
man remains generalised, a multiple life-
form which covers the face of the earth
as it does the sculpted exteriors of the
Hindu temples. Chinese culture on the
other hand contains a humanistic element
which is revealed not only in a bureaucratic
rather than a religious organisation of
society, but also in the taste for commemor-
ative art and the depiction of secular life.
As we saw in the Classical world, this secu-
lar approach to life goes hand in hand with
a taste for the realistic portraiture of indivi-
dual persons. In the mysterious East, the
Chinese view of life appears as the less mys-
terious, though many of its aspects still
remain inaccessible to the West.

Himeji Castle. Himeji,
Hyōgo prefecture.
Momoyama period,
completed 1608.

opposite
Suzuki Harunobu. *Woman
with a Fan at the Garden
Fence.* Left leaf of a
diptych. Edo period.
1766–1770. Colour
woodcut. $10\frac{1}{2} \times 8\frac{1}{4}$ in.
(27·4 × 20·9 cm.).
Kunstbibliothek,
Staatliche Museen, Berlin.

The Medieval World

While the armies of Islam were overrunning the eastern Mediterranean and western Asia, Europe was passing through a period of uncertainty, of changing political and cultural values, from which the Church of Rome emerged first as a guiding spiritual force and ultimately as a political and social entity which challenged the might of the European states themselves.

It was the Roman Church which, during the Middle Ages, had the role of sponsoring Western cultural development, and therefore we need scarcely be surprised that medieval art was a religious art in practically all its manifestations. It was also inevitable that this art should make use of the Classical, Roman tradition which had played an important part in the Early Christian period and was still the most directly available body of artistic techniques and values. Nevertheless, with the political realignment of Europe during the Dark Ages the immediacy of the Classical tradition had faded. Its pagan and humanistic elements had become increasingly repugnant to a militant church which was concerned to acquire followers for its doctrine of individual salvation through the grace of a single God. Unlike the gods of the Classical myths, the Christian God was conceived as a being infinitely far removed from humans in virtue and accomplishment, and communal worship was the chief means of instilling a suitable sense of this divine superiority into his human followers. As a result, the church itself became the overriding preoccupation of Christian artists. Church architecture is the medieval art form par excellence, and the decorative arts – sculpture, wall-paintings, etc. – were conceived chiefly as a means of contributing to that architecture's overall impact. In the Romanesque period, architects were still experimenting with techniques learned from Roman and Byzantine models, but in the Gothic cathedrals they achieved a new sublimity of expression and technique which places these buildings among the architectural wonders of the world. Their soaring spires, dominating the communities gathered around their feet, symbolised the transcendental aspirations of their builders and the burgeoning power of the organised church in medieval life.

opposite top
The Franks Casket. Late
7th century. Whalebone.
l. 9 in. (23 cm.). British
Museum, London.

opposite bottom
St Lawrence, Bradford on
Avon. 8th century or late
10th century.

Christ and Mary
Magdalene. Detail from a
stone cross at Ruthwell.
Late 7th century. h. 15 ft.
(457 cm.).

Purse lid and clasps from
Sutton Hoo, Suffolk.
Before c. 655. Gold,
garnets and mosaic glass.
Purse lid $7\frac{1}{2}$ × 3 in.
(19 × 8 cm.). British
Museum, London.

opposite
Nave of St Sernin,
Toulouse, looking east.
Late 11th–12th century.

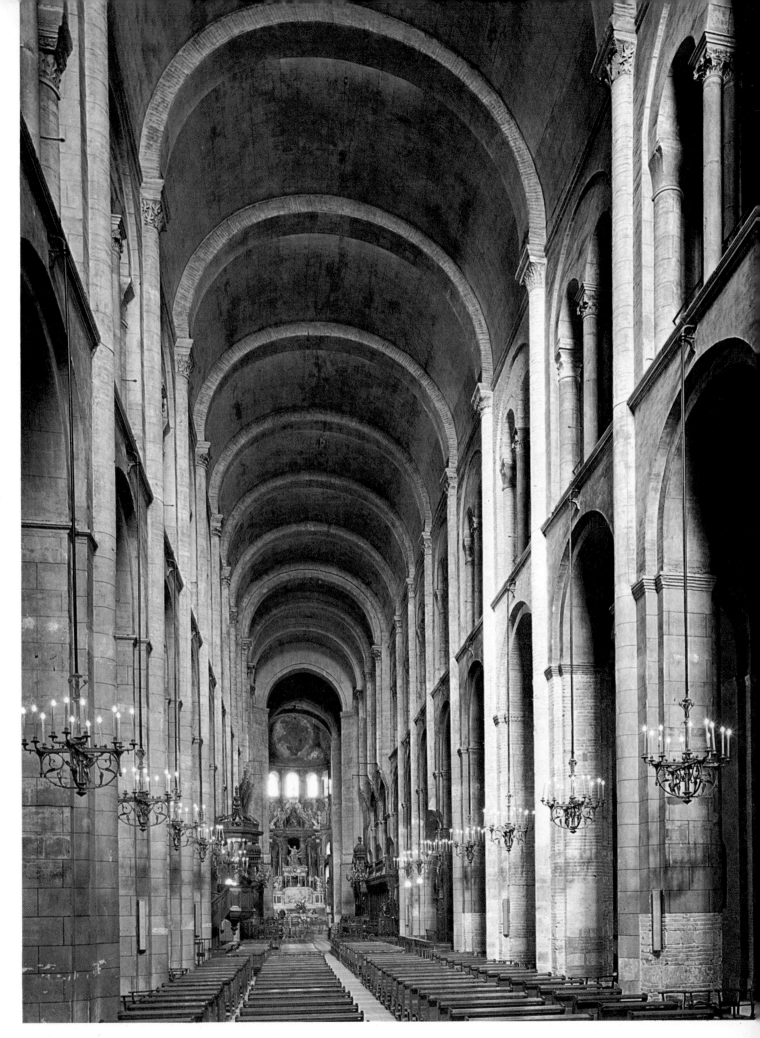

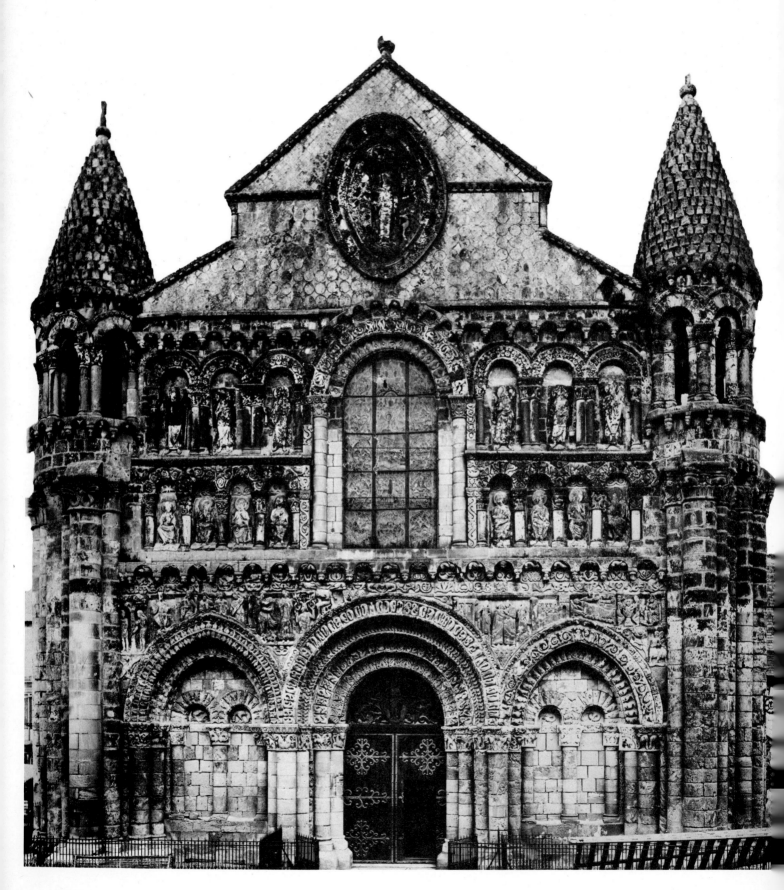

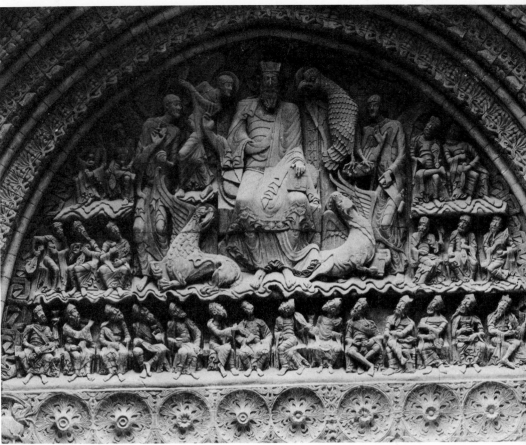

Isaiah. Second quarter of the 12th century. Abbey church of Souillac.

above right
The Apocalyptic Vision. Tympanum of the abbey church at Moissac. First third of the 12th century. Christ is surrounded by the evangelists' symbols and the Elders of the Apocalypse.

opposite
West front of Notre Dame la Grande, Poitiers. Mid-12th century.

The Indigenous Contribution

As we have already seen in an earlier chapter, Early Christian art in Western Europe was an amalgam of the Classical heritage and the indigenous motifs of the 'Barbarian' tribes which invaded the Roman empire. The court of Charlemagne witnessed an early fusion of these disparate elements, which included the Celtic motifs spread by the illustrated manuscripts of the Irish monastic movement and the Byzantine style which already formed a second generation to Classical art in eastern Europe.

The art of England in the Dark Ages shows just how rich the Barbarian contribution could be. The treasures found in a burial ship at Sutton Hoo in Suffolk stand on the borderline between the pagan and Christian worlds. Brooches and clasps of this kind were a favourite adornment of the tribes of northern Europe. Their opulence and highly skilled workmanship entirely belie the 'barbarian' epithet and they were to set a fashion for elaborate metalwork in the reliquaries, crosses and portable altars which formed the devotional apparatus of the medieval Church. The Franks casket combines narrative scenes from Norse mythology with Christian subjects, and shows how the European peoples were already developing a figurative style which was later to combine with the Class-

ical and Byzantine traditions as the basis of medieval church decoration.

Anglo-Saxon architecture illustrates how at the fringes of the Roman empire, Classical styles were no more than a surface accretion, overlaying local styles and techniques. The Saxon church of St Lawrence at Bradford on Avon is probably built of re-used Roman masonry, and its walls show vestigial Roman arches, but its box-like construction is of the simplest possible plan. It also highlights an important advance in church design which was to be carried forward into the medieval cathedrals. Whereas the early Christian basilicas had taken the form of an open hall with an apse housing the bishop's chair or altar at the east end, now the tendency was increasingly to build a separate nave and chancel, dividing the public part of the church from the section which housed the relics of the founding saint.

Also in the British Isles, monumental sculpture is found remarkably on the fringes of the Roman empire at a time when it was being practised scarcely anywhere else in Europe. The stone cross at Ruthwell is one of a series of monumental stone crosses, in which Classical influence is clearly recognisable in the treatment of the drapery and the vine-scroll motifs down the side.

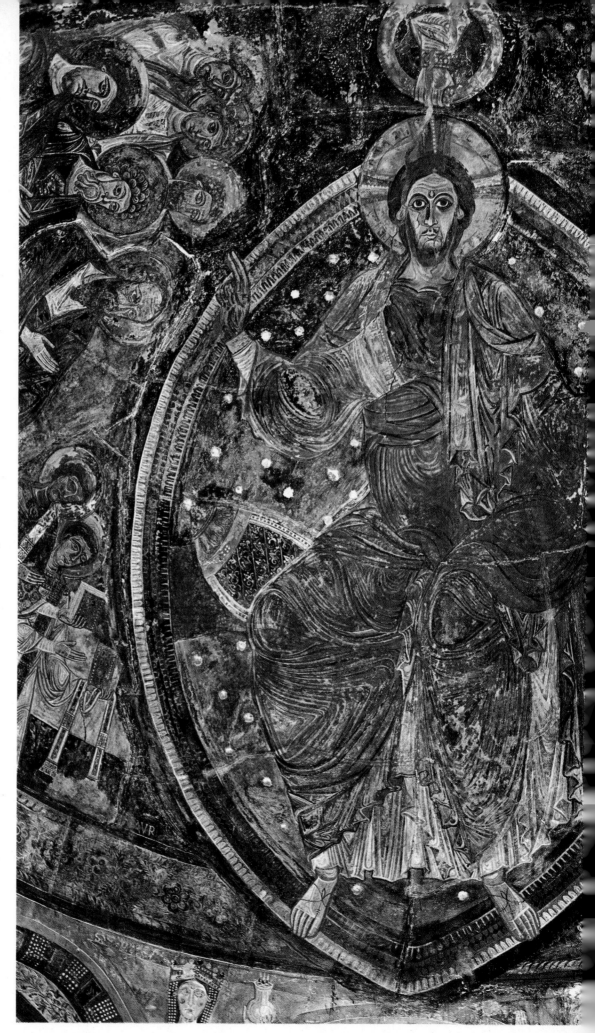

Christic in Majesty. Detail of
painting in the apse of the
chapel at Berzé la Ville,
Burgundy. Early 12th
century.

opposite right
Ambulatory of the church
of St Denis. Before 1144.

Romanesque Art

Thus, by the end of the Dark Ages, a body of artistic traditions existed in Europe combining Classical and non-Classical, Christian and non-Christian motifs. And all of these were available to the artists who took part in the first flowering of medieval art, creating a hybrid style which is known as Norman in the British Isles and as Romanesque in continental Europe.

The beginnings of Romanesque art were accompanied by two events of major significance for the subsequent development of the medieval Church and society. The creation of a Benedictine monastery at Cluny in Burgundy in 910 heralded a new independence for the Church from the feudal rulers. And the settlement of a band of Northmen in the lower valley of the Seine in 911 marked the beginning of the Norman domination of medieval Europe, which was to stretch from Scotland to Sicily. The new independence of the Church brought with it a process of growth and reform which also produced the flowering of Romanesque art. And the Norman domination ensured the dissemination of Romanesque styles throughout Europe.

The development of pilgrim routes across Europe led to the creation of a series of fine churches which embodied the medieval architects' first attempts at elaborating the styles and techniques of Roman 123 and early Christian architecture. Saint Sernin, Toulouse, is one of the finest of these pilgrim churches and illustrates how in Romanesque architecture the simple colonnades and arched apertures of the early Christian basilicas have become a major decorative feature and an integral part of the church's structure. The arches of the upper gallery are supported on slender double columns entirely in the Classical style, while the slender half-columns facing the main piers are extended to meet the barrel-vaulted roof.

Yet the impact of these lofty and as yet rather dimly lit buildings could not be further from that of the early Christian basilicas. No longer modestly conceived sanctuaries for a small and devoted congregation, they were simultaneously the earthly abode of an almighty God, a majestic symbol of the newly militant Christian church, and the hallowed receptacle of the relics of the founding saint. Those who entered them must be able to gain a foretaste of the afterlife which was promised them in Christian belief and commune with the saints who had already achieved that blessed state. It was the desire to create this impression which led church architects to abandon their previous aversion to the graven image and fill the niches, arches and pediments of their creations with figurative sculpture and surface ornamentation. Con-

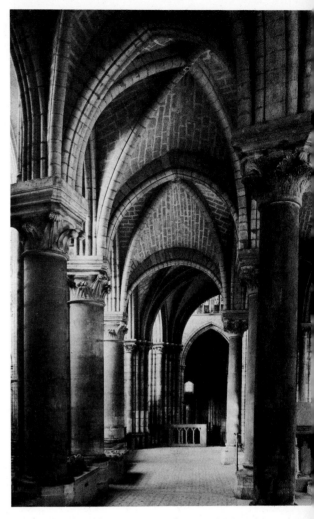

fronted with a facade such as that of Notre Dame la Grande, Poitiers, the humble 124 pilgrim could be sure that he was entering a building well-peopled with the saintly figures of his imagination.

It is possible to draw an analogy between the development of art in the medieval world and the course it followed in the Classical period. Indeed, we may take as a general pattern of developing cultures the initial interest in abstract geometric patterns, followed by an increasing realism in the portrayal of the human form, a progression from the non-figurative and essentially mysterious through to the highly representational and commemorative. The position of the Romanesque sculptors within this 125 pattern is roughly that of the artists who had the task of decorating the early Greek temples. Both generations had to learn anew the techniques of monumental sculpture, and both were preoccupied with the need to create sculptural solutions for the decoration of architecturally defined spaces. The Romanesque sculptors could of course refer back to the idealised human forms of later Classical art, but their preoccupations were different. Figures such as the *Isaiah* of Souillac, with its twisted body 125 and swirling drapery, and the upturned faces in the Apocalyptic vision of the Moissac tympanum, show a desire to por-

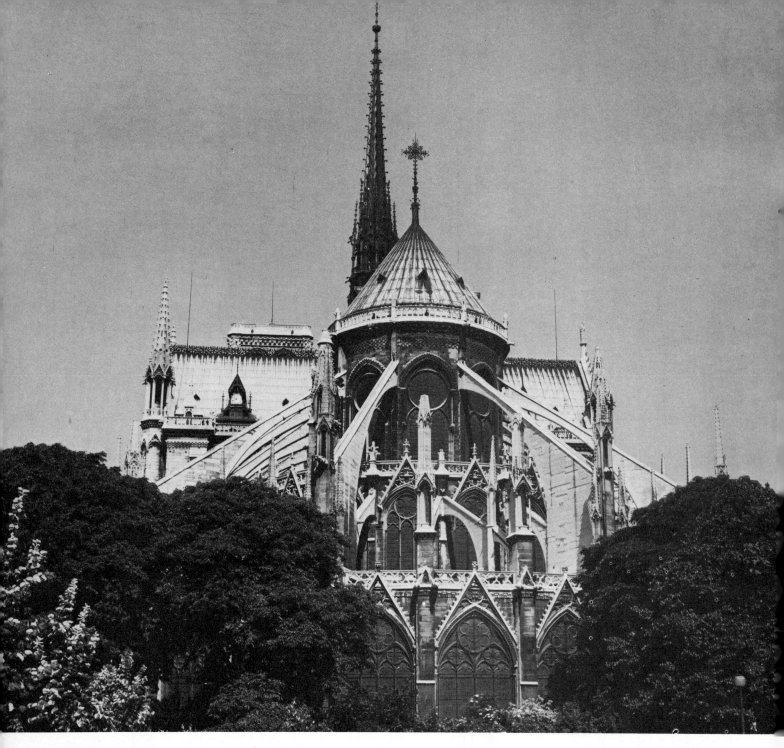

East end of Notre Dame, Paris. 12th and 13th centuries.

opposite
North transept rose window of Notre Dame, Paris. Mid-13th century.

tray not man as the incarnation of a universal ideal, but man under the impact of the awe-inspiring majesty of God or the violence of divine inspiration.

As far as the interior decoration of churches was concerned, the wall paintings and mosaics of early Christian and Byzantine art provided a ready-made tradition already sanctified by its use within the Christian church. Wall-painting was a universal form of decoration for Romanesque church interiors, and the *Christic in Majesty* at Berzé la Ville, Burgundy, illustrates just how closely it followed the earlier styles. The faces are thoroughly Byzantine in inspiration, while the interest in effects of drapery and the treatment of perspective in the seated figure of Christ clearly follow the Classical and early Christian modes.

Gothic Architecture

The growth of Western culture has been marked by an ever-accelerating process of change, of which the relatively abrupt appearance of the Gothic style in art and architecture is an early example. During the 12th and 13th centuries the Roman Church was at the height of its temporal power, embodied in particular in its relations with the state of France. At the same time it experienced a new stage of spiritual growth, marked by a greater emphasis on the salvation of the individual soul. The aim of the Gothic church builders was more sophisticated than that of the architects of Romanesque. Instead of impressing the worshipper with a sense of the Church's

128

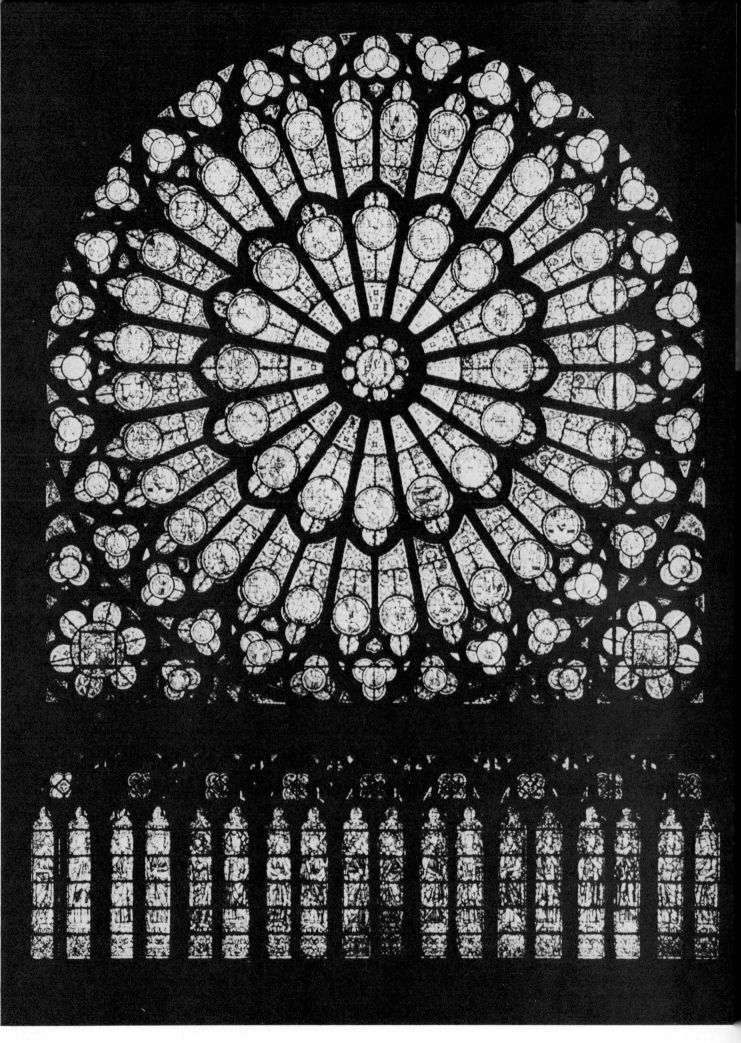

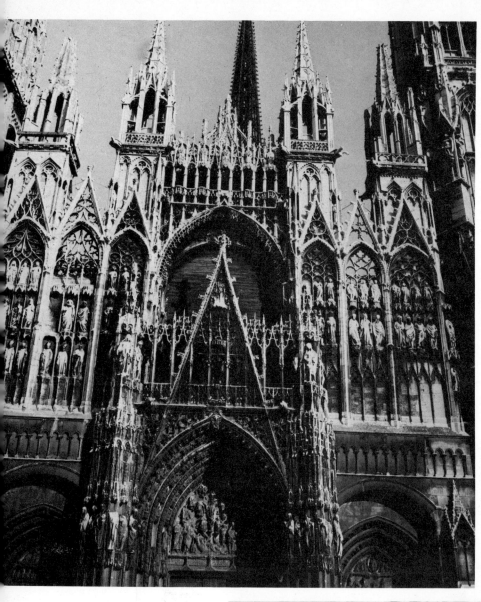

West façade of Rouen cathedral. First half of the 15th century. French Flamboyant style.

Portail Royal. West front of Chartres cathedral. c. 1145–1155.

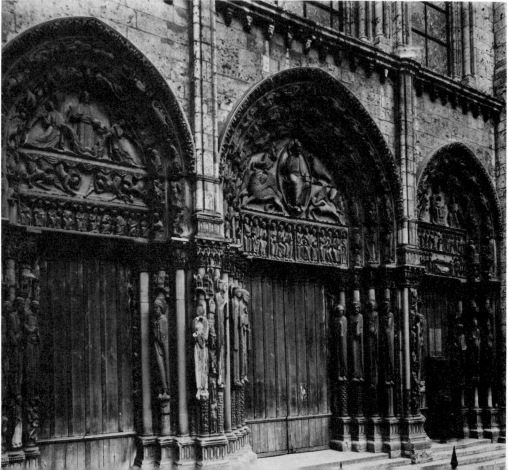

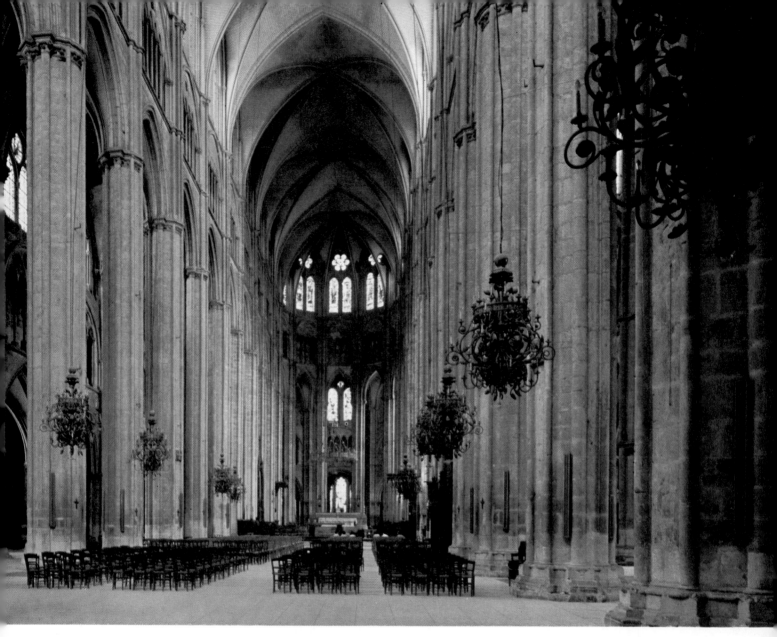

Interior of Bourges
cathedral, looking east.
End of 12th and early 13th
century.

richness and solidity, and its purely symbolic function as a representation of the kingdom of Heaven on earth, the great Gothic cathedrals aimed to have a far more direct effect on the minds of those who entered them. All the most characteristic features of the Gothic style were conceived with this end in view.

Architecturally, the characteristic device is that of rib-vaulting. The use of barrel-vaulting in the Romanesque churches imparted a certain heaviness to the structure which was emphasised by the fact that all the arches supporting the vault had to be of the same height. The Gothic builders found that they could span large areas just as effectively by using heavy ribs of stone interspersed with a filling of lighter material. Moreover the use of a pointed rather than a round arch enabled the crossing to be made at any height which the architect might choose. The principle of rib-vaulting is well illustrated by the ambulatory in what is sometimes held to be the first 127 Gothic building – the church of St Denis outside Paris, begun by Abbot Suger in 1135. Though the structure still has a certain Romanesque heaviness about it, we can see how the tracery of the rib-vaulting sprouting from the free-standing columns gives the whole a new spaciousness which is added to by the light from the large number of windows.

During the 12th and 13th centuries a whole series of magnificent cathedrals were built in France, representing the height of the Gothic achievement. In the cathedrals of Notre Dame in Paris, Chartres, Bourges, 130 Le Mans, Reims, the rib-vaulting seems to dematerialise the roof structure so that instead of the brooding enclosed spaces of the Romanesque churches, there is an impression of open-ended spaciousness, a soaring upwards which not only symbolises but invites the development of the transcendental aspirations of the human mind. As time went on, this emphasis on lightness – the desire to achieve an effect of illumination which might parallel the interior illumination of the Christian mystic – became more and more marked. The use of flying buttresses to support the great weight of the rib-vaulting enabled the walls to be cut away increasingly and used as

Nave of Barcelona
cathedral. Begun 1298.

opposite
West tower of Ulm
minster. 15th and 19th
centuries.

The great rose windows such as those 129
added to Notre Dame in the 13th century
are the essence of the so-called Rayonnant
style. With their figurative and naturalistic
details incorporated into an overall abstract
pattern of remarkable complexity, they
seem to echo the Islamic approach to archi-
tectural design and religious ornament. In-
deed, in their emphasis on the dematerial-
isation of solid masses and specifically mys-
tical function, the great Gothic cathedrals
are the nearest Western art has approached
to the spirit of Islamic architecture.

Yet for all that the Gothic art of the
12th and 13th centuries revealed a preoccu-
pation with the condition of the individual
soul, the symbolic elements which had
characterised the Romanesque churches by
no means disappeared. The Romanesque
tradition of sculptural decoration was
developed, and found its most perfect
expression in the famous portals of 130
Chartres cathedral. The concept of the
church as a reliquary persisted. Indeed the
church and the reliquary became identified
to the extent that the reliquary itself, once
shaped like a tomb, took on the appearance
of a church, and was sculpted with elabor-
ate architectural detail.

In the later Gothic style, known as Flam-
boyant from its flame-like tracery patterns,
stonework tracery is no longer used exclusi-
vely for mounting stained glass windows,
but also as a purely decorative device, and
the different functional and symbolic ele-
ments combine to produce an effect of un-
precedented delicacy and complexity. On
the west façade of Rouen cathedral, for 130
example, the figure sculptures, tracery and
architectural forms all blend into an intri-
cate overall effect.

The taste for overall surface decoration
is in fact the characteristic feature of later
Gothic architecture, particularly in
Germany, where the Gothic style inevita-
bly took some time to penetrate. The great
minster at Ulm is a mass of elaborate 133
tracery, on the towers at the east end, on the
flying buttresses, and most strikingly on
the great tower rising from the west end
which, though designed in the medieval
period, was not completed until the 19th
century. A similar use of complex tracery
patterns is found in the internal decoration
of German churches.

In southern Europe the Gothic style
retained a greater simplicity. A Mediter-
ranean climate naturally inhibited the use
of large expanses of glass and southern
Gothic interiors have a cool remoteness
which suggests more the inner recesses of
the soul than the brilliance of divine illu-
mination. The lofty arcades and graceful
rib-vaulting of Barcelona cathedral are 132
reminiscent of Bourges, but the dimly-lit
interior is typical of the southern Gothic
style.

a setting for stained glass. In the cathedral
128 of Notre Dame in Paris, with its slender
flying buttresses and enlarged clerestory
added in the 13th century, the masonry
becomes little more than a scaffold for large
areas of glass.

Stained glass was another element which
the cathedral builders deliberately used to
create a specific atmosphere. The reds and
blues which were characteristic of early
135 Gothic stained glass produce a glowing
richness in the interior. Not only the
windows themselves, seen from inside, but
also their colours thrown on the floor by
the rays of the sun contribute a feeling of
calm and tranquility. Later Gothic stained
glass is lighter in tone, as the elaborate
stone tracery used as a mounting for the
glass becomes an integral part of the design.

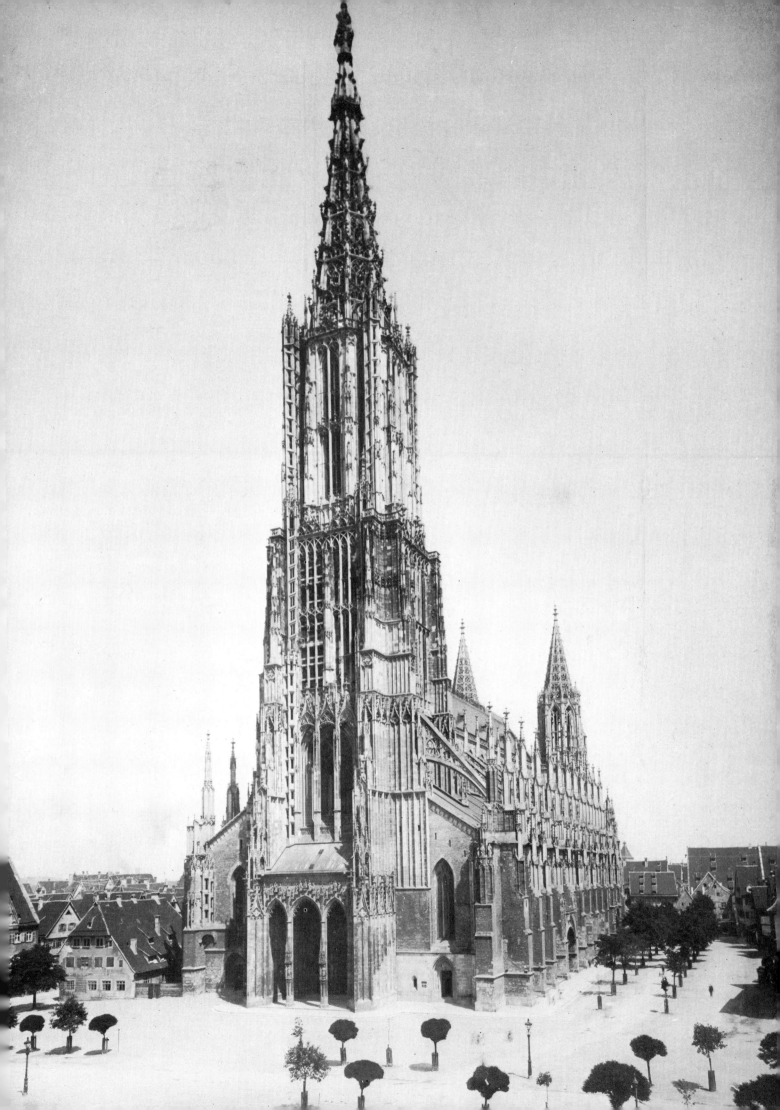

Gothic Sculpture

If the Romanesque sculptors found themselves at a similar stage of development to the sculptors of the early Greek temples, one might expect that the Gothic sculptors would at some point arrive at the idealised forms of the high Classical period. This was indeed the case for a short space of time. French Gothic sculpture of the early 13th century, of which the figures from Reims cathedral are an example, has a monumental serenity which clearly derives from a Classical inspiration. But this miniature renaissance of the Classical humanist ideal was short-lived. Classical humanism was associated with paganism, and the Church's limited ability to tolerate unorthodox ideas was brought to a head by the so-called Albigensian heresy. The suppression of the latter during the first decades of the 13th century was followed by the establishment of the Inquisition, and any Classical humanist ideals were forgotten, at least for the time being.

Otherwise, and particularly in Germany, Gothic sculpture followed the Romanesque preoccupation with the expression of human emotion rather than the depiction of idealised human forms, and we find the familiar progression towards a greater realism and increasing secularisation of the subjects. One of the best known German Gothic sculptors is the Master of Naumberg, and his figures of the founders of Naumberg cathedral represent an invasion

Master of Naumburg. *Ekkehard and Uta.* After 1249. Life-size. West choir, Naumburg Cathedral.

School of Giotto. *St Francis Driving out the Devils from Arezzo. c.* 1300. Upper church, S. Francesco, Assisi.

opposite
The Virgin and Child, traditionally called the 'Belle Verrière'. Stained glass window in Chartres cathedral. Late 12th century.

St Elizabeth. c. 1235.
Bamberg cathedral.

opposite
The Blessed in Heaven.
1230s. Tympanum of the
Christ Porch in the north
transept of Reims
cathedral.

decadence of Gothic art, a regression from a concern with real spirituality to an appeal to crude emotion.

Gothic Painting – Giotto

The Christian tradition of painting, from early Christian and Byzantine to Romanesque, had been largely iconographic, concerned with the production of devotional images and the decoration of church interiors. As the art of sculpture was revived and developed during the Middle Ages, the supremacy of painting as an iconographic medium declined, and it tended to be regarded as a cheap alternative to sculptural decoration. At the same time, this change of status naturally freed it from the formal restraints implicit in its former role. In Italy, where painting had remained a living form of expression to a greater extent than in the rest of medieval Europe, the work of Giotto and his school at the beginning of the 14th century shows an entirely new approach which is exemplified by the frescoes adorning the church of St Francis at Assisi. For the first time in Western art, these pictures seem primarily concerned in telling a story, in setting human figures in a three-dimensional context and revealing their emotional reactions to their situation. *St Francis Driving out the Devils* exemplifies 134 this new relationship between the human figures and their setting. The buildings are an integral part of the formal composition, and there is a sweeping movement from left to right, through St Francis' upraised arm to the devils in the sky above. The work of Giotto and his school marks the beginning of a new tradition in Western art which leads directly to the Italian Renaissance.

In medieval art we can see what is beginning to become a familiar pattern of cultural development, from the decorative styles of its 'barbarian' beginnings to the secular, commemorative elements of late Gothic. In the great Gothic cathedrals of the 12th and 13th centuries the element of mystery reaches its highest point in Western art, executed with a sophistication and technological mastery matched only by the great achievements of Islamic architecture. If we draw a loose parallel between the pattern of cultural development in the Classical world and that in the 'neo-Classical' era which runs from the birth of Christ to our own day, it is perhaps not surprising that the demystification of Western art at the end of the Gothic period should be succeeded by a renaissance of Classical humanist ideals, both matching and directly inspired by the flowering of Classical culture in the city states of Ancient Greece.

of sacred territory by secular art and a progression from iconographic art to realistic
136 portraiture. The figure of St Elizabeth in Bamberg cathedral shows both a brutal realism in the treatment of the saint's face, and a concern for dramatic effect in the treatment of the drapery which is characteristic of German Gothic sculpture. This latter tendency was to be taken to grotesque extremes in wood carvings such as the Gabelcrucifix. The suffering figure of
138 Christ has been deliberately caricatured to evoke terror and pity in the beholder. One might see this development as the final

Gabelcrucifix, or Pestkreuz. 1304. Wood. Over life-size. Church of St Maria im Kapitol, Cologne.

The Renaissance

In the cycle of growth which has brought our Western culture to its present state, the Renaissance appears as a half-way point. The religious, 'mysterious' phase was over; not God, but man, was now in the centre of the stage, and artists, thinkers, craftsmen and politicians all played their part in the celebration of his worth.

The key factor in the situation was the loosening of the stranglehold which the Roman Church had exerted on medieval society. Men were quick to take advantage of this new freedom and the 15th and 16th centuries saw radical changes in every aspect of human life. The discovery of worlds new to Western eyes – India, Africa, America – was accompanied by a rediscovery of the humanist ideas of Classical antiquity. Man's greatest technological advance since the wheel, the invention of printing, increased the impact of these innovations a hundredfold, putting the whole of the Western world into a ferment of intellectual activity.

Jan van Eyck. *The Madonna with Chancellor Rolin. c.* 1435. Painting on panel. 26 × 24½ in. (66 × 62 cm.). Louvre, Paris.

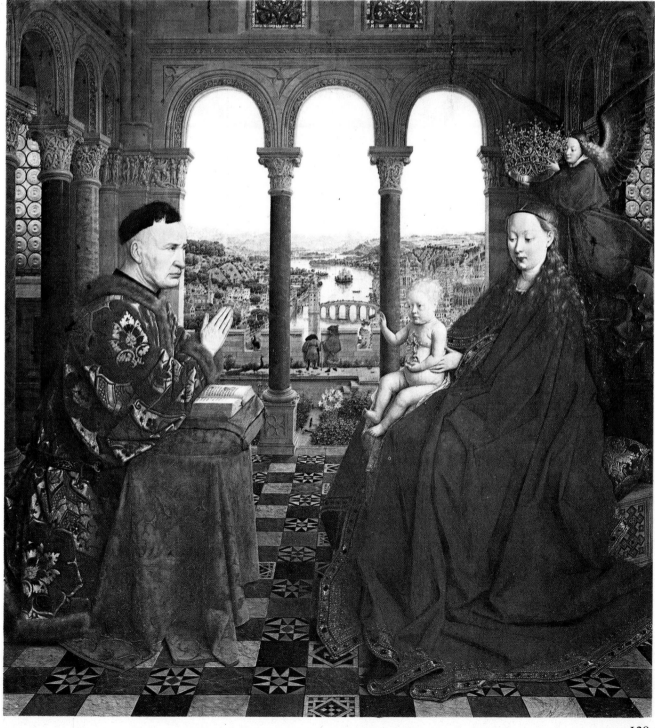

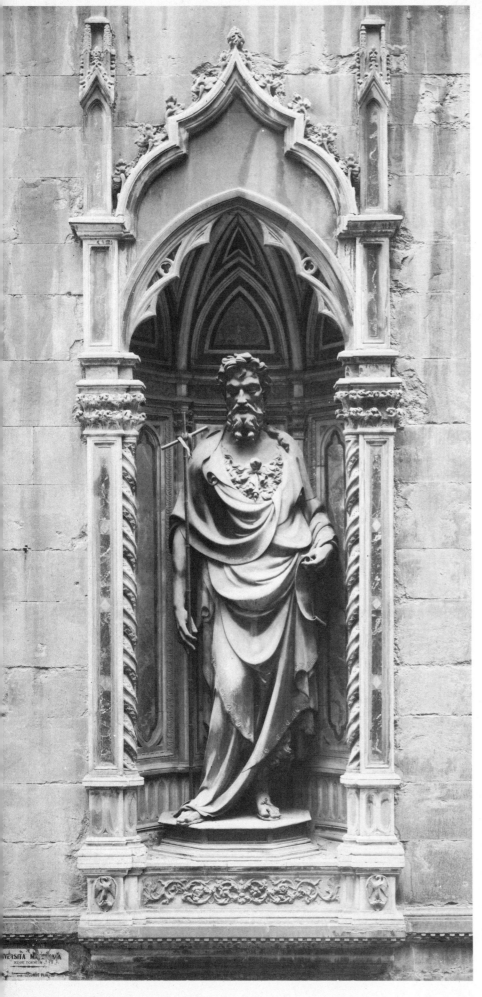

In the fields of art and architecture the Renaissance was essentially a period of rediscovery. Throwing off the dogmatic and iconographic ties of the medieval Church, Renaissance artists took a fresh look at what had survived of the art of Classical times and exploited its themes and styles with a new openness and exuberance. Inevitably, the roots of this new growth were to be found in Italy, historically linked with the Roman Empire and possessed of vast numbers of Classical remains.

While Renaissance art took its cue from the Classical past, the political and social make-up of Renaissance Italy was also not unlike that of Ancient Greece at the time of its greatest cultural achievements. It was a conglomeration of prosperous city states and republics whose ruling families, themselves immensely wealthy, dominated European commerce and vied with one another in their patronage of the arts. In Florence, Venice, Pisa, Milan and elsewhere, the Medicis, the Sforzas, the Gonzagas and their like provided a fertile soil for the most remarkable flowering of artistic talents the West had ever seen.

The End of Gothic Art

During the course of the 14th century, Gothic figure sculpture had settled down into a relatively homogeneous, international style, in which formal, decorative values had come to predominate, paralleling the preoccupation of late Gothic architecture with surface ornament and elaborate tracery patterns. The religious passion and dramatic sense of earlier Gothic sculpture had given way to something graceful, formally pleasing, and basically rather anodyne. In the early 15th century a number of Florentine artists showed the first signs of discontent with this style, turning back for inspiration both to Classical antiquity and to the more dramatic character of earlier Gothic works by sculptors such as Giovanni Pisano. One of these artists was the sculptor Lorenzo Ghiberti (1378–1455) whose first important surviving work is the figure of *St John the Baptist* 140 in the church of Or S. Michele in Florence. The formal pose and graceful arrangement of the drapery are typical of the international Gothic style, but the figure already has a certain robustness which was to become one of the characteristic elements of Renaissance art.

Ghiberti's contemporary, Donatello, instilled a dramatic force and vigour into his sculptures for various Florentine churches which were entirely in the spirit of the age. His dancing *putti* carved in the balustrade 141 of a pulpit in the church of Or S. Michele

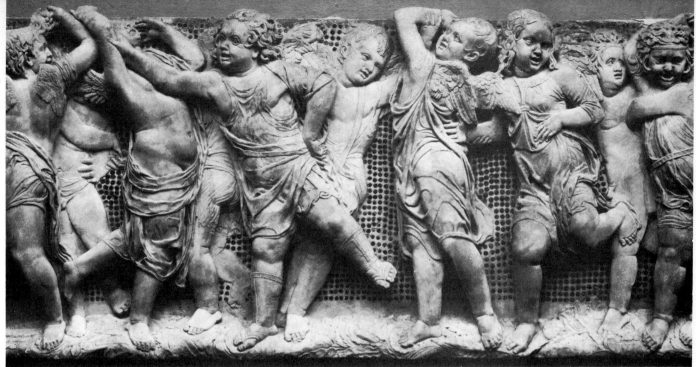

Donatello. *Cantoria.*
1433–1438. Marble with
polychrome mosaic inlay.
Overall size 137 × 224½
in. (348 × 570 cm.).
Museo dell'Opera del
Duomo, Florence.

right
Filippo Brunelleschi. The
dome of Florence
cathedral from the
south-east. Built *c.*
1420–1436. Lantern
designed 1436 but only
built after 1446.

opposite
Lorenzo Ghiberti. *St John
the Baptist.* 1414. Bronze.
h. of figure 8 ft. (244 cm.).
Or S. Michele, Florence.
Executed for the Arte dei
Mercanti.

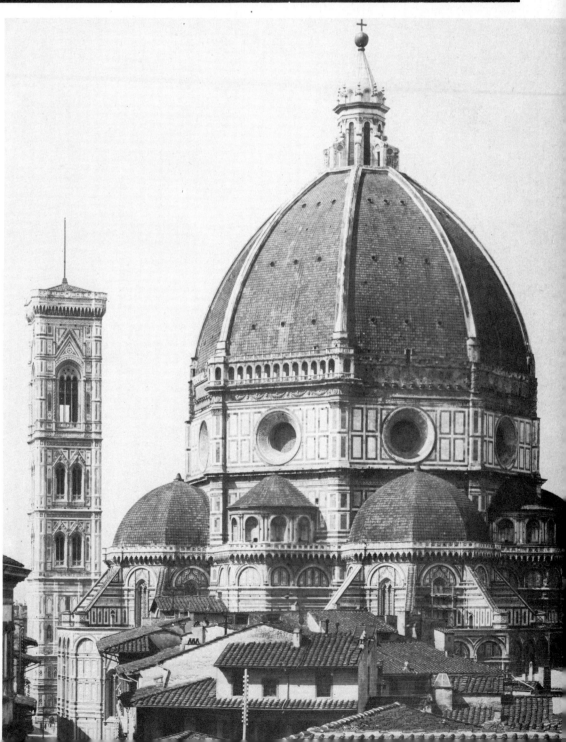

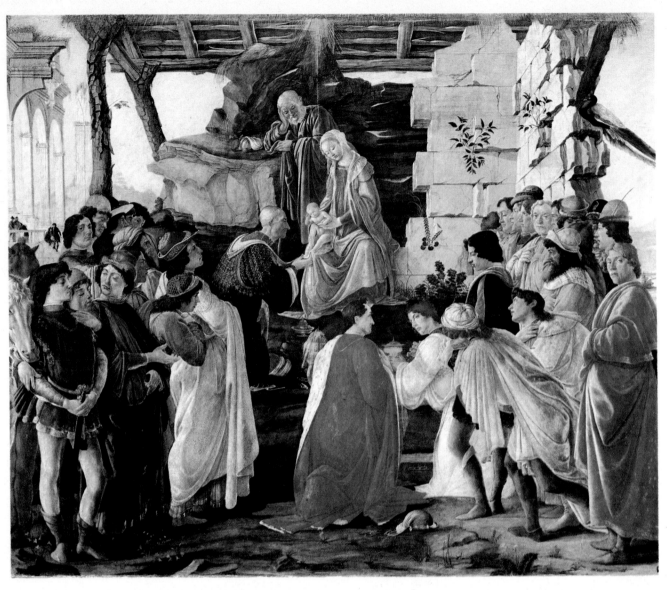

are a remarkably fresh and vivacious rendering of a motif which was to become familiar in Renaissance art, and had at the time been recently reintroduced from Classical models by the Sienese artist Jacopo della Quercia. Filippo Brunelleschi had visited Rome with Donatello and like his contemporary had been much impressed with the Classical remains which he found there. Also a sculptor, Brunelleschi became particularly interested in architecture and the technical problems it presented. The dome of the cathedral in Florence is one of his first great feats of structural engineering. While the shape is not a replica of any Classical structure, the scale of the enterprise is an echo of Roman times, and the method of brick construction used seems to be modelled on that found in ancient Roman buildings.

All these works are indicative of a new spirit in Western art which was not confined to Italy alone. In northern Europe, artists such as Claus Sluter and Jan van Eyck (c. 1390–1441) working for the Duke of Burgundy, produced their own versions of the new style. Sluter's *Madonna and Child* in the chapel of the Chartreuse de Champmol in Dijon, has a dramatic vigour and a sense of emotional engagement between the Mother and Child which are entirely foreign to international Gothic, though they may perhaps derive something from 13th-century German Gothic sculpture. Little survives of Jan van Eyck's work as court painter to the Duke of Burgundy in the Netherlands, but his superb *Madonna with the Chancellor Rolin* offers a microcosm of the elements of Renaissance painting – the influence of Classical antiquity, the interest in perspective and landscape, the rich colours and above all the realistic portraiture of the Chancellor. The Renaissance was a period of individualism; in Italy in particular the influence of Classical texts such as Plutarch's *Lives* fostered a cult of the individual which was revealed in the fashion for biographies of great men – a life of van Eyck himself was written by an Italian scholar, Bartolommeo Fazio, between 1453 and 1457. The portraiture of living individuals was a natural

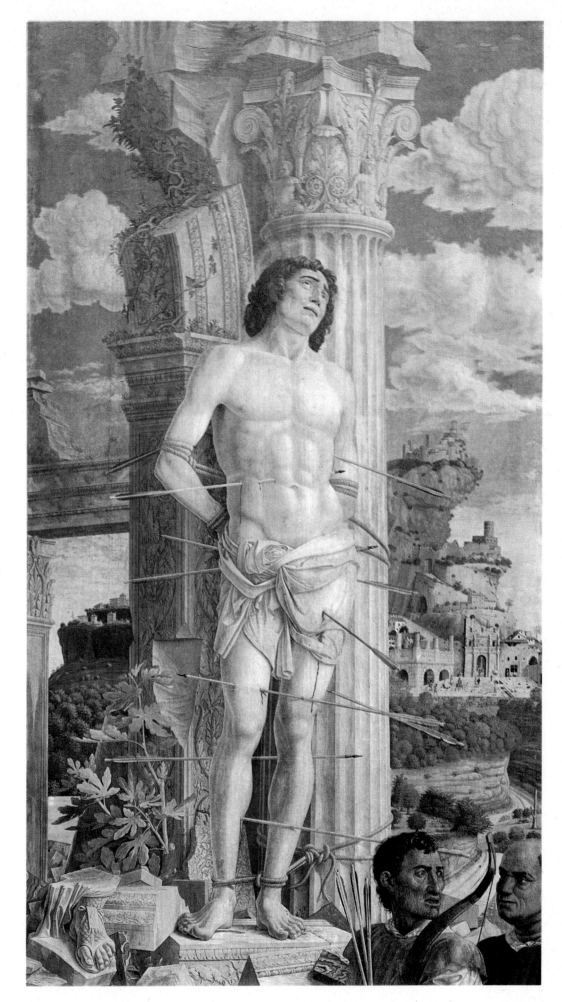

opposite
Sandro Botticelli.
Adoration of the Magi. c.
1475. Tempera on panel.
$43\frac{3}{4} \times 52\frac{3}{4}$ in. (111 × 134
cm.). Uffizi, Florence.

Andrea Mantegna. *St
Sebastian. c.* 1470.
Tempera on canvas. $101\frac{1}{4}$
× 56 in. (257 × 142 cm.).
Louvre, Paris.

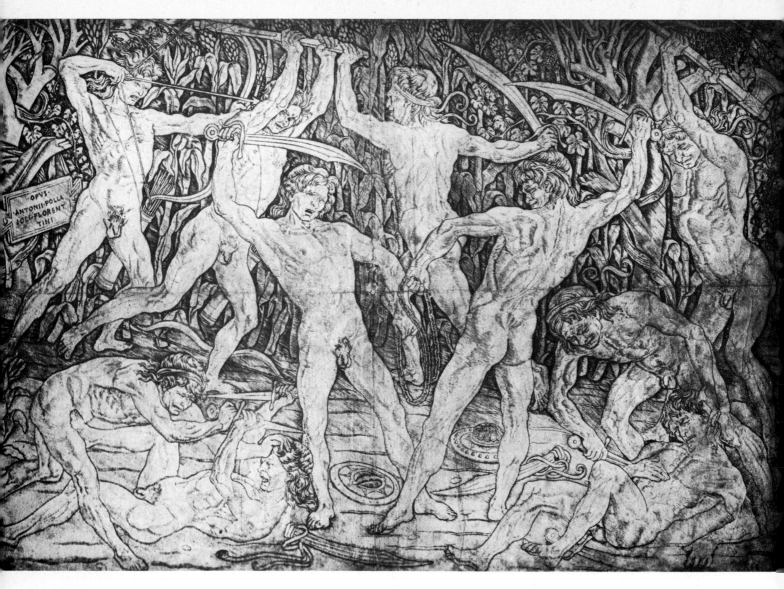

Antonio Pollaiuolo. *Battle of Nude Men. c.* 1470. Engraving.

opposite left
Claus Sluter. *Madonna and Child. c.* 1390. Marble. Chapel, Chartreuse de Champmol, Dijon.

opposite right
Desiderio da Settignano. *Angel* (detail). *c.* 1450–1451. Marble. Part of the altar of the Sacrament, S. Lorenzo, Florence.

part of such an atmosphere, as well as being a predictable element of this secular, humanistic stage of development in Western culture.

The Influence of Antiquity

During the second half of the 15th century, the response of Italian artists to their Classical heritage became more specific. What had begun as a generalised interest in antiquity, inspired by the developments in literature and philosophy, became a more intense interest in the techniques and styles of Classical art. Among Florentine sculptors in particular, an interest in the modelling and finish of Classical statuary contributed a strain of elegance and grace which served to counterbalance the vigorous expressiveness of Donatello's style. Desiderio da Settignano was one of the masters of this 'alternative' style in early Renaissance sculpture, and his figure 145 of an angel in the church of S. Lorenzo in Florence is remarkable for its exquisite

surface finish and sensitive rendering of what is evidently a contemporary face.

The engraving, *Battle of Nude Men*, by 144 Antonio Pollaiuolo emphasises another aspect of Renaissance art inherited from the Classical world – the interest in the human figure in motion. Pollaiuolo was one of the first Renaissance artists to use the rapid sketch as a means of studying the human form, and here the composition is clearly designed to show the latter in a variety of different poses. The young Leonardo made use of Pollaiuolo's studies and overall there was a growing emphasis on competent draughtsmanship as part of an artist's stock-in-trade.

Clarity of detail and careful modelling of the human form clearly reflect the humanistic tenor of the times, the taste for realism which was an inevitable part of the Renaissance outlook, and which is a feature of the paintings of Sandro Botticelli (1444–1510). In his *Adoration of the Magi* 142 the figures are carefully arranged in naturalistic poses, while the fact that the faces of the onlookers are in many cases recognisable as members of the Medici family betrays the increasingly secular

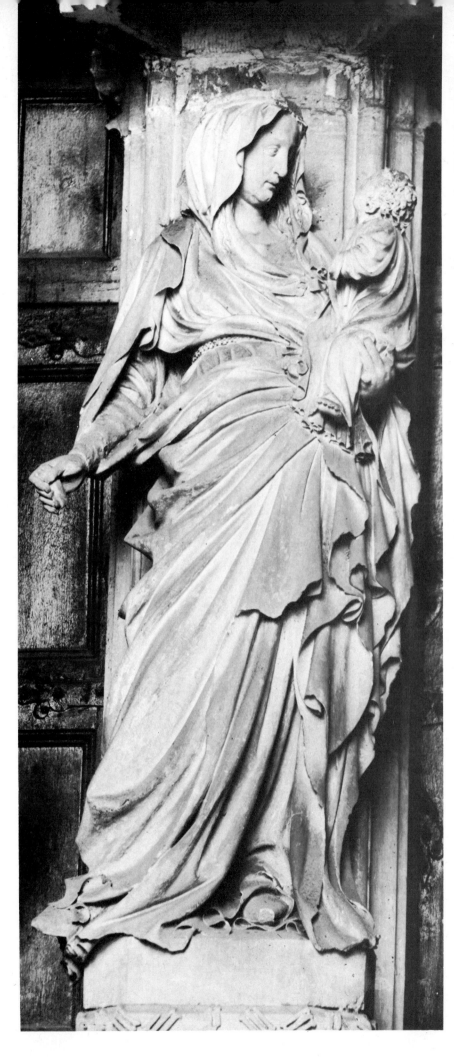

approach of Renaissance art to subjects which would have been held sacrosanct in medieval times. The use of Classical ruins as a background reflects a nostalgia for the antique which is even more evident in the *St Sebastian* by Andrea Mantegna. The [143] columns and fragments of sculpture are quite explicit references to the Classical past, while the firm, sculptural appearance of the body suggests a close study of Classical statuary. At the same time the faces of the archers in the foreground provide a contemporary reference which is perhaps deliberately jarring.

The High Renaissance

At the beginning of the 16th century, a period of political instability in Florence marked the end of Florentine domination of Renaissance culture. The election of a powerful pope, Julius II, in 1503, ushered in a brief but glorious period of papal patronage of the arts which lasted until the Sack of Rome in 1527. This was the so-

called High Renaissance, an explosion of artistic creativity in which the great names of Michelangelo, Leonardo da Vinci and Raphael predominate.

One of the most famous works of the High Renaissance is Michelangelo's *David*. Here we find the direct influence of Classical antiquity in the texture and modelling of the figure, in its air of repose and monumental scale. At the same time it has an immediacy and human realism which make it very much a work of its own time. The gigantic figures of the ceiling paintings in the Sistine Chapel, which occupied Michelangelo from 1508 to 1512, have the same Classical monumentality, while the masterly rendering of the flesh tones, the vigorous modelling and the sheer exuberance of the whole ensemble typify one aspect of High Renaissance art. At the same time the Sistine Chapel symbolises the growing secularisation of the Roman Church in Renaissance times. Religious art is no longer devotional, impressing the beholder with a sense of the central mystery of life, but a brilliant celebration of papal power and opulence.

Leonardo da Vinci was in many ways the archetype of the many-sided, complete Renaissance man, a genius of immense versatility who adorned Renaissance Italy with a host of outstanding works. His treatments of religious themes, such as the *Virgin of the Rocks*, are remarkable for their complexity of composition, their delicate use of colour and subtle gradation of tone, while possessing an air of sweetness and grace which contrasts with the essentially monumental character of much of Michelangelo's work.

Leonardo's paintings inevitably exercised a strong influence on younger artists, many of whom were his pupils, and also upon the third great figure of High Renaissance art, Raphael. Such was Raphael's regard for Leonardo's work that he more than once reworked subjects or compositions which originated with the latter. In his *Triumph of Galatea*, a fresco which he painted in the Villa Farnesina in Rome, the pose of the nymph herself is based on a work of Leonardo's which has since been lost. The painting is full of drama and movement, allied to an inventiveness of composition and a lively grace which are characteristic of Raphael's work and once again contrast with the ponderous grandeur of Michelangelo.

Not all the outstanding works of the period were to be found in Rome. In the cathedral at Parma, Correggio decorated the ceiling of the great dome with a fresco of the *Assumption of the Virgin* in which the figure style owes much to Michelangelo. The composition is such as to guide the eye of the spectator inwards from the edge.

Michelangelo Buonarroti.
Male figure. Fresco.
Sistine Chapel, Rome.

right
Hieronymus Bosch. *The Temptation of St Anthony.* *c.* 1500–1510. Paint on panel. 51¾ × 46¾ in. (132 × 119 cm.). Museu Nacional de Arte Antiga, Lisbon.

opposite
Correggio. *Assumption of the Virgin.* 1526–1530. Fresco inside the dome of the cathedral, Parma.

below
Michelangelo. *David.* 1501–1504. Marble. h. 16 ft. 10½ in. (514 cm.). Accademia, Florence.

The Renaissance in Europe

Although the beginnings of a new style in northern Europe had already appeared in the 15th century in the work of artists such as Sluter and Van Eyck, the influence of the Italian Renaissance spread fairly slowly north of the Alps. Such changes as did take place were chiefly the contributions of a few highly individual artists, among whom the Flemish painters stand out. The strange surrealist visions of Heironymus Bosch are without precedent and their meaning remains obscure. Yet their precision of detail and interest in landscape are characteristic of the age and specifically of the Flemish style of painting which we have already seen in the work of van Eyck. Italian Renaissance painters had already introduced landscape as an element of pictorial composition, but in the work of Flemish painters such as Pieter Breughel the Elder the landscape itself becomes a major theme.

If in many cases the influence of Italian ideas in northern Europe was indirect, in the case of Albrecht Dürer (1471–1528) it was assimilated directly through two journeys which he made to Italy at the end of the 15th century. One of the great figures of the Renaissance outside Italy, Dürer was fascinated by Italian artistic theories and himself compiled *Four Books on Human Proportion*, which were published shortly after his death. Though much of his work remains resolutely Germanic in style, his engraving of *Adam and Eve* shows a strong Italian influence, especially in the modelling of Adam's figure, which bears comparison with Michelangelo's *David*.

While northern artists visited Italy and absorbed Italian ideas, Italian artists also moved to courts elsewhere in Europe. The great Florentine sculptor and goldsmith Benvenuto Cellini worked for five years at the court of Francis I at Fontainebleau. Two other Italian artists, Rosso Fiorentino and the Bolognese Francisco Primaticcio, had the task of decorating Francis I's hunting lodge at Fontainebleau, and their schemes have a lightness, a grace and fantasy which added a new dimension to Renaissance art. His work at Fontainebleau uses a characteristic combination of painting and moulded stucco, the latter being treated for the first time in curling scrolls known as 'strapwork'.

The Spanish Habsbourg court was yet

opposite
Leonardo da Vinci. *The Virgin of the Rocks.* Finished *c.* 1507. Paint on panel. $74\frac{1}{2} \times 47\frac{1}{4}$ in. $(189 \cdot 5 \times 120$ cm.). National Gallery, London.

Raphael. *The Triumph of Galatea.* 1511. $116\frac{1}{4} \times 88\frac{1}{2}$ in. $(295 \times 225$ cm.). Fresco from the Villa Farnesina, Rome.

Albrecht Dürer. *Adam and Eve.* 1504. Engraving. $9\frac{3}{4} \times 7\frac{1}{2}$ in. (24 × 19 cm.). British Museum, London.

Pedro Machuca. Palace of Charles V, Granada. Probably built from 1539 onwards.

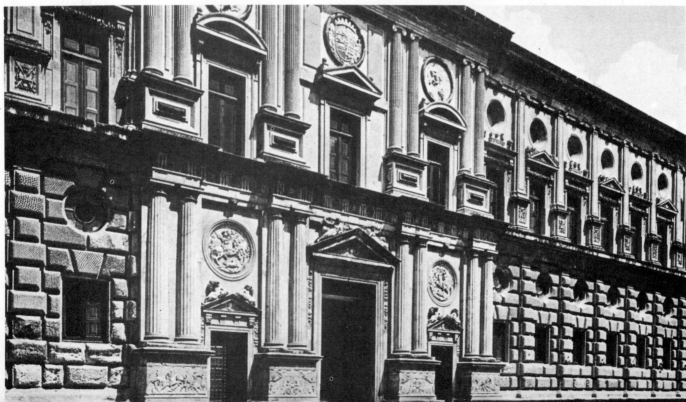

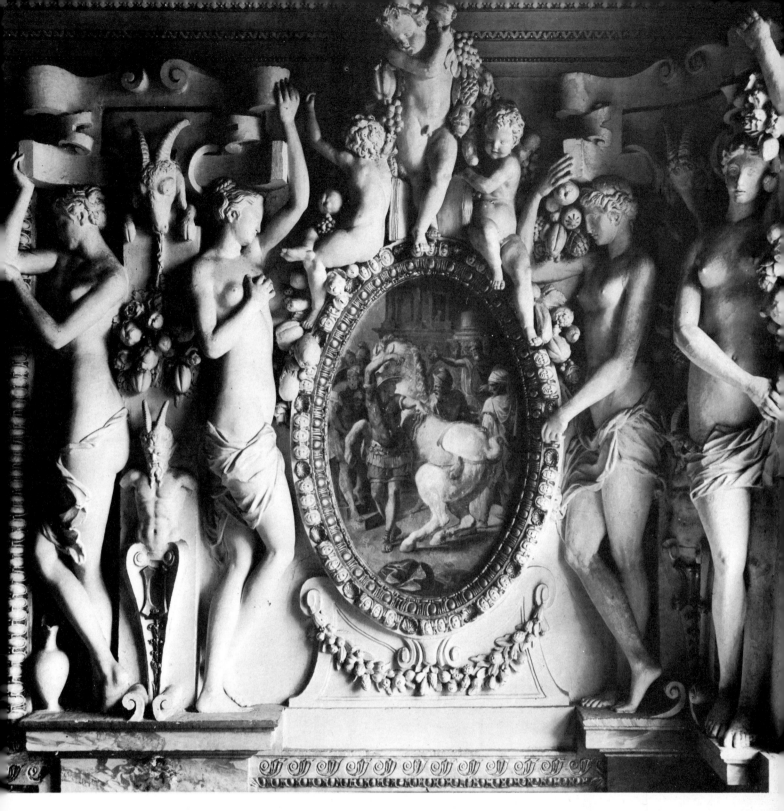

Primaticcio. Detail from the Chambre de la Duchesse d'Etampes, Fontainebleau. *c.* 1541–1545. Paint and stucco.

another centre where the taste for Italian work was developing. Philip II collected many paintings by Italian artists, as well as showing a predilection for the fantasies of Heironymus Bosch, and both he and the Emperor Charles V commissioned palaces to be built in the Italian style. For Charles V the Spanish architect Pedro Machuca built a Renaissance palace which was directly inspired by early 16th-century Roman architecture. A reaction against the exaggerated Spanish taste of the time, which was already shading into Baroque extravagance, it is one of the most Italianate buildings of its period outside Italy.

The Renaissance in Venice

Renaissance Italy, as we have already noted, was composed of a number of independent republics and city states, among which Venice was both the most stable politically and the most cosmopolitan. Long the gateway between eastern and western Europe, Venice was a city of prosperous merchants who could well afford to act as patrons of the arts, and were also open to new ideas and developments. As

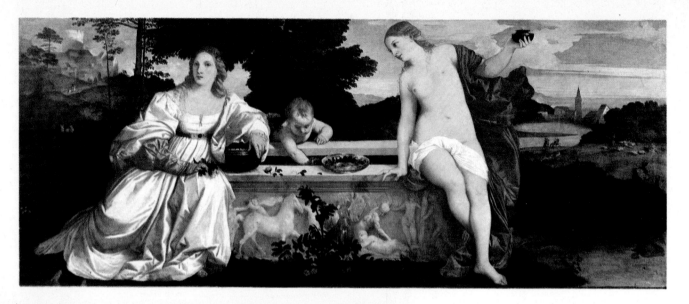

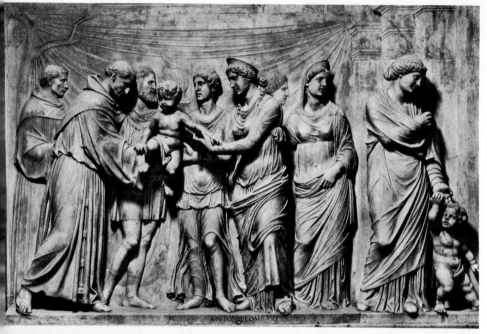

a result, Venetian art in the 15th and 16th centuries provides a microcosm of the Renaissance.

The initial change of spirit and style in Venice was largely brought about by one family of sculptors and masons, the Lombardi, who worked in the city during the latter part of the 15th and the early years of the 16th century. Antonio Lombardo's relief *A Miracle of St Anthony of Padua* contains many of the Classical features found in Florentine work of the same period, together with a dignity and restraint which are typical of Venetian Renaissance art.

The relief, that Classical art form par excellence, was much favoured by Renaissance artists and its use was not restricted to sculpture. A famous canvas by the most renowned of the Venetian Renaissance painters, Titian (d. 1576), makes a double use of the motif. In his *Sacred and Profane Love* the composition and shape of the picture are suggestive of a relief panel, and this is echoed by the depiction of a sculptured relief in the foreground of the painting. Titian's intense interest in the human form, which is revealed both in figure studies and portraits, is a clear artistic expression of the Renaissance humanist spirit.

In the mid-16th century, Venetian painting was revolutionised by the work of Jacopo Robusti, called Tintoretto. His painted decoration for the Scuola di S. Rocco has a vastness of conception and a sense of drama which take us back to the world of Michelangelo. The strong contrasts of light and shadow, of brilliant and sombre colour, were all part of a theatrical effect designed to draw the spectator into an emotional involvement with the subject matter. His painting of *The Ascension* also shows how, like Titian, Tintoretto had thoroughly mastered figure style, and used human figures as shapes to be arranged within a surface pattern in which depth

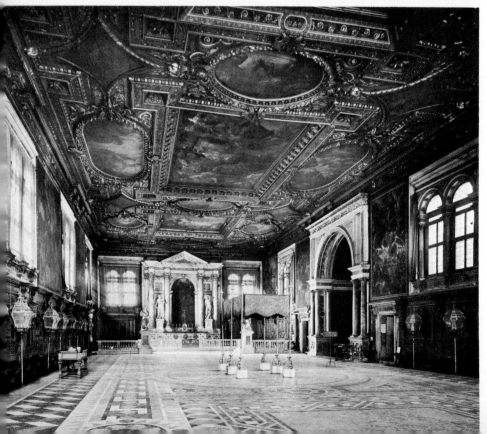

opposite top
Tiziano Vecelli (Titian).
Sacred and Profane Love.
c. 1515. Paint on canvas.
$46\frac{3}{4}$ × 111 in. (118 × 282
cm.). Borghese Gallery,
Rome.

opposite centre
Antonio Lombardo. *A
Miracle of St Anthony of
Padua.* 1505. Marble.
Detail of decoration of the
Capella del Santo, S.
Antonio, Padua.

opposite bottom
The Upper Hall, the
Scuola di S. Rocco,
Venice. The Scuola was
built between 1517 and *c.*
1545. The painted
decoration of the interior
is entirely by Tintoretto;
the Upper Hall was
decorated 1576 1581.

right
Tintoretto. *The Ascension.*
c. 1576 1581. Paint on
canvas. $211\frac{3}{4}$ × 128 in.
538 × 325 cm.). Scuola
di S. Rocco, Venice.

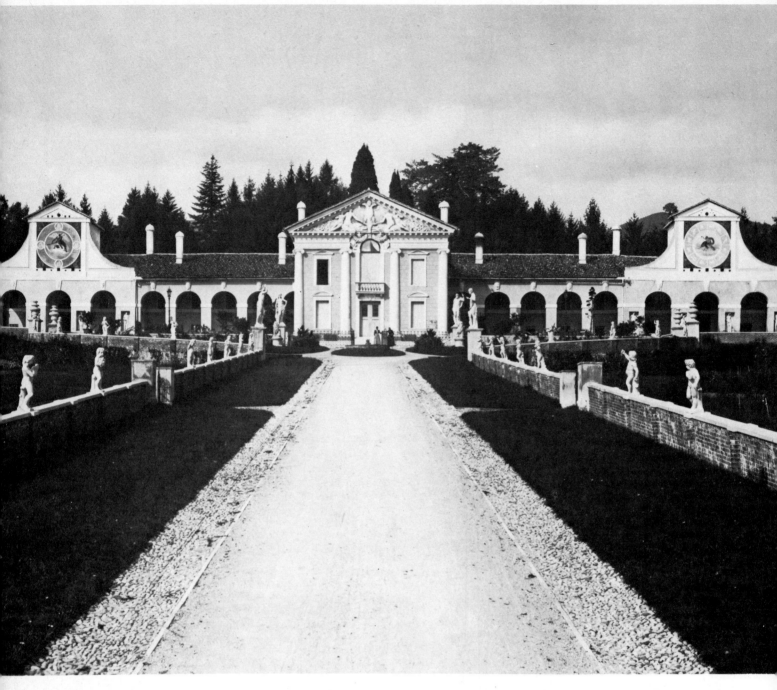

Andrea Palladio. Villa
Barbaro, Maser, near
Castelfranco. *c.*
1550–1560.

was only of secondary importance.

A sidelight of Renaissance culture which once again forms a link with the Classical world is the appearance of the villa as a country residence for the kind of wealthy citizens who could afford to act as patrons to the arts. The architect Andrea Palladio, who gave the Palladian style to later centuries, built a remarkable series of such villas in the Veneto region during the second half of the 16th century, and their Classical purity of design provided – and still provides – a fitting setting for many of the masterpieces of the Venetian Renaissance.

Like the golden age of Ancient Greece in the Classical world, the Renaissance appears in many ways as the peak of Western culture, a period of such brilliance in every different sphere that all that came

after it was likely to pale by comparison. It marked the end of mystery in Western culture, the beginning of rationalism, of technology, of democracy. In Renaissance art we find in embryo all the preoccupations which, from being merely facets of human experience, have become the obsessions of modern man – the increasing secularisation of art; the passion for commemoration; a taste for extreme realism, both in portraiture and in the new development of landscape painting; and the acceptance of art for its own sake, both as a creative exercise and as a medium for patronage and investment by wealthy citizens. In the Renaissance Western art for the first time becomes above all a form of play. And it is this preoccupation with play which gains increasing ascendency as we move into the age of Baroque.

The Age of Baroque

The term 'Baroque' was first used pejoratively to describe the indiscriminate mixing of different Classical styles which characterised the art of the 17th and early 18th centuries. Now purely descriptive, it refers to a period in which artists shared many of the basic attitudes of the Renaissance. Classical art – though significantly Roman rather than Greek – was still the major source of inspiration. But by contrast with the refinement and balance of Renaissance art, the tone of Baroque is more strident, more dramatic and emotional.

In Baroque art the human passion for decoration and variety began to predominate, and this was matched by an expansion of artistic frontiers. National schools grew up in France, Spain, Holland, England and Central Europe, each now more developed than they had been during the Italian-dominated Renaissance. At the same time the monolithic nature of Renaissance art gave way to an increasingly complex mixture of styles. A Classical movement centred on France sought to counter the extravagances of the Baroque style itself, while a third style, Realism, began with Caravaggio and was developed by painters such as Velasquez and Vermeer.

The Baroque Style

The ornamental richness of Baroque art has one aim – to impress the spectator, to draw from him an emotional involvement with a depicted incident or scene. The interior of the Gesù church in Rome by 157

Giacomo Vignola. The interior of the church of Il Gesù, Rome. Begun 1568. Frescoes by Gaulli, 1672–1683.

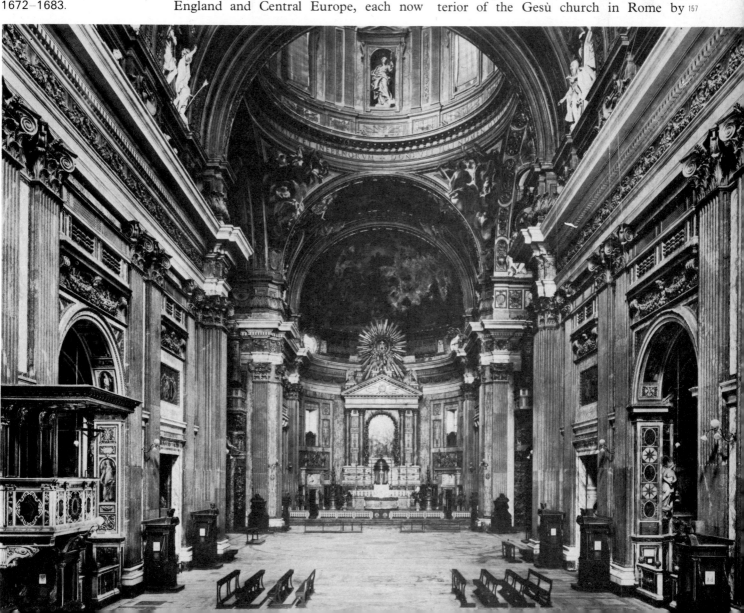

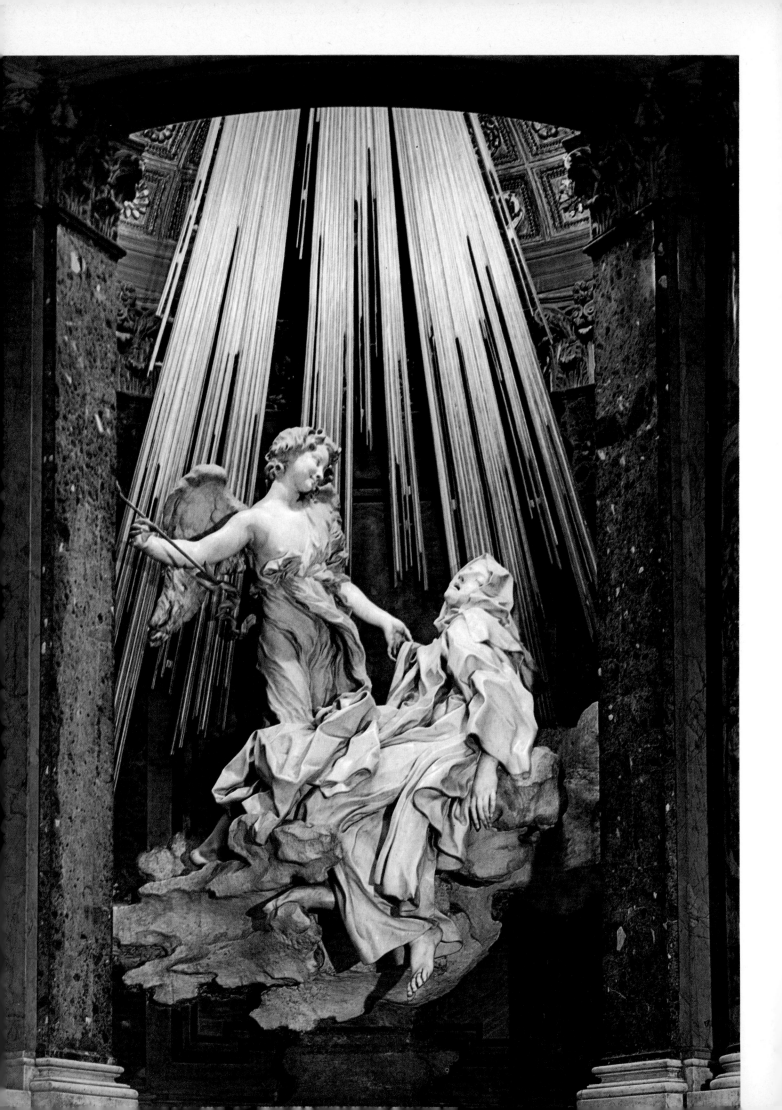

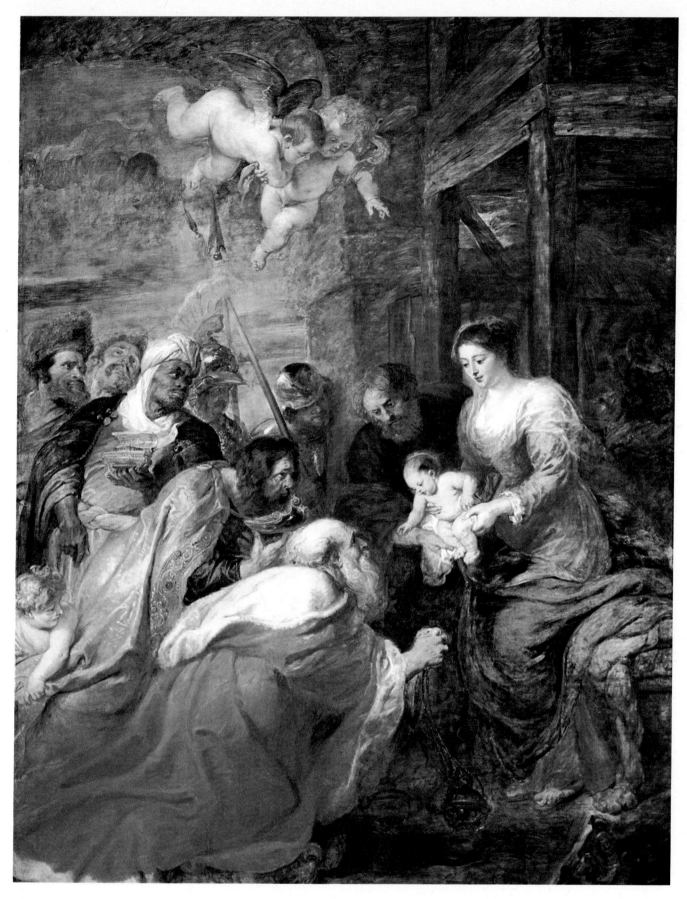

opposite
Gianlorenzo Bernini. *The
Ecstasy of St Teresa.*
1645–1652. Marble.
Life-size figures. Cornaro
Chapel, S. Maria della
Vittoria, Rome.

Peter Paul Rubens. *The
Adoration of the Kings.*
1634. Oil on canvas. $129\frac{1}{4}$
$\times 97\frac{1}{4}$ in. (328 \times 247 cm.).
Kings College Chapel,
Cambridge (Reproduced

by courtesy of the Provost
and Fellows).

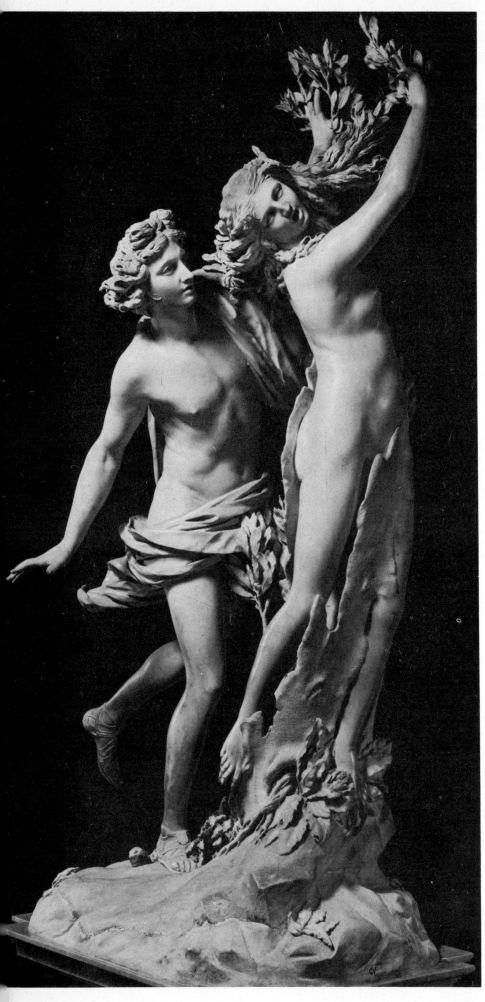

Giacomo Vignola typifies many aspects of Baroque theatricality – the heavy ornamentation overlaying a relatively simple, Classically inspired framework, the rich profusion of marble inlay, sculpture and painting, all contributing to an impression of splendour which, in spite of the religious setting, remains markedly secular in flavour.

The essence of Baroque is found in the work of the Italian sculptor Gianlorenzo Bernini (1598–1680). His *Ecstasy of St* 158 *Teresa* shows a characteristic combination of sculpture, architecture, and effects of lighting which are derived from painting. The aim is to produce a convincing visual parallel of St Teresa's account of her own mystical experience. For the spectator, however, it is no more than a theatrical representation of an event in which he does not participate. In fact if we look at Bernini's sculpture on the pagan theme of *Apollo and Daphne* we find that the effects 160 achieved are very much the same. We are again faced with a theatrical event, a frozen moment of time full of implied drama and movement.

Bernini's fusion of the different arts was a characteristic feature of Baroque, in which the different artistic media all tended towards a greater visual impact. Thus architecture became more plastic, sculpture more pictorial, and painting itself emphasised the effects of light and colour.

The great Baroque painter, Peter Paul Rubens (1577–1640), visited Italy at the beginning of the 17th century, and the works he produced on returning to his native Antwerp reflect this preoccupation with illumination. In his famour altarpiece, *The Adoration of the Kings*, the colours have a translucency and brilliance which are used to complement the dynamics of the composition in drawing the spectator's eye towards the central focus of the Holy Child. In an earlier work, *The Conversion of St* 161 *Paul*, the strong lighting effects accentuate the violent, swirling movement which is another characteristic of Baroque painting. The composition is based on a dynamic spiral, mounting up through the centre of the picture and balanced by powerful curves on either side. In works such as these Rubens established many of the basic concepts which were to appear shortly afterwards in the work of Bernini and Italian painters such as Pietro da Cortona. The ceiling which the latter painted in the 161 palace of Pope Urban VIII developed the dynamics of Baroque art to new heights of complexity. The painted architectural framework and the decorative details at the corners combine in a surging movement towards the figure of Divine Providence in the centre. Like many Italian works of the period it has an overblown grandeur which emphasises its role as a piece of propaganda for the power of the Roman

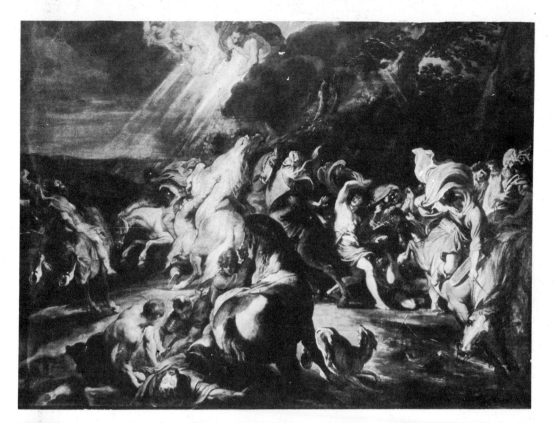

opposite
Jakob Prandtauer. The
Monastery of Melk, Lower
Austria. Begun 1702.

Jan Vermeer. *A Lady and
Gentleman at the
Virginals. c.* 1660. Oil on
canvas. $28\frac{1}{2} \times 24\frac{1}{2}$ in. (72
× 62 cm.). Royal
Collection (Reproduced
by gracious permission of
Her Majesty the Queen).

Salvator Rosa. *The Temptation of St Anthony.* Pinacoteca Rambaldi di Coldirodi, S. Remo.

Carlo Maderna. Sta Susanna, Rome 1597–1603.

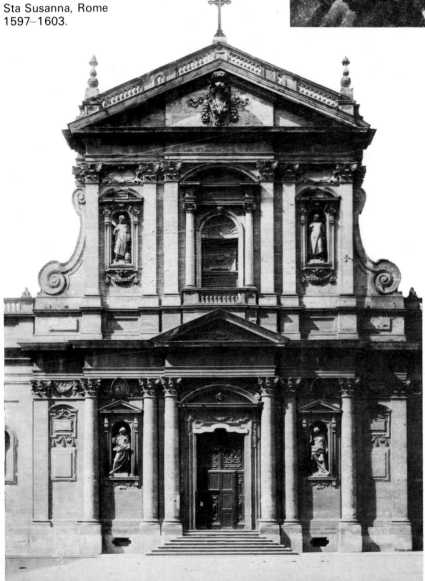

Church. The bees which appear in the centre of the wreath above the figure of Providence add a grotesque element to the ensemble which is another feature of Baroque. This was particularly evident in the work of Neapolitan painters such as Salvator Rosa, whose *Temptation of St Anthony* is a nightmare vision worthy of Heironymus Bosch. The strong effects of light and sweeping lines of the composition show clearly that Rosa had absorbed the same lessons as Rubens.

Baroque architecture was developed in Rome in the 17th century by architects such as Carlo Maderna, Guarino Guarini and Francesco Borromini. Early works such as the church of Sta Susanna by Carlo Maderna are relatively simple in concept, differing from Renaissance architecture mainly in the fusing of disparate Classical motifs. Here an arrangement of pilasters, half-columns and niches is used to fill the façade, while the upper and lower storeys are linked by volutes in an entirely non-Classical manner.

Borromini's church of S. Carlo alle Quattro Fontane shows how later Baroque architecture departed increasingly from Classical simplicity. Here the mixture of concave and convex curves on the façade and the 45-degree angle of the corner of the tower are matched by a correspondingly eccentric arrangement of the interior, which is based on a combination of equi-

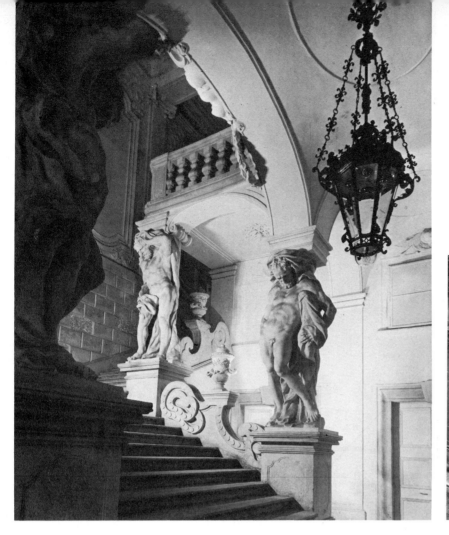

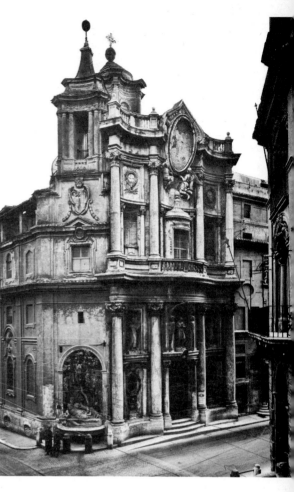

Johann Bernhard Fischer
von Erlach. Staircase of
the Prinz Eugen
Stadtpalais, Vienna.
1694–1698, 1708–1711.

above right
Francesco Borromini.
Façade of S. Carlo alle
Quattro Fontane, Rome.
1665–1682.

lateral triangles and circles. The large
medallion in the centre of the façade is a
typically theatrical feature.

The work of Borromini and his contem-
porary, Guarini, was the main inspiration
for the architects of south Germany and
Austria, where Baroque architecture
reached unprecedented heights of grandeur
in the late 17th and early 18th centuries.
162 The Monastery of Melk, built on a rock
overlooking the Danube, is the supreme
expression of Baroque theatricality. The
mass of the building as well as its detail
combine with the geographical location to
create an overwhelming scenic effect.
Baroque interiors showed an equal taste for
creating dramatic vistas, and the staircase
in particular gave architects a unique
opportunity to exercise their ingenuity in
the manipulation of interior space. With
its dramatic lighting, picking out the
heavily sculpted figures in their swirling
drapery, and the elaborate scrollwork of the
balustrade imposed on the rising spiral of
the stairs themselves, the staircase of the
165 Prinz Eugen Stadtpalais in Vienna repro-
duces many of the effects of Baroque paint-
ing.

In Spanish architecture Baroque rapidly
assumed the proportions of a national style,
which spread throughout the Spanish col-
onies in Latin America. The cathedral of
166 Santiago de Compostela – a Baroque exter-
ior imposed on a Romanesque original –

typifies the Spanish variant of Baroque in
which relatively simple forms were overlaid
with an ever-increasing proliferation of
architectural and sculptural decoration.

Classicism in the 17th Century

We need hardly be surprised that the
excesses of much of Baroque art called
forth a 'resistance movement' which sought
a return to Classical ideals and to the
balance and harmony of the previous age.
In France, the painter Nicolas Poussin
(1594–1665) drew his inspiration directly
from the Classical world and from the work
of Raphael, though his unfinished canvas
Bacchanalian Figures Nurturing a Child, 166
with its complex composition and dramatic
use of light, clearly shows that he had
absorbed some of the lessons of Baroque
painting as well. An innovation of 17th-
century Classicism was the ideal landscape,
which found its greatest interpreters in
Poussin and his contemporary Claude
Lorrain. The latter's *Landscape with the
Nymph Egeria* exemplifies the pictorial con-
ventions of the genre – an idealised Roman
landscape with Classical buildings or ruins,
and a group of figures from Classical myth-
ology in the foreground. At the same time
Claude's work has a subtle luminosity

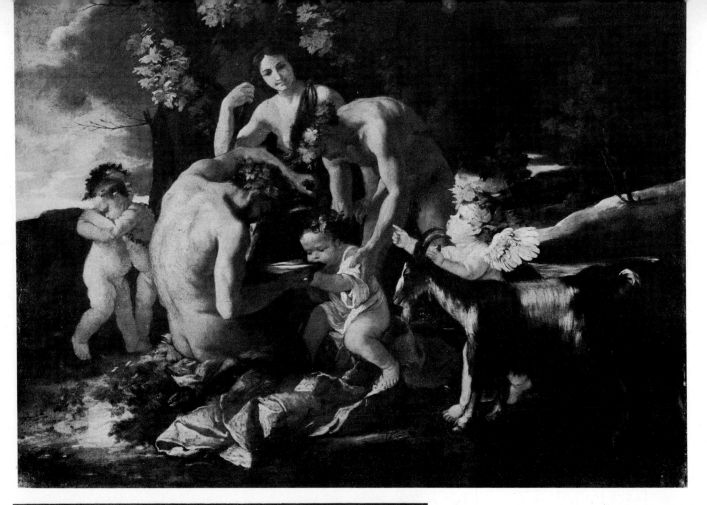

which is a refinement of the Baroque preoccupation with light and simultaneously looks forward to the achievements of Impressionism.

As these examples of French painting imply, the terms Baroque and Classical are used for convenience of classification and there was by no means a clear-cut distinction between the styles. Louis XIV's great palace at Versailles is strictly Classical in its architecture, but it breathes a lavishness and grandeur, a taste for display which is certainly Baroque in feeling. One of the several architects of Versailles, Jules-Hardouin Mansart, also built the church of the Invalides in Paris which now houses 168 the tomb of Napoleon. While the main body of the church has a Classical severity and simplicity, the dome is splendidly Baroque, with its rich applied decoration and needle-like spire surmounting a tall lantern at the top.

In Britain, where the influence of the Renaissance did not penetrate until the 17th century, the first Classical buildings were directly inspired by Italian Renaissance models rather than the second-generation style of 17th-century Europe. The earliest Classical building in England was the Queen's House at Greenwich, 169 begun by Inigo Jones in 1616. A modified replica of a Palladian villa, it established the style of English domestic architecture for the next two hundred years. Later in the same century, the demand for more imposing public buildings and churches led

Rembrandt van Rijn.
Bathsheba. 1654. Oil on
canvas. 56 × 56 in. (142
× 142 cm.). Louvre, Paris.

opposite top
Nicolas Poussin.
*Bacchanalian Figures
Nurturing a Child.* Oil on
canvas. 29½ × 38¼ in. (75
× 97 cm.). National
Gallery, London.

opposite bottom
José Peña and Fernando
de Casas. West front of
the cathedral of Santiago
de Compostela, Galicia,
Spain. 1667–1750.

to the introduction of a semi-Baroque
'Renaissance' style of which Sir Christo-
pher Wren's design for the new St Paul's
Cathedral is one of the finest examples.

Realism in Painting

The theatrical effects of Baroque were but
one manifestation of a general trend in
Western art – the desire for greater realism.
The effects of light in Baroque painting
aimed to present the spectator with an
approximation of reality which showed a
new understanding of the selectivity of the
human senses. But there was also a second
aspect: a striving for psychological realism.
Seventeenth-century painting shows a new
desire to impress on the spectator the emo-

tions being felt by the characters, to repre-
sent them as real people. One of the first
exponents of this new realism was the
Italian painter Caravaggio (1573–1610).
His painting *The Entombment* contains the
essential elements of the style – the drama-
tic poses of the figures, emphasised by the
lighting of their limbs, the use of non-
idealised contemporary faces for the bibli-
cal characters, all designed to give the scene
immediacy and psychological realism.
Caravaggio's influence was extensive, espe-
cially in Spain, where painters such as
Francisco de Zurburan and Diego
Velasquez (1599–1660) had inherited a
taste for realism from the Spanish tradition
of wooden religious sculpture. Velasquez's
The Surrender at Breda clearly shows the
influence of Caravaggio in the strong con-

167

Jules-Hardouin Mansart. The church of the Invalides, Paris. 1680–1691.

Claude Lorrain, *Landscape with the Nymph Egeria* (detail). 1669. Oil on canvas. 61 × 78½ in. (155 × 199 cm.). Galleria Nazionale di Capodimonte, Naples.

trasts of light and shade and the realism of the faces, some of which stare disconcertingly at the observer.

Dutch painting in the 17th century instituted a third type of realism – the presentation of scenes from everyday life. The Dutch countryside, the sea and its ships, people from every class at work or play in taverns, farms and domestic houses, appear in the work of painters such as Pieter de Hooch, Adriaen Brouwer and Willem van de Velde the Younger. The master of Dutch realism, however, was undoubtedly Jan Vermeer (1632–1675), who achieved a classical serenity in his depiction of Dutch domestic interiors. His *A Lady and Gentleman at the Virginals* exemplifies his approach – the careful posing of objects and people, the muted rendering of daylight, the taste for arrangements of geometric patterns. Here the figures have no more impact than the objects – the realism is one of light and atmosphere rather than psychology or emotion.

In the work of the greatest 17th-century Dutch painter, Rembrandt van Rijn (1606–1669), we find all the artistic strains

Inigo Jones. The Queen's
House, Greenwich.
1616–1618. 1630–1635.
Originally two rectangular
blocks joined by a bridge
which spanned a public
road running through
Greenwich Park. The sides
were filled in by Jones'
pupil, John Webb, in the
early 1660s. The
colonnades on either side
were added in the 19th
century, following the line
of the former road.

Christopher Wren. St
Paul's Cathedral, London.
1675–1711.

Diego Velasquez. *The Surrender at Breda.* 1634 1635. Prado, Madrid.

far right
Michelangelo da Caravaggio. *The Entombment.* 1602–1604. Pinacoteica Vaticana.

of the age of Baroque combined with a sense of balance and a humanity which place him on a level with the great figures of the Renaissance. His *Bathsheba* unites all the major components of his style in one of the most moving and realistic treatments of sex in Western art. It has a Baroque luminosity comparable to that of Rubens, and the pose is derived from an engraving of a Classical relief. But chiefly it is realistic, in the sheer domesticity of the scene, in the texture and tone of the body, and above all in its suggestion of Bathsheba's conflicting emotions as she reflects on the contents of King David's letter.

The proliferation of styles in the age of Baroque may be seen as the beginning of a process of fragmentation in Western culture. While there had always been regional differences in artistic styles, the Church during the medieval period and the ideals of Classical humanism during the Renaissance imposed a certain coherence on Western art which began to dissolve in the 17th century. To a far greater extent than before, different artists in different countries began to experiment with different facets of artistic creation. It was in a sense the beginning of the specialisation which was to become one of the dominant characteristics of the modern world.

The Age of Reason

If the 17th century was an age of proliferating styles, the 18th century was a period in which style itself became the most important facet of artistic creation. It was a fitting development in a world where rationalism had become the ideal and men sought to raise the business of human intercourse to the level of an art. While Baroque art and architecture did not die out immediately, the style which most faithfully reflected the spirit of the age was Rococo.

Nowhere is man's passion for decoration better expressed than in Rococo. It is an art in which the manner takes precedence over the content. Stylishness is its major requirement and since stylishness is a human rather than a monumental quality, Rococo relates above all to the minor arts – architectural and interior decoration, ceramics, furniture – and to a lesser extent to painting and sculpture.

Rococo began in France, and it was essentially the art of the *ancien régime*. Inevitably, as the mood of Europe changed in the second half of the century there was less and less tolerance of its fundamental frivolity. Instead, it was once again an art inspired by Classical antiquity which took

Cabinet de la Pendule, Versailles. 1738.

the centre of the stage. Unlike that of the previous century, this new, Neo-classical movement eventually bypassed Baroque and Renaissance models and returned directly to the Classical roots of Ancient Greece and Rome. In so doing, it established the basis of a style which in architecture at least was to last well into modern times.

Rococo Art and Decoration

Rococo began specifically as a style of decoration instituted around 1700 as an antidote to the stiff formality of the state apartments at Versailles. One of its first exponents was Claude Audran, whose designs for the decoration of the Château de la Ménagerie near the royal palace first made use of the fresh, almost calligraphic motifs based on traditional arabesques which are the hallmark of Rococo design. A tapestry design by Audran, contains the essential ingredients – vine- and acanthus-leaf scrolls, garlands of flowers, birds and cherubic figures, a stylised rustic bower – all adding up to an impression of cornucopian richness combined with delicacy and charm.

The new style of decoration was welcomed at the French court. Louis XIV

opposite top
Jean-Honoré Fragonard.
La Gimblette. Cailleux
Collection, Paris.

opposite bottom
Claude Audran III. Portière
showing Juno. *c.* 1699.
One of a set of eight
portière panels of *The
Triumph of the Gods*,
designed by Audran.
Gobelins series in high
warp with gold ground
and border.

right
Egid Quirin Asam. *The
Assumption of the Virgin*
(detail). 1718—1722.
Painted stucco. Life-size
figures. Monastery church,
Rohr, Bavaria.

Antoine Watteau.
*L'Embarquement pour l'Ile
de Cythère.* 50¾ × 76¾ in.
(130 × 192 cm.).
Staatliche Museen, Berlin.

enthused over its delicate charm, and in the 1730s Louis XV ordered its use for the 'Petits appartements' which he created in the north wing of Versailles. The Cabinet de la Pendule forms part of that suite. The gilt arabesques around the cornice, the repeated wall panels with decorative motifs at top and bottom and medallions in the centre, the large mirrors with curved tops and the painting over the door, are all typical of French Rococo decoration.

From its original, specific meaning, the term Rococo was extended to describe an artistic approach which was in many ways a refinement of Baroque, both in its use of applied decoration and in its portrayal of the human figure. In late German Baroque figures the pose does carry an echo of the dramatic vigour of Bernini and his contemporaries, but the tone of the composition has changed. Now it is almost one of nonchalance; the swirling draperies, no longer suggestive of violent movement, have an airy lightness which looks forward to Rococo painting.

By its very nature, Rococo produced few individual artists of genius, but Antoine Watteau (1684–1721) was one of them. Watteau created French Rococo painting practically single-handed, adopting the idiom of the *fête galante* or courtly idyll from the Baroque paintings of Rubens and interpreting it with a lyrical grace which he inherited from his master, the arabesque painter Claude Audran. His *L'Embarquement pour l'Ile de Cythère* is possibly the masterpiece of Rococo painting. Its delicate treatment of natural forms, the feathery foliage of the trees, the cherubs strewn like a garland across the sky, echo the patterns of gilt ornament in Rococo interior decoration, while the human figures are posed in groups which simultaneously suggest the stylised gestures of 18th-century manners and hint at a deeper psychological reality, at the subtle interplay of human emotions and desires.

In the work of Watteau's immediate successors there is little psychology, and all is airy lightness and charm. François Boucher painted the panel *Cupid a Captive* as a decoration for the boudoir of his friend and protectress, Madame de Pompadour. With its lightweight rendering of a Classical subject, its titillating, doll-like female figures, it has a prettiness which makes it indeed a piece of boudoir art. The playful eroticism of Boucher is also found

François Boucher. *Cupid a Captive.* 1754. Oil on canvas. $64\frac{1}{2} \times 32\frac{5}{8}$ in. (164 × 83 cm.). Wallace Collection, London (Reproduced by permission of the Trustees).

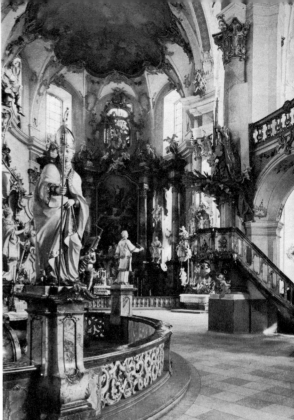

François Cuvilliés. The Amalienburg, Schloss Nymphenburg, Munich. 1734–1739

above right
Balthasar Neumann. Interior of the church of Vierzehnheiligen, northern Bavaria. 1743–1772.

Sir John Vanbrugh. The front of the court of Castle Howard. Plate by Colin Campbell from *Vitruvius Britannicus*, Vol. I, London, 1717. British Museum, London.

in the work of Jean-Honoré Fragonard, who continued the style of Rococo painting up to the French Revolution. Even airier than that of his predecessors, Fragonard's work continues the tradition of the *fête galante* begun by Watteau, and includes such intimate pieces as *La Gimblette*, which is both essentially French and essentially Rococo in flavour.

Perhaps the most direct successor of Watteau was the English artist, Thomas Gainsborough (1727–1788). A landscape painter by preference, Gainsborough was forced to paint portraits to earn his living. His canvas *The Morning Walk* manages to combine the two with a delicate grace which undoubtedly echoes Watteau, and

simultaneously reflects the late 18th century cult of 'sensibility' which was a foretaste of Romanticism. The unprecedented growth of portraiture during the 18th century was a significant indication of the increasing individualism of Western culture, soon to reach extreme heights in Romantic literature.

Rococo in Germany and Italy

In 18th-century Germany the transition from Baroque to Rococo is more evident than in France, particularly since there was still a demand for lavishly decorated, prestige buildings in the style of the age of Baroque. As a result, particularly in Bavaria and Austria, we find churches and palaces being built up to the middle of the century which are essentially a mixture of the two styles. In the church of Vierzehnheiligen in northern Bavaria the manipulation of space and light in the interior, the dramatic

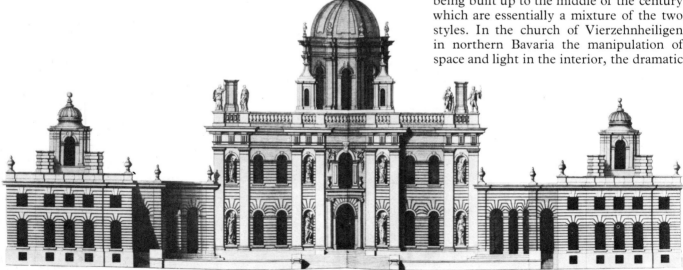

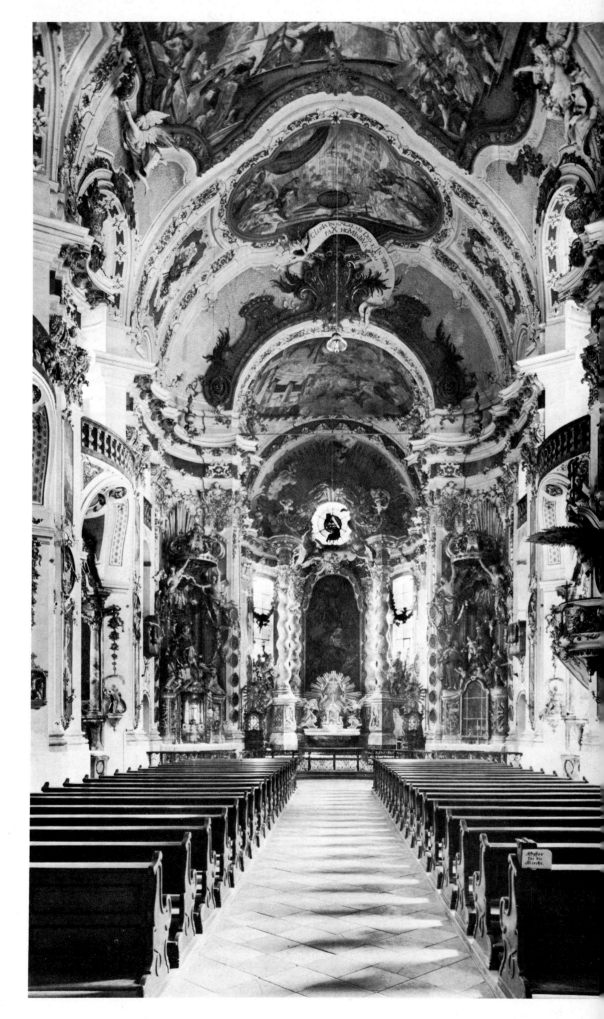

Johann Michael Fischer.
Abbey church of
Osterhoven, Austria.
1726–1740. Decorated by
the Asam brothers.

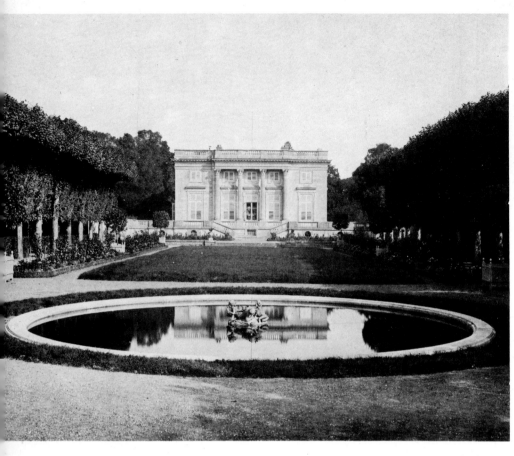

Ange-Jacques Gabriel.
The Petit Trianon,
Versailles. 1762–1768.

centre
Thomas Gainsborough.
The Morning Walk. Oil on
canvas. 93 × 70 in. (236
× 178 cm.). National
Gallery, London.

opposite right
J. N. Servandoni, Façade
of St Sulpice, Paris. Begun
1733.

setting of the great altar piece and the sur-
rounding statuary are essentially Baroque,
but there is a definite Rococo element in
the gilt medallions and garlands decorating
the vaulting and the columns. This is even
177 more apparent in the Abbey Church at
Osterhoven in Austria, where the overall
impression is even more intensely Baroque,
but the profusion of sculptured decoration,
the garlands and scroll-work surrounding
the painted panels of the ceiling bear a dis-
tinct resemblance to Audran's French
Rococo designs.

Elsewhere, the French influence was felt
more directly. In the work of the dwarf
François de Cuvilliés, who was sent to
study in Paris by the Elector of Bavaria,
Max Emmanuel, French Rococo is deve-
loped to new heights of sophistication. His
design for the hunting lodge of Schloss
176 Nymphenburg at Munich is generally
accepted as one of the supreme master-
pieces of Rococo architecture and deco-
ration. The elegance and simplicity of the
interior conceal a lavishly decorated Hall
of Mirrors, forty feet in diameter, in which
gilt Rococo motifs are reflected in a multip-
licity of glittering images.

The growth of Rococo in Italy was
largely hampered by the conservative influ-
ence of the Roman Church and the sheer
weight of the Classical, Renaissance and
Baroque traditions. Only in Venetian paint-

ing do we find a development comparable to that which was taking place elsewhere in Europe, and significantly the work of its major exponent, Giambattista Tiepolo (1696–1770), was heavily influenced by Venice's own Renaissance past. A number of Tiepolo's major works were produced in Germany, whence he was summoned at the height of his career to provide painted decorations for the royal residence at Würzburg. Most remarkable among these is the ceiling which he painted for the 182 Kaisersaal or dining room. Although the figure style owes much to Italian Renaissance painting and the illusionistic effects are derived from Baroque, the delicate colours, the flying *putti*, the nymphs and satyrs sprawling nonchalantly around the edge, contribute to an overall impression of airy lightness which is essentially Rococo in spirit.

Neo-classicism

Already in the 17th century, the excesses of Baroque had been countered by a Classical revival. But Baroque had persisted, and by the middle of the 18th century symbolised together with Rococo a world view which was increasingly inappropriate in an age of impending revolution. Eighteenth-century architects in particular came to

John Michael Rysbrack. Study for the monument to Sir Isaac Newton in Westminster Abbey. *c.* 1731. Terracotta. h. 8 in. (20.3 cm.). Victoria and Albert Museum, London.

opposite
Jacques Soufflot. The interior of the Panthéon, Paris. Designed 1755–1756. Originally built as the church of Ste Geneviève, the Panthéon was secularised during the Revolution and made into a mausoleum for France's national heroes.

Josiah Wedgwood. Vase with the Apotheosis of Homer. *c.* 1789. Blue and white jasper ware. h. 13 in. (33 cm.). Nottingham City Art Gallery.

regard the imitation of Classical models as the only rational form of architecture. At first this tendency was revealed in a return to the purer Classical forms of Renaissance Italy. In his work *Vitruvius Britannicus* (1717), the Scottish architect Colin Campbell extolled the virtues of the 176 Palladian style adopted by Inigo Jones as against the relative Baroque extravagance of Sir Christopher Wren, Sir John Vanbrugh and Nicholas Hawksmoor. The 3rd Earl of Burlington travelled to Italy to study Palladio's work on the spot, and the house which he built for himself at 186 Chiswick is based on a type of villa which Palladio created in northern Italy – compact and restrained, with a Classically correct portico on the main front and rooms arranged around a central octagon.

In France, too, there was a movement towards Classical purity in architecture. One of the architects of Versailles, Ange-Jacques Gabriel, drew his inspiration mainly from the Renaissance and 17th-century French Classicism, but his design for the Petit Trianon, built as a retreat for 178 Louis XV's mistresses, has a Classical correctness combined with a simplicity and a sense of intimacy which make it the counterpart of English Palladianism.

Other architects of the period were striving more earnestly towards a Classical authenticity in their designs. The church of St Sulpice in Paris, begun in 1733, 179 reflects a general attempt to bring back a note of nobility and grandeur to French architecture. The effect here is one of Roman monumentality, an overall heaviness which is only emphasised by the cylindrical additions to the towers.

In the other arts, the Classical bias was as yet less clear-cut, but in England the portrait tombs and busts of the Flemish-

Giambattista Tiepolo.
*Apollo Conducting
Beatrice of Burgundy to
Frederick Barbarossa.*
1751–1752. Fresco.
Ceiling of the Kaisersaal,
Residenz, Würzburg.

Jacques-Louis David. *The Lictors Bringing back to Brutus the Bodies of his Sons*. 1789. Oil on canvas. 128 × 164 in. (325 × 423 cm.). Louvre, Paris.

right
Etienne Falconet. *Baigneuse. c.* 1760–1780. Marble. h. 15 in. (38 cm.). National Trust, Waddesdon Manor, Bucks.

opposite top
Anton Raphael Mengs. *Parnassus with Apollo and the Muses*. 1761. Fresco. Villa Albani, Rome.

opposite bottom
Robert Adam. The Sculpture Gallery, Newby Hall, Yorks. *c.* 1767–1780. The gallery consists of three rooms built and decorated by Robert Adam to display the sculpture belonging to the owner of the house, William Weddell.

born sculptor Michael Rysbrack showed the influence of Classically-orientated French sculptors of the 17th century. His study for the monument to Sir Isaac Newton in Westminster Abbey reveals the heritage of Baroque sculpture in the vigorous modelling of the drapery and the figure, but the composition is Classical in spirit, and the noble head and grave expression suggest the portrait busts of ancient Rome.

In the first half of the 18th century Classicism was no more than a counterweight to the Baroque-Rococo strain. Around 1750, however, the pendulum began to swing heavily in its favour as a spate of publications in France, Italy and England marked an intense scholarly interest in the ancient world which was the true beginning of Neo-classicism. From all over Europe, artists flocked to Rome to study the remnants of antiquity on the spot and carry back their inspiration to their native countries. Among these was the French architect, Jacques Soufflot, who designed the Panthéon in Paris, generally considered the first truly Neo-classical building. Planned as a Greek cross surmounted by a dome, its galleries supported by slender Corinthian columns, the building has an

austere grandeur which strikingly conveys the dramatic impact which the Roman experience had upon Soufflot and his contemporaries.

But it was not only the art and architecture of Rome which inspired the new movement. An opposing faction upheld the validity of Greek architecture as the only true Classical source, while others discovered the more exotic attractions of Egypt, and the Etruscan civilization which was mistakenly thought to be the ancestor of both Greece and Rome. Some Greek vases excavated in southern Italy and Sicily and assumed to be Etruscan, provided a source of inspiration for Josiah Wedgwood, who used their motifs in the now famous blue and white jasper ware which he began 180 manufacturing in Staffordshire in the early 1760s. The same motifs were adopted by the British architect Robert Adam in his

185

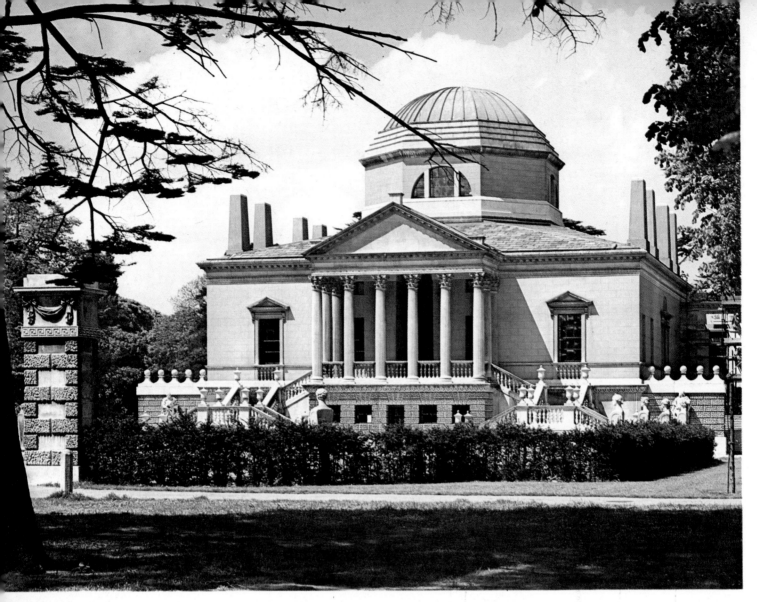

Lord Burlington. Chiswick House, London. *c.* 1725.

interior decorations, where they were combined with other Greek and Roman elements in a highly original composite style. 185 The sculpture gallery at Newby Hall in Yorkshire exemplifies this 'Etruscan' mode of decoration, and also highlights the vogue for collecting Classical antiques which was a feature of the Neo-classical period.

In fact, as these developments indicate, there was considerable confusion as to the true nature of the different Classical styles, and the term 'Greek' came to be used loosely to describe anything with an antique flavour. Such was the case with the work of Etienne Falconet, the director of sculpture at the Sèvres porcelain manufac-184 tory, whose statues and figurines combined Rococo eroticism with a Classical simplicity of form.

In Neo-classical painting in particular, fidelity to Classical models became less important than an overall smoothness and clarity of line – the 'noble simplicity and calm grandeur' which the German scholar Winckelmann claimed to be the essence of Greek art. The work of Anton Raphael 185 Mengs represents an early interpretation of this ideal, though it is not purely Neo-classical, being inspired by the works of

Poussin and Raphael as well as by Classical originals. By the time of the French Revolution the Neo-classical style had become more assured, finding its supreme expression in the works of Jacques-Louis David (1748–1825). Scenes of Classical heroism, executed with masterly assurance, provided a dramatic interpretation of contemporary events. In David's *The Lictors* 184 *bringing back to Brutus the Bodies of his Sons*, Brutus, putting the public good above personal feelings, turns his back on the bodies of his sons, who have been executed for treason on his own orders. It is a revealing picture, demonstrating how Classical 'rationality' formed an increasingly thin veneer over the essentially emotional tenor of the times.

If Rococo represented in artistic terms the last fling of the *ancien régime*, Neo-classicism was a fairly apt reflection of the uncertainty which was bound to follow. The 18th-century vogue for rationality, of which Neo-classicism was theoretically the final expression, was in fact a demonstration of Western man's increasing instability. The pendulum was beginning to swing from one extreme to another, into the Romantic era.

The 19th Century

The 19th century marks a turning point in Western culture. The humanistic phase which had begun with the Renaissance came to an end, the dehumanising influence of science and technology began to take effect. The great traditions of Western art made their last fleeting appearance before being finally abandoned.

To begin with, the major themes of Classical and Baroque were combined in the products of Romanticism, but the sense of continuity which marked previous ages had been substantially lost. Just as religious or social orthodoxy gave way to political extremism, so stylistic conformity gave way to individualism and experiment. The repertory of styles from other ages and other cultures was vastly increased by the growth of antiquarian scholarship, and architects in particular tried out one after another.

By the middle of the century, the radical changes affecting the whole of Western culture were beginning to make themselves felt in the arts. The need for commemorative art was diminished by the growth of photography, and the value of decorative art was diminished by the replication of ornamental motifs by industrial methods. Some artists welcomed these changes, others sought refuge from them in revivalism and nostalgia. The multiplicity of artistic movements in the latter half of the century – Impressionism, the Gothic Revival,

Eugène Delacroix. *The Death of Sardanapalus.* 1827. Oil on canvas. 145 × 195 in. (395 × 495 cm.). Louvre, Paris.

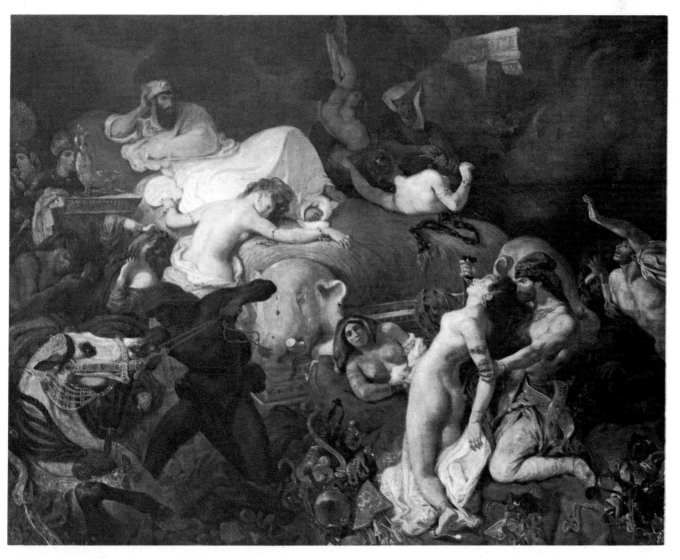

William Morris's Arts and Crafts Movement, Art Nouveau and the beginnings of modern architecture – reflects the range of emotions, from exhilaration to revulsion, with which artists faced the challenge of the modern world.

The Romantic Era

Whereas the reasoned individualism of the 18th century had derived from a serious interest in the workings of the human mind, the emotional individualism of the Romantic era was essentially a belief in the validity of personal inspiration. It is therefore not surprising that the major works of the period were the products of individual, often idiosyncratic minds. In French painting, the supreme Romantic artist was Eugène Delacroix (1798–1863), who inherited both the Classical tradition handed down through Poussin, David and his pupil Ingres, and the Baroque tradition derived from Rubens. His famous canvas *The Death of Sardanapalus* displays typically [187] Romantic qualities – the interest in exotic cultures, the Baroque orchestration of colour and movement, the barbaric sensuality of the subject. At the same time the picture has a Classical stillness which seems to emanate from the figure of the king as he reclines on his funeral pyre, watching with indifference the destruction of all his worldly possessions.

A solitary genius, one of the great individual artists of all time, was the Spaniard Francisco de Goya y Lucientes (1746–1828), whose famous series of etchings *Los Caprichos* displayed a Romantic awareness of man's subconscious obsessions and anxieties. Goya's large canvas *The Execu-* [190] *tion of the Rebels on 3 May, 1808* typifies his intensely personal vision of the human condition and contemporary political events in Spain. Combining elements of Baroque painting with the psychological realism of Velasquez, it is chiefly remarkable for its muted use of colour and simple, almost abstract depiction of the human

189

Francisco de Goya y
Lucientes. *The Execution
of the Rebels on 3rd May
1808*. 1814. Oil on
canvas. $104\frac{1}{2} \times 135\frac{1}{2}$ in.
(266 × 345 cm.). Prado,
Madrid.

John Nash. Royal
Pavilion, Brighton. Rebuilt
and elaborated 1815.

Joseph Mallord William
Turner.
*Snowstorm—Steamboat
off a Harbour's Mouth.*
1841–1842. Oil on
canvas. 36 × 48 in. (91·5
× 122 cm.). Tate Gallery,
London (Reproduced by
courtesy of the Trustees).

form, which simultaneously echoes the primitive Renaissance art of Giotto and looks forward to the achievements of 20th-century painting.

The eccentric genius of British painting in the Romantic era, William Blake (1757–1827), upheld the values of passion and imagination against reason and authority. His visionary works, many of which he claimed to produce under supernatural influence, were remarkable in an age when spirituality was generally lacking in Western art. An engraver and book illustrator, Blake used line as his chief means of expression, and many of his pictures incorporate his visionary ideas in a literary form.

188

The 19th century witnessed a dramatic growth in landscape painting which was a not unexpected reaction to the invasion of the countryside by Blake's 'dark satanic mills'. In Britain John Constable celebrated the charm of his native Suffolk with impressionistic vigour. But it was J. M. W. Turner (1775–1851) who provided the link between the ideal landscapes of Claude

Lorrain and the luminous world of the French Impressionists. In his later work Turner became almost obsessed with the use of light as a means of conveying the raw energy of nature. At an advanced age he had himself lashed to the mast of a boat in a storm and afterwards painted *Snowstorm – Steamboat off a Harbour's Mouth.* 191 The effect is totally luminous, nearly abstract. The swirling vortices of sea and sky meet in a completely convincing expression of the sensations which the artist must have felt at the time.

By comparison with the achievements of Romantic painting, the sculpture of the first half of the 19th century has little to offer. The Neo-classical tradition still weighed heavily, reinforced by a wealth of archaeological discoveries. The English sculptor John Flaxman produced a series of line illustrations to Homer, Dante and 189 other authors which did much to establish a Classical purity of line in sculpture throughout Europe. One of the few expressions of the Baroque-Romantic strain is

Karl Friedrich von Schinkel. Altes Museum. Berlin. 1823–1825.

found in the work of Antoine-Louis Barye, whose vigorous animal sculptures were studied from life in the Paris Jardin des Plantes. [189]

Architecture in the 19th century was above all marked by a proliferation of styles, indicating the fragmentation of Western cultural traditions. Style became increasingly an ornamental rather than a functional consideration, to be chosen according to individual whim rather than accepted canons of taste. Individual styles became crudely associated with particular concepts – Gothic for spirituality, Greek for democracy, Renaissance for commercial achievement. The Altes Museum in Berlin [192] and the Royal Pavilion, Brighton, combine [190] a predominantly visual appeal with this kind of symbolism. Karl Friedrich von Schinkel's building in Berlin is a masterpiece of Neo-classical design, a symbolic shrine to an ancient culture, remarkable chiefly for its visual impact. The Royal Pavilion at Brighton, rebuilt by John Nash in 1815, is a fundamentally Classical building clothed in domes and minarets on the outside, and chinoiserie decoration in the interior – a fitting combination to suggest the exotic diversions of a Prince Regent's pleasure palace while hinting at the more solid values of colonial empire.

The Beginnings of the Modern World

In the latter half of the 19th century, Western art was beginning to be overtaken by the passion for change and experiment which we recognise as one of the characteristic features of the modern world. Gradually, the very bases of artistic creation, the assumptions on which the whole of Western art had been based, were to be subjected to dissection and analysis, and in many cases rejected. Among the first

opposite centre
Edgar Degas. *The
Madame's Name-Day*
(detail). 1879.
Monotype. 4¾ × 6¼ in.
(12 × 16 cm.). Private
collection, Paris (Ex
Collection of Librairie
Augustus Blaizot, Paris).

opposite bottom
Vincent van Gogh.
Garden. July 1888. Pen
and ink on paper. 19½ ×
24 in. (49·5 × 61 cm.).
Dr Oskar Reinhart
Collection, Winterthur,
Switzerland.

right
Paul Gauguin. *Three
Tahitians* (detail). 1899
(?). 28 × 36¾ in. (71·5
× 93 cm.). National
Gallery of Scotland,
Edinburgh.

experimenters were the French Impressionists, who used the knowledge that the human eye is always selective in what it sees to revolutionise painting. The movement began with Edouard Manet 194 (1832–1883), whose masterpiece *Olympia* was greeted with howls of execration when shown at the Paris Salon of 1865. It is uncompromising, almost harsh, an age-old subject given a revolutionary treatment in which only that which the eye would actually register when presented with the scene is given clarity and detail. Attention is focused on the model's face, with its direct, challenging stare, and on the heavily shaded left hand. The rest, flesh-tones and drapery, is merely hinted at with delicate touches of shadow, while the background is a dim suggestion of curtains and a room beyond.

One of the major reasons for the unfavourable reception of Manet's work must lie in its lack of emotion, and the same can be said for that of his followers. These were the true Impressionists, painters such as Claude Monet and Auguste Renoir, who developed the technique which Manet had initiated, using their brushstrokes to convey the fall of light upon their subject rather than its actual form. Despite the warm eroticism of some of Renoir's work, Impressionism was a cold art, imbued with the passion of the scientist rather than the poet. Edgar Degas added to the optical 192 realism of the Impressionists an unflatteringly realistic view of the human form, allied to a masterly rendering of pose and movement.

The Impressionists broke the major traditions of European painting, and after them nothing could ever be quite the same again. Their immediate successors all showed their influence in one way or another. Vincent van Gogh (1853–1890) pursued the Impressionist themes of light and colour with almost mystical fervour.

193

Edouard Manet. *Olympia*.
1863. Oil on canvas. $51\frac{1}{4}$
$\times 74\frac{3}{4}$ in. (130 \times 190 cm.).
Musée de
l'Impressionnisme, Paris.

Auguste Rodin. *St John
the Baptist Preaching*.
1878. Bronze. 79 $\times 21\frac{3}{4}$
$\times 38\frac{3}{4}$ in. (200 \times 55 \times
98 cm.). Musée Rodin,
Paris.

For Van Gogh the sheer optical value of
paint was insufficient to convey his impres-
sions, and the surging violence of the
brush-strokes in his later paintings testifies
to the intensity of the recorded experience.
Such was Van Gogh's mastery of technique
that there is a strong sense of light even
in his pen and ink drawings. One of the 192
great innovators of the late 19th century,
Paul Cézanne (1839–1906) extended the 195
pictorial vocabulary of the Impressionists,
becoming preoccupied with the formal as
well as the pictorial construction of reality.
His increasing tendency to break up his
still-life and landscape subjects into a series
of flat planes manipulated according to the
structural requirements of the picture pro-
vides a link between 19th-century painting
and Cubism. The work of Paul Gauguin 193
initiates another important element of
modern painting, combining a flat linear
style with an overt primitivism partly de-
rived from the simple art of the Breton
peasants and expressed in the exotic can-
vases which he produced after turning his
back on European civilisation and going
to live among the primitive peoples of
Tahiti.

In the sculpture of the late 19th century,
change is less evident than in painting.
Edgar Degas used sculpted clay figures as

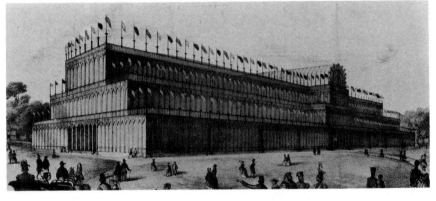

top
Paul Cézanne. *Bathers (La Grande Baignade)*. 1898–1905. Oil on canvas. 82 × 98¼ in. (208 × 249·5 cm.). Museum of Art, Philadelphia (Wistach Collection).

Sir Joseph Paxton. Crystal Palace, London. 1850–1851.

a means of capturing the fleeting poses of the human body which held such a fascination for him, while the Italian Medardo Rosso sculpted small figures marked by an indistinctness, a sketch-like rendering of form which approximated to the technique of Impressionist painting. But the scene was dominated by a figure who owed much to tradition. Auguste Rodin (1840–1917) took his inspiration from Gothic sculpture and the work of Michelangelo, using the latter's technique of swift line and wash sketches as a basis for his sculptures. Like Degas he was fascinated by the articulation of the human form, but his work has a powerful emotional content which looks forward to Expressionism.

The vogue for historicism in architecture was carried well into modern times – indeed it is not entirely dead today – but the development of new buildings in the second half of the 19th century brought about a rapprochement between engineering and architecture which was to change the face of the modern world. One of the first examples of this technological architecture was the Crystal Palace in London, designed by the Duke of Devonshire's head gardener, Joseph Paxton, on the basis of mass-produced glass and cast iron elements similar to those which he had already used for the construction of greenhouses.

The use of cast iron, followed shortly by steel, in building opened up new possibilities of spanning large areas with the minimum of support. The Reading Room of the Bibliothèque Nationale in Paris showed that such tasks could be achieved with considerable grace and elegance, by no means diminished by the use of Classical ornament in terra-cotta and iron. An enduring symbol of the new constructional possibilities opening up at the time is found in Gustave Eiffel's famous tower, built for the Paris exhibition of 1889.

The history of Western art since the Renaissance is one of action and reaction, and in an increasingly machine-dominated

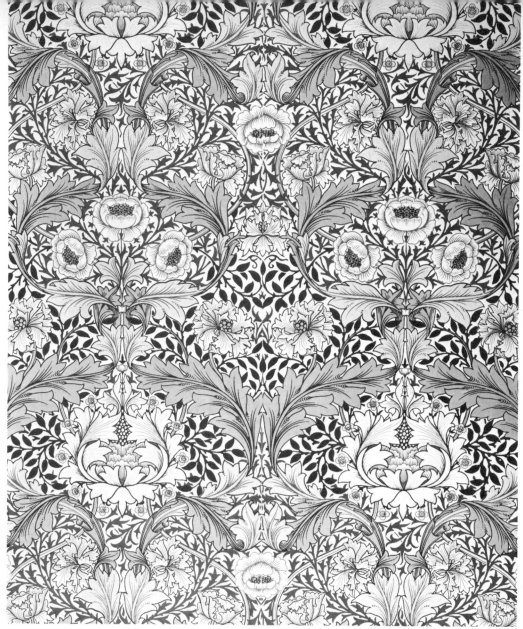

William Morris. Myrtle
wallpaper. 1899. Victoria
and Albert Museum,
London.

Henri Labrouste. Reading
Room, Bibliothèque
Nationale, Paris.
1862–1868.

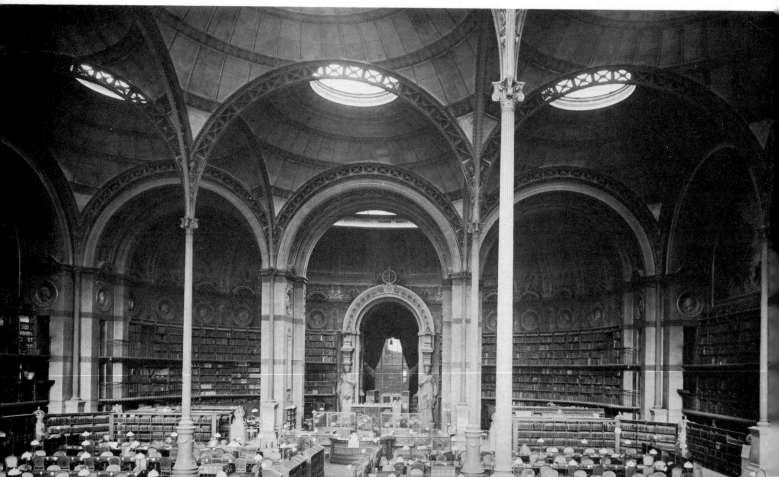

Philip Webb. The Red House, Bexley Heath, Kent, 1859–1860.

Frank Lloyd Wright. Ward Willits House, Illinois. 1902.

world, an attempt to revive the simpler values of a more primitive past was almost inevitable. In the late 19th century, primitivism was still a relative term. The English Arts and Crafts Movement founded by 196 William Morris (1834–1896) sought to counter the atrocities of mass-production design by a return to traditional methods of craftsmanship, and Morris's own two-dimensional designs for wallpaper and fabrics have a timeless appeal. Their elaborate plant and flower patterns, carried out with supreme confidence and precision, clearly echo the decorative motifs of Western primitive art. In architecture, Philip Webb evolved an organic style which while

hinting at Gothic in some respects owed little to historical forms. Its timeless quality is well illustrated by the Red House at 197 Bexley Heath in Kent, which Webb designed for William Morris.

In the United States, one of the founders of modern architecture, Frank Lloyd Wright (1869–1959) built a series of houses 197 in the 1890s and early 1900s which show a different aspect of primitivism. With rooms grouped around a central chimney core, so that space flows outwards towards the periphery, they combine a strongly organic quality with a simplicity and almost spiritual calm which reflect Wright's admiration for Japanese architecture.

Charles Rennie
Mackintosh. Glasgow Art
School. 1898–1909.

above right
Victor Horta. Dining
Room, Maison Horta,
Brussels. 1895.

The interest in what we have called primitivism during the last decades of the 19th century indicates that by now Western artists had recognised that the great stylistic traditions of Western art were irrevocably broken. The search for a non-historical basis for style found its first fruit in the Art Nouveau movement. In Art Nouveau architecture and interior decoration, primitivism was allied to the products of the machine age. Sinuous vegetable forms executed in metal or glass formed the basis of decorative motifs which were applied to subjects as diverse as Paris Métro stations and Belgian domestic interiors. In Britain the Scottish architect Charles Rennie Mackintosh (1869–1928) evolved a personal interpretation of Art Nouveau which found its finest expression in the Glasgow Art School. Here architecture, exterior and interior decoration and furniture are designed as a homogeneous ensemble. The façade of the Glasgow Art School combines a hint of Gothic fantasy with a taste for asymmetry and clear-cut lines which suggest many of the stylistic developments in 20th century architecture.

By the end of the 19th century, change had become an endemic state in Western culture. The final relinquishment of the styles which had served Western artists for a thousand years was but one facet of an overall uncertainty, soon to be expressed in a spate of revolutionary artistic movements which marked the first decades of the 20th century. The way was open for the final dehumanisation and fragmentation of art in our own times.

Modern Times

Piet Mondrian.
*Composition with Red,
Yellow and Blue.* 1930.
Oil. 19× 19 in. (48 × 48
cm.). Alfred Roth
Collection, Zurich.

The first decades of the 20th century were marked by a wave of creative experimentation without precedence in Western art. A multitude of revolutionary movements arose – Fauvism, Cubism, Futurism, Expressionism. Different schools of artists experimented with different facets of the creative vocabulary, contributing to the general fragmentation of stylistic traditions. In a world where commemorative art had been rendered redundant and ornamentation was felt to run counter to the spirit of the age, this spirit of restless enquiry was inevitable.

But the styles of the past had only been the outward manifestation of basic human tendencies, which still had to be expressed. And in 20th-century art, as clearly as ever before, there are two main streams. The Classical striving for simplicity and stillness found its expression in the cool functionalism of the Bauhaus movement and the

International style of architecture, while the emotional element once revealed in Romanticism or Baroque continued, despite the increasing abstraction of sculpture and painting, in the various forms of Expressionism.

What is lacking in much 20th-century art is the basic human quality which formerly held these two elements in balance. The vogue for abstract rather than figurative art is matched by a preoccupation with the impersonal qualities of space and form. And the emotional element when it appears tends to take the negative forms of anger, frustration, anxiety, which are a reflection of men's feeling's in present-day society.

The First Twenty Years

The revolutionary movements of the years 1900 to 1920 established the major trends of modern art, bringing into prominence figures which are now regarded as the great masters of the 20th century. Henri Matisse (1869–1954) was the central figure of a group of painters who, on exhibiting their work together in Paris in 1905, found themselves labelled *fauves* ('wild beasts'). Their main characteristic was an aggressive use of unnatural colours, partially derived from the work of Gauguin and Van Gogh, but Matisse himself added a classical stillness to the style, painting elegant nudes which continued a long tradition of French painting. His *Le Luxe II* shows a preoccupation with the formal qualities of the female form which echoes the work of Cézanne.

Robert Wiene (director). Still from the film *The Cabinet of Dr Caligari*. Germany. 1919.

right
Umberto Boccioni. *Muscular Dynamism or Unique Forms of Continuity in Space*. 1913. Polished bronze. h. 43½ in. (110·5 cm.). Museum of Modern Art, Milan.

202

Pablo Picasso. *Guernica*. 1937. Oil on canvas. 11 ft. 6 in. × 25 ft. 8 in. (3·5 × 7·8 cm.). On extended loan to the Museum of Modern Art, New York, from the artist's collection.

right
Jacques Duchamp-Villon. *The Horse*. 1914. Bronze. h. 40 in. (101·5 cm.). The Museum of Modern Art, New York (Van Gogh Purchase Fund).

Another element of Cézanne's style, the rendering of three-dimensional subjects as a series of two-dimensional planes, was one of the starting points for Cubism, which found its major exponents in the young Spanish artist Pablo Picasso (1881–1973) and his associate Georges Braque. Initially concerned with breaking up their subjects into their structural components and re-assembling them in two-dimensional terms, by 1912 the Cubists were producing synthetic, rather than analytical works, in which two- and three-dimensional objects were constructed on the canvas from paint 203 and other materials. Picasso's *Still Life with Pipe* is an early example of Cubist collage in which the use of elements from the real world, such as the matchbox cover, introduces a sense of ambiguity, a blurring of the distinction between fact and fiction, which was to become an important theme in modern art.

Simultaneously with Cubism, the Futurist movement, originating in Italy found a romantic appeal in the speed and bustle of the modern technological world. Futurist artists learned from photographic studies that the repetition of objects, or the use of abstracted 'lines of force' could be used to convey speed and movement. 200 Umberto Boccioni's *Muscular Dynamism* represents an attempt to translate these ideas into plastic terms which curiously recall the swirling draperies of Baroque sculpture. A work by the French sculptor 201 Jacques Duchamp-Villon, *The Horse*, instils a Futurist sense of mechanical energy into an animal form which has undergone the same kind of abstraction as the subjects of Cubist painting.

In Germany, the various artistic activities grouped under the name of Expressionism aimed at a direct and intense form of communication, conveying an anguished pessimism which was essentially Nordic in feeling. Expressionism found a natural outlet in the new 20th-century art form of cinema, adding a characteristic atmosphere 200 to the early masterpieces of the German silent screen.

In the same period, the work of Piet Mondrian (1872–1944) and the De Stijl group in Holland represented an entirely contrary mode to that of Expressionism, indicating just how diverse were the artistic currents of the time. From the elements of analytical Cubism, Mondrian developed a style of classical simplicity and calm, in which vertical and horizontal bands of black-framed rectangular areas of primary

colours were interspersed with white or grey. Canvases such as Mondrian's *Compo-*

199 *sition with Red, Yellow and Blue* are typical of the way in which abstract art rejects all specifically human associations, evoking a directly intellectual or sensual response in the observer.

The German painter Paul Klee (1879–1940) formed a bridge between these two conflicting styles, combining the Expressionist view of painting as a means of translating the artist's feelings into graphic terms with a more abstract concern for colour and form. One of the great innovators of 20th-century art, Klee maintained a primitivist belief in the value of intuition, allowing his pictures to 'grow' under the brush according to the promptings of his imagination. The resemblance between his

206 *Senecio* and the magical masks of primitive cultures is by no means coincidental, for Klee shared with other 20th-century artists a desire to cut away the accretions of modern life and return to the intuitive, child-like responses of primitive man.

Le Corbusier. Villa Savoie,
Poissy-sur-Seine.
1929–1931.

Constantin Brancusi.
Torso of a Young Man.
1925. Polished bronze on
limestone, wood base. h.
60 in. (152·5 cm.).
Collection of Joseph
Hirshhorn, New York.

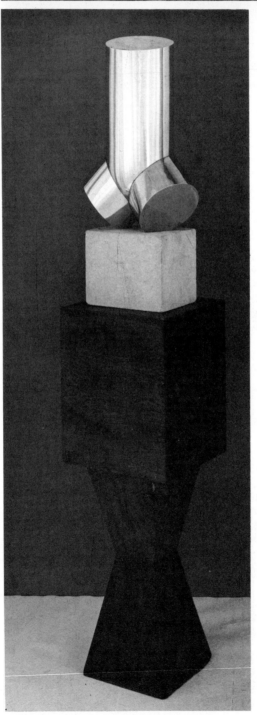

The Twenties and Thirties

While the revolutionary movements of the first two decades of the 20th century were so fundamental that they scarcely left room for traditionalist opposition, they did provoke a reaction of another kind. In 1916 a group of émigré artists in Zurich had founded a movement which they christened with the nonsense word Dada, to signify their complete rejection of the value of artistic endeavour. The artistic iconoclasm of the age had reached its ultimate form. In the 1920s, Dada was developed into Surrealism in Paris, at a time when the aftermath of the First World War had dampened revolutionary energies elsewhere. The essence of Surrealism was the theory that the contents of the subconscious mind as revealed in dreams and the free play of the imagination have far greater relevance to real human existence than the traditional subject-matter of the arts. Prominent among Surrealist painters was the Spaniard Joan Miró, who developed a very free and personal style full of images which are at once child-like, sinister and humorous. *The Carnival of Harlequin* is one 207 of his most Surrealist works, curiously combining elements which could well have sprung from the nightmare landscapes of Hieronymus Bosch.

Sensitive to every artistic trend, both past and present, Picasso absorbed some of the elements of Surrealism. His famous canvas *Guernica*, commemorating the 201 destruction of a Spanish village in 1936, combines Cubist composition with Expressionist intensity and a Surrealist atmosphere in what is generally considered one of the masterpieces of modern European art. A forceful expression of man's inhumanity to man in the tradition of Goya's *Execution of the Rebels*, it reflects a trend of social comment in European art at a

Jean Arp. *Human Concretion*. 1949 (original 1935). Cast stone (original, plaster). h. 19½ in. (49·5 cm.). The Museum of Modern Art, New York (Gift of the Advisory Committee).

Henry Moore. *Madonna and Child*. 1944. St Matthew's church, Northampton.

time when social and economic disorders had resulted in the rise of totalitarian regimes in Italy and Germany. Picasso also inherited the Dadaists' taste for 'found objects' as an element of sculpture. His *Head* sculpture makes use of the products of the machine age as the basis of a construction which is clearly inspired by African masks. Of all 20th-century artists, Picasso's intuitive approach to art is the nearest to that of primitive man, and the effortless mastery of line found in his drawings and etchings, as well as his paintings, equals that of the primitive hunter-artists of the Franco-Cantabrian caves.

Against the Expressionist flavour of Picasso's sculpture we may place the controlled elegance of Constantin Brancusi. A Rumanian sculptor who had come to live in Paris in 1904, Brancusi dominated European sculpture in the Twenties and Thirties, producing works such as the *Torso of a Young Man*, in which what at first appears as a machine-like severity of form in fact transmits a remarkably sensuous appeal which is reinforced by the obsessive attention to surface finish. Brancusi's belief in allowing the nature of the material to influence the character of the work is one of the major themes of modern sculpture, and is closely linked with Klee's view that the work of art should 'grow' under the artist's hand. In the work of Jean Arp, once a member of the Dada movement, this latter concept resulted in abstract forms of Surrealist ambiguity which seem to appeal directly to the human subconscious. Sculptures such as the *Human Concretion*, for all their abstraction, convey a remarkable impression of human warmth and sensuality.

Paul Klee. *Senecio*. 1922.
Oil on linen. 16 × 15 in.
(40·5 × 38 cm.).
Kunstmuseum, Basle.

Both Brancusi and Arp influenced the work of Henry Moore (b. 1898), Britain's first modern sculptor of international standing, whose work reveals an instinctively sympathetic response to the physical world. Moore combined a natural primitivism with traditional Western influences such as Greek sculpture and the work of Michelangelo to produce works of timeless appeal, many of them variations on the theme of the reclining female figure. His 205 *Madonna and Child* of 1943–44 shows Moore's interpretation of a traditional theme, more realistic than many of his works but possessing his characteristic

qualities of monumentality and physical presence.

In the Twenties and Thirties the first truly modern movement in architecture came to fruition. The new building materials, glass, steel and reinforced concrete, were combined with geometric simplicity in the work of three outstanding architects who between them established what became known as the International style. The great propagandist of the new movement was Le Corbusier (Charles-Edouard Jeanneret, 1887–1965); his declaration that 'the house is a machine for living in' found expression in buildings such as the Villa

204 Savoie at Poissy, near Paris and in ambitious urban development projects which were the first to envisage the use of high-rise residential blocks. In fact Le Corbusier's severe rationalism and belief in traditional systems of proportion place him in the tradition of French Classical architecture, despite the obvious modernity of his style.

In Germany, Ludwig Mies van der Rohe (1886–1969) embellished his interpretations of the International style with the use of fine materials such as chromium plated steel, ebony, onyx and marble. The most important building of the period however was that designed by Walter Gropius (1883–1969) for the Bauhaus in Dessau. An 207 informal arrangement of rectangular units executed in white concrete with large areas of glass covering the workshop block, the building was a synthesis of the progressive architectural ideas of the period. But more than that it was a symbol of the famous school of industrial design which imposed the creed of functionalism on every aspect of modern living. Identifying functionalism with geometric abstraction, the exponents of the Bauhaus movement and the International style of architecture tended to forget that true functionalism could never be incorporated into a single uniform style.

The Post-War Period to the Present Day

The decades since the Second World War have once again seen a proliferation of revolutionary movements, their pronouncements becoming more obscure and in many cases their inspiration thinner as time goes by. The division between the arts has become more blurred as works are produced which emit light and sound, move and generally have their being on the borders between painting, sculpture and architecture. The Hungarian-French artist

Alberto Giacometti. *The Square.* 1948–1949. Bronze. $24\frac{3}{4} \times 17\frac{1}{4} \times 8\frac{1}{4}$ in. (63 × 44 × 21 cm.). Öffentliche Kunstsammlung, Basle (Emanuel Hoffman Collection).

Jackson Pollock. *Number 32.* 1950. Kunstsammlung Nordrhein-Westfalen, Düsseldorf.

210 Victor Vasarely (b. 1908) is the founder of the technique known as optical or Op art, in which the juxtaposition of geometric shapes and dissonant colour tones on the canvas gives the observer an illusion of movement. Sculpture has become increasingly concerned with the arrangement of objects and their 'interrelations' in space, be it the humanoid figures of the Swiss 208 sculptor and painter Alberto Giacometti (1901–1966), or the steel tubes and girders of the English sculptor Anthony Caro (b. 1924).

The influx of émigré artists before and during the Second World War ensured that the United States, and particularly New York, became the centre of artistic developments during the Fifties and Sixties. The work of Jackson Pollock (1912–1956) and Willem de Kooning (b. 1904) represented two facets of a new school of painting which aimed at a greater immediacy of communication between the artist and the observer. Pollock's 'action paintings', executed by 208 dribbling paint from all sides onto a canvas stretched out on the floor, demanded an unprecedented degree of physical involvement on the part of the artist which comes out forcibly in the finished work. De Kooning's approach is more traditional but no less immediate, heavy brushstrokes criss-crossing the canvas in abstract and semi-figurative patterns of Expressionist intensity.

In the field of architecture, New York provided an ideal setting for large-scale interpretations of the International style. Mies van der Rohe had settled in the United States in 1937, and his elegant, sophisticated buildings in glass and steel

Ludwig Mies van der Rohe. Seagram Building, New York. 1957.

Frank Lloyd Wright. Solomon R. Guggenheim Museum, New York. Designed 1943–1946, built 1956–1959.

seemed to have found their natural home. The Seagram Building in New York, which 209 he designed in collaboration with his disciple Philip Johnson is the ultimate refinement of his personal idiom, a monument of austere elegance and classical simplicity.

At almost the opposite pole to Mies van der Rohe, the great American exponent of 'organic' architecture, Frank Lloyd Wright, produced a design for the Solomon R. Guggenheim Museum of Art in New York 209 which was a violent rejection of all that the International style represented. The great areas of glass and steel are replaced by a brooding mass of concrete hiding a spiral ramp which forms one long continuous gallery around a vast central space inside the building. A number of other architects sought to find an alternative to the International style, usually taking advantage of the flexibility of reinforced concrete as a building medium. Abandoning the classical severity of his earlier work, in Europe Le Corbusier produced the famous pilgrim church at Ronchamp, using 211

Le Corbusier. Notre Dame du Haut, Ronchamp. 1955.

right
Roy Lichtenstein. *Holly Solomon.* 1966. 60 × 48 in. (151 × 121 cm.). Oil and magna on canvas. Collection of Mr and Mrs Horace Solomon.

opposite
Victor Vasarely. *Cassiopée.* 1957. Oil on canvas. 76¾ × 51 in. (195 × 129·5 cm.). Denise René Collection, Paris.

an *ad hoc* method of design and construction which aimed at producing an affecting environment in the manner of the medieval cathedrals.

One of the most recent developments in modern art, again originating in the United States, has been the return to a kind of realism, which has been given the name of Pop Art. Basically a celebration of the products of the mass media and consumer society, Pop Art narrows the gap between art and modern commercial design. With its graphic crudity, reference to the printing techniques of popular journalism and banal expression of emotion, Roy Lichtenstein's portrait of *Holly Solomon* is at once a characteristic product of the Pop movement and a symbolic comment on the level of much Western art today.

Despite the creative brilliance of the early revolutionary movements, the development of 20th-century art appears essentially as a process of dissolution. The collapse of long-standing traditions, after the initial intoxication of freedom, has left in its aftermath a sense of bewilderment, a loss of direction which of course extends well beyond the purely artistic sphere. We live in a time where Western culture is seeking a new direction, and no doubt once found this new direction will be reflected in the art of future centuries.

The World of the Ancient Americas

We began by looking at those primitive cultures which slowly developed into the mature cultures of the Middle East, of Greece and Rome, and finally modern Western culture itself. Now Western man is turning once again to that primitive world in search of the values which he seems to have lost. And in the indigenous civilisations of North and South America, he finds a group of cultures whose contact with man's primitive roots is tantalisingly direct.

Man's occupation of the American continents began some twenty thousand years ago, when the primitive peoples inhabiting the great plains of Siberia began filtering across the Bering Strait to what is now Alaska. They traversed the entire length of the two continents, establishing nomadic hunting cultures which in some areas survived practically into modern times.

Agriculture was discovered around 6,000 to 4,000 BC, probably in northern Mexico and, as in other parts of the world, eventually resulted in the growth of 'mature' cultures possessed of towns, calendars, numbers and writing. But because of their isolation from the rest of the world, these Central and South American cultures did not undergo the same kind of intellectual and technological development which led to the high cultures of Asia and the West. Rather they developed certain primitive characteristics to a high degree of sophistication. The result was a series of brilliant but ultimately sterile societies which reached their apogee between 300 and 900 AD and were already degenerating by the time the Spaniards arrived, bringing with them the first unassimilable taste of Western culture.

The North American Indians

Until as late as the 19th century, the North American continent was a living museum of primitive peoples, containing as it did various groups of Indians at different levels of development, whose conditions of life had not compelled them to progress any further. Their art showed many of the decorative forms originated by the primi-

above
Eskimo spoon from North
America carved out of a
walrus's shoulder joint.
20th century. w. 2½ in. (6
cm.). Museum für
Völkerkunde, Munich.

right
Pueblo Indian clay vessel
(Zuñi tribe). 19th century.
h. 9 in. (23 cm.). Museum
für Völkerkunde, Munich.

opposite
Beaded and painted
leggings of Plains Indians.
James H. Hooper
Collection.

Long-peaked Aleut hunting hat from Alaska. *c.* 1850. Painted wood, incised ivory, beads and sea-lion whiskers. h. 8¾ in. (22·3 cm.). Museum of the American Indian, New York.

opposite
Coatlicue. Aztec culture. From the Plaza of Mexico City. 15th century. Olivine basalt. h. 8 ft. 6⅜ in. (260 cm.). National Museum of Anthropology, Mexico City.

tive peoples of western Asia, which reached Alaska via the Bering Strait at around the time of Christ. The unique hunting hats worn by the neolithic hunter-fishermen of the north-west coast clearly show an Asian ancestry. The example illustrated is decorated with the familiar spiral pattern of the Asian farmers, while the bead-decorated crown has a Mongolian flavour. The long peak served to shield the chief's eyes from the dazzle of the water as he led the hunt from his boat, while the adornment of sea-lion whiskers was a shamanistic talisman, designed to give magical protection to the wearer and ensure the success of the hunt.

The Indians of the great plains of central North America were among the first to engage in organised agriculture, which they combined with a yearly hunt of the migrating herds of buffalo. Their simple garments of buffalo hide, painted and decorated with beads, have passed into popular mythology as the traditional dress of the North American Indian. The leggings were decorated with a beadwork meander pattern, which is a stylised version of the snake motif characteristic of primitive art.

The most advanced indigenous culture in North America was that of the Pueblo Indians on the south-west mesa. Their painted clay pottery is the mark of a people on the threshold of civilisation. The bowl illustrated combines two familiar primitive styles – an abstract design based on western

Asian spiral motifs, and a clearly depicted hunter motif of deer with their organs exposed in the X-ray style of northern Europe. At the opposite extreme to the Pueblos, both in location and cultural development, the Eskimos still produce designs reminiscent of another type of European primitive art, the Second Hunter style which spread from the Spanish Levant to Africa and Australia.

The concepts of shamanism played an important part in the world of the North American Indians, whose picturesque mythology is peopled with animal spirits. Animals such as the bear and the buffalo were the symbolic representatives of a spirit world with whom contact might be made by the ritual smoking of tobacco. Ornamental pipes and pipe heads are a characteristic form of North American Indian art, and the example illustrated, carved in red stone, shows a shaman receiving instruction from a bear spirit. Among the Navajo Indians of the south-western desert, contact with the spirit world was achieved by the making of sand-paintings, whose meaning was expounded in ritualistic chants. The example shown formed part of a healing ceremony; in the centre is a lake from which four stalks of maze are growing, while the figures are representations of the supernatural powers which the shaman would summon to his assistance during the ceremony.

Pipe bowl. Red pipe stone. East Dakotas. l. 6½ in. (16·5 cm.). Linden Museum, Stuttgart.

Hosteen Bezody. *Moisture in the Mountain*. Replica of Navaho sand painting. Chinlee, Arizona. 1902. 48 × 40 in. (121 × 111cm.). Taylor Museum, Colorado Springs (J. F. Huckel Collection).

The Pre-Columbian Cultures of Mexico and South America

While the animal-orientated mythology of the North American Indians showed the essential preoccupations of a hunter culture, the system of beliefs which prevailed in Central America was clearly that of an agricultural people. The snake, with its associations of the earth and fertility, is one of the basic motifs of pre-Columbian art; the most prominent gods were those of rain and sun.

But the peoples of Central America developed these basic themes of agriculturalist mythology to a degree of sophistication which reflected their level of social organisation. As early as the 2nd century AD, the city of Teotihuacan, near present-day Mexico City was a religious and political centre comparable in size to Ancient Rome. Only the foundations of the houses and temples now remain, but the pyramid base of the so-called Temple of Quetzalcoatl has the typical form of Teotihuacan architecture. Its steps and terraces are decorated with masks representing Quetzalcoatl himself and the rain god Tlaloc. 217

Quetzalcoatl, the plumed serpent, is the most powerful figure in Central American mythology, a symbol of great psychological profundity which embraces all the different levels of material and spiritual existence. The word is a composite one, combining the name of the quetzal bird – an inhabitant of tree-tops seldom seen by man – with the terms for snake and water. Earth and air are joined by life-giving water in a symbol of man's dual nature, his condition and his possible development. Second only to Quetzalcoatl, the rain god Tlaloc has an obvious place in this system. In the reconstructed mural illustrated, the god sits in his heaven with water flowing from his hands, and water creatures at his feet. In the lower half the souls of men gambol happily, playing leapfrog, singing songs and chasing butterflies. It is a place of rebirth whence they must return after a time to the ceaseless round of existence. 218

The name of Quetzalcoatl was adopted as an indication of divine descent by the historical rulers of the Toltecs, who succeeded the unknown builders of Teotihuacan to power in Mexico. And when the Aztecs gained control of Central America around 1200 AD, they sought to perpetuate this divine connection by marrying Toltec princesses. The Aztecs were a race of warriors, the chief god in their pantheon was the sun or war god Huitzilopochtli, and an awareness of death permeated their existence as it did that of all the Mexican peoples. The rock crystal skull is the ultimate expression of this 217

theme, a bleak and sinister reminder of man's mortality.

Even the traditional agriculturalist themes of earth and fertility are endowed with a savage force in Aztec art, exemplified in the figure of Coatlicue, the Lady of the Serpents or Mother Earth, of whom Quetzalcoatl is the offspring. The face is made from two rattlesnake heads, the necklace of human hands, hearts and a skull. Like the figure of Quetzalcoatl it embodies a whole complex of symbols relating to man's place in a universal order: life and death, the physical and spiritual planes, the labour and sacrifice needed to produce everything from the fertility of the maize crop to the fruition of man's highest potential. If the image seems cruel and inhuman, it is because it relates to cosmic forces infinitely greater in scale than individual human existence. Significantly, nearly all pre-Columbian art is monumental and symbolic; commemorative scenes and realistic portraiture are almost entirely absent; the human countenance is given a generalised form reflecting the primitive, non-individualised view of man.

A characteristic feature of the pre-Columbian civilisations was the organisation of life into ritualistic patterns originally intended to enact some religious or psychological truth. The Aztecs conducted their lives according to a complex astrological system, which is embodied in the great calendar stone found at the Aztec capital of Tenochtitlán. Twenty named days were repeated in a magical 260-day cycle known as Tonalpouhalli, or the 'count of fate', and this coincided with the 365-day astronomical cycle once every fifty-two years, when the opening of a new era was celebrated with human sacrifice. Ultimately it was the Aztecs' belief in astrology and their rich mythological heritage which proved their undoing. Following astrological predictions, the Aztec emperor Moctezuma believed Hernán Cortés to be the god Quetzalcoatl returned to claim his former lands and people, and his demoralised armies rapidly capitulated to the Spanish invaders.

One of the richest and most complex of the Central American cultures was that of the Mayan-speaking peoples, which flour-

Tlaloc, the rain god.
Reconstructed mural from
Tepantitla. Teotihuacan
culture. 1st–6th centuries
AD. National Institute of
Anthropology and History,
Mexico City.

opposite
Kinich Ahau. Cylindrical
carving from Palenque. *c.*
700 AD. National Institute
of Anthropology and
History, Mexico City.

Calendar stone, found
near the main temple
enclosure, Tenochtitlán.
Carved just after the year
1502. diam. 13 ft. (3·9
m.). National Museum of
Anthropology, Mexico
City.

ished in an area centred on southern
Mexico between about 300 and 1300 AD.
With their flattened foreheads and pro- 220
minent noses, which appear in stylised
form in the art of the so-called classical
period (300–900 AD), they stand out from
the other Central American peoples in their
physical appearance as well as their degree
of cultural development.

The figure of Quetzalcoatl appears in
Mayan mythology in various different
forms. The Mayan version of his name is
Kukulcan, but he is also Itzamná, who in-
troduced maize into the human diet, and
the fire bird Kinich Ahau, the Mayan sun 219
god. Once again we find him as the centre
of a complex of ideas relating to a cycle
of growth and development. The maize
plant has a special significance in Central
American mythology, not only as the origin
of agriculture but as a symbol of fertility
and growth which extends far beyond the
purely nutritional plane. Its ritual impor-

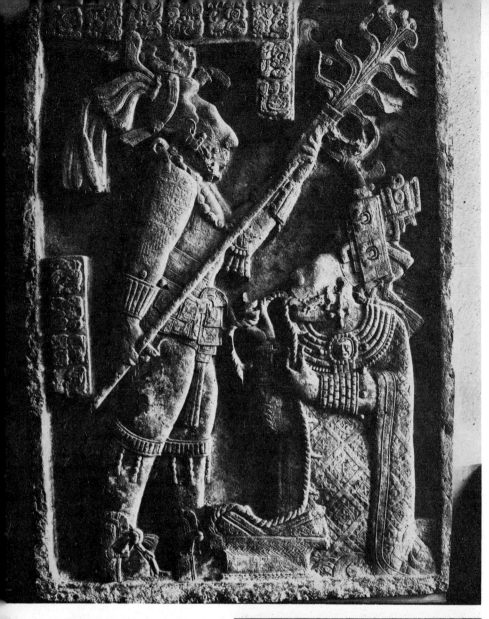

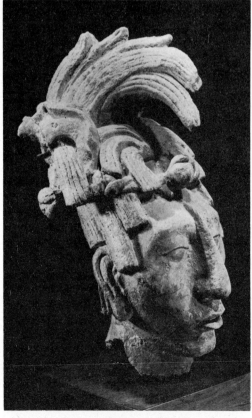

Relief panel used as a lintel in the ancient Maya city of Yaxchilan. Carved limestone, with some traces of having been painted. Classic Maya. About 8th century AD. British Museum, London.

Head from one of the tombs in the Temple of Inscriptions, Palenque. 7th century AD. National Institute of Anthropology and History, Mexico City.

tance is clearly indicated in the Mayan 220 relief panel illustrated, where a rain-priest kneels tearing his tongue with a spiked cord as an offering of pain to a god who carries a growing maize plant.

The Mayans developed astronomy and mathematics to a remarkable degree, and used a similar system of astrological periods to the Aztecs. But an equally interesting fact of their ritualised existence appears in the sacred ball game, prevalent among the Mayans but played throughout ancient Mexico and Central America. Of unknown origin, it was on one level a physical battle not unlike tennis or football, and on another a symbolic ritual, variously interpreted as representing the play of cosmic forces and the movements of stars and planets in the heavens. The carved medal- 221 lion illustrated shows a Mayan ball-player surrounded by hieroglyphic signs probably commemorating a religious festival.

The latest and the most southerly of the great pre-Columbian civilisations was that of the Incas. Appearing in the highlands of Peru in the 11th century AD, they established a highly organised theocratic society. The sun was their tribal god, and they themselves were worshipped by their subjects as his 'sons' or representatives. Less is known of the Incas than of the Central American cultures, because they lacked a written language, but their society was evidently no less dependent on an elaborate mythology and a complex symbolic ritual applied to every aspect of life. The Inca *keru* or ceremonial beaker illustrated 223 depicts some scene of magic in which bird figures perch on the heads of humans, who hold up their hands in gestures of worship and amazement.

Also highly organised on a purely social level, the Incas maintained a strict system of communications which enabled them to control their territories high up in the Andes. Teams were employed by the government to keep open the roads and bridges leading to such mountain fastnesses as the famous 'lost city' of Machu Picchu, which 221 the Spaniards failed to find and was only rediscovered in 1912. The whole complex is a remarkable feat of engineering, the hillside being covered in stone terraces which served to retain the earth for cultivation, and enabled even remote centres such as this to be self-sufficient. There are over a hundred stairways in the ruins, the most imposing of which leads from the central *plaza* to the hill on the left, on which stands the *Intihuatana* or 'hitching post of the 222 sun'. These enormous, curiously carved slabs of rock have been found on the summit of several Inca strongholds. Apparently an elaborate form of shadow-clock or sundial, they would have been used by Inca astrologers to determine the sequence of festivals for the sun ritual.

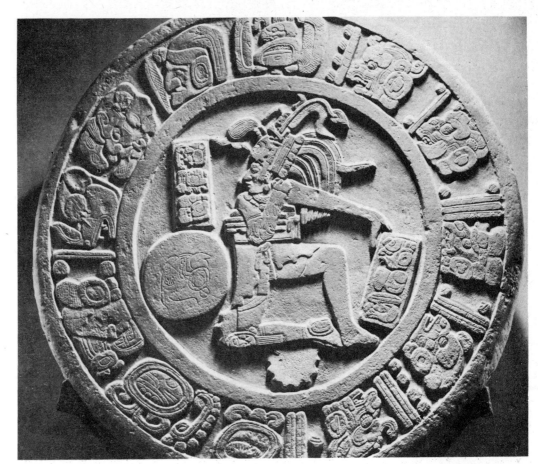

Ball player. Carved stone medallion from Ratinlixul, Guatemala. Pre-Classical Maya. c. 750 AD. National Museum, Mexico.

Panorama of Inca ruins and terraces, Machu Picchu, Peru.

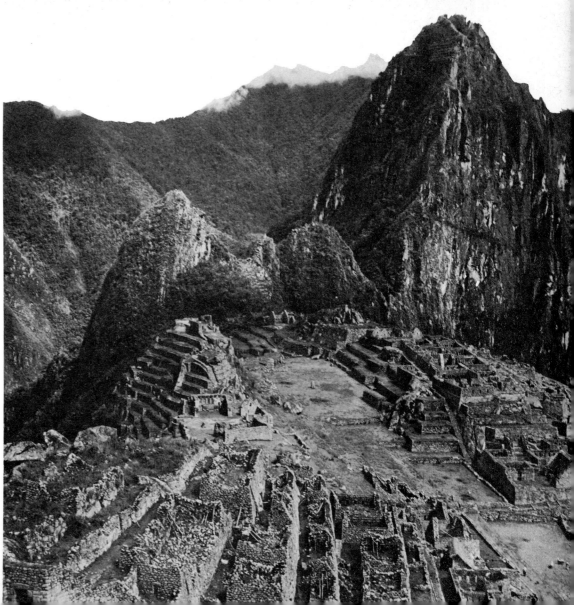

The *Intihuatana* ('Hitching Post of the Sun') at Machu Picchu.

opposite
Inca *keru* or beaker. Painted and lacquered wood. Kemper Collection.

Polychrome painted *aryballus*, ornamented with birds and geometric decoration. Inca, Peru. Late Post-Classical period. Kemper Collection.

As one might expect from the harsh conditions of their existence, the people ruled by the Incas were engineers rather than architects, craftsmen rather than artists. Renowned for their skilled masonry work and rich gold ornaments, they were also accomplished potters though, like the other ancient American cultures, they were ignorant of the potter's wheel. The most typical of Inca pottery forms was the aryballus. It shows the geometric decoration characteristic of early painted pottery the world over, and the large handles and the knob on the body of the vessel enabled it to be carried by means of a strap which passed over the forehead of the bearer.

The destruction of the Inca civilisation by the Spaniards in their greed for gold is a well-known episode in Western history; little remains of the Incas' achievements, save the superbly engineered stone walls which now serve as a foundation for Spanish colonial buildings in places such as the ancient Inca capital of Cuzco.

The relics of the pre-Columbian cultures are a startling reminder of a facet of the primitive world which had only just begun to decline as Western civilisation was reaching the height of its development. Just how far Western man had travelled from his primitive beginnings was evidenced by the ease with which he overcame the American natives, regarding them as fit subjects only for plunder and exploitation. And just how far removed was his own world from that of primitive man is evidenced by the rapidity with which the native civilisations collapsed after their first contact with the culture of Western Europe.

222

Conclusion

Having come to the end of this survey of man's artistic output over the ages, we find that the two main aspects of his art, the decorative and the commemorative, also represent two extremes in the cycle of his cultural development. The art of primitive man is sometimes representational, but it is always generalised, reflecting his view of the non-individual role of man in an organic system. The characteristic feature of primitive art tends to be the geometric pattern, a form of decoration which, through association with archetypal symbols, acquires a magical significance. This is the 'mysterious' element in human art, representing the sense of a central mystery in life which always appears as a motivating force at an early stage in the cultural cycle. As man becomes more sophisticated, more advanced in the trends and techniques of his own particular culture, the representational element becomes stronger, the idea of commemoration, of stopping the march of man-made time, becomes more important. The concept of a fundamental unity in life is gradually lost and the culture begins to disintegrate, until some shock from the outside, or some rediscovery of the 'primitive' view of existence, sets it on a new course.

Western culture today has reached a point where the passion for commemoration rules our daily lives. The written and spoken word, the recording eye of the camera, perpetually seek to capture events which are already past. The vagaries of modern art reflect a loss of direction which is apparent in every walk of life. If many people are wilfully seeking a new direction, at the same time it is being forced upon us. In a curious way the wheel has come full circle. Through his very material and biological success, man is being forced into a reappraisal of his earthly situation which in itself is creating a new mythology. While primitive man felt himself instinctively to be part of an organic whole, modern man is being forced by the prospect of self-extinction to regard himself scientifically as being part of a complex interrelated system – a system which in the modern terms of technology, economics, sociology and psychology requires handling with a sense of balance at least as delicate as that involved in the magical precautions of primitive shamanism. Since we have seen most clearly that mythology lies at the origin of all art, we may perhaps expect that this new mythology, in one form or another, will shape the art of the future.

ACKNOWLEDGEMENTS

Colour Illustrations
The illustration on page 163 is reproduced by gracious permission of Her Majesty the Queen.

The following illustrations have been supplied by: Albright-Knox Art Gallery, Buffalo, New York, 207 top; Janine Auboyer, Paris, 98; Bibliothèque Nationale, Paris, 71, 74; British Museum, London, 35; J. E. Dayton, London 82; Werner Forman, 38, 39, 87; Freer Gallery of Art, Washington, 91; D. Hughes-Gilbey, 47, 50, 54, 55 right, 58 right; Giraudon, Paris, 83, 126, 139; Leo Gundemann Würzburg, 182–3; Hamlyn Group Picture Library, Frontispiece, 11, 14, 15, 18, 22, 23, 31, 51, 58 left, 59, 70, 75, 90, 94, 99, 135, 138, 143, 150, 151, 154, 158, 159, 167, 171, 175, 187, 191, 194, 195, 210, 215, 219, 223; Hans Hinz, Basle, 10, 206; Firmer Fotoarchiv, Munich, 27; Michael Holford, London, 42–3, 107; Holle Verlag, Baden-Baden, 111; A. F. Kersting, London, 186; M.A.S. Barcelona, 95, 190; Erwin Meyer, Vienna, 162; Museum of the American Indian, New York, 214; National Gallery, London, 178–9; National Gallery of Art, Prague, 203 top; Pierpont Morgan Library, New York, 79, 86; Rapho, Paris, 19, 123; Professor A. Roth, Zurich, 199; Royal Museum of Fine Arts, Copenhagen, 202; Sakamoto, Tokyo, 115; Scala, Antella, 34, 63 top, 66, 67, 134 top, 134 bottom, 142, 146–147, 155; Staatliche Museen zu Berlin, 30; Staatliche Museen, Preussischer Kulturbesitz, Berlin, 119; Thames & Hudson, London, 122; Verwaltung der Staatlichen Schlösser und Gärten, Berlin, 174; Victoria and Albert Museum, London, 106; ZFA, Düsseldorf, 102–103.

Black and White Illustrations
The following illustrations have been supplied by: Paul Almasy, Paris 44–45, 108–109; American Museum of Natural History, New York, 221 bottom;

T. & R. Annan & Sons Ltd., Glasgow, 198 left; Archaeological Survey of the Government of India, 102 bottom; Archives Photographiques, Paris 40 left, 130 bottom, 172 bottom, 179; Bauhaus Archive, Darmstadt, 207 bottom; Belzeaux-Zodiaque, 73; Benvido, Kyoto, 117, 118; J. Bottin, Paris, 41 top, 217 top right; Boudot-Lamotte, Paris 89 right, 93, 198 right; British Museum, London, 12 top right, 16, 20, 24, 36, 37 top, 120 top, 152 top, 217 bottom, 220 top; British School, Rome, 64; British Travel Association, London, 190 centre; Charles Bueb, Pfastatt, 211 top; Rudolf Burckhardt, New York, 211 bottom; Cairo Museum of Islamic Art, 84 bottom, 90 right; Chicago Architectural Photo Co. 197 bottom; Cleveland Museum of Art, 84; Country Life, 185 bottom; Courtauld Institute of Arts, London, 161 top, 184 bottom; Deutsches Archaologisches Institut, Athens, 49 top; Deutsches Archaologisches Institut, Rome, 61; Directorate General of Antiquities, Baghdad, 29 top, 29 centre, 29 bottom; Werner Forman, New York, 45 right, 112–113; Galerie Louise Leiris, 203 bottom; Giraudon, Paris, 33, 78 bottom, 101 right, 124, 125 left, 125 right, 153, 157, 170 top, 172 top, 178, 200 bottom, 201 top; Solomon R. Guggenheim Museum, New York, 209 bottom; Ara Guler, Istanbul, 76; Hamlyn Group Picture Library, 13 top, 17, 21, 25, 49 bottom, 53, 54 top, 56 left, 60, 81, 104, 110, 112 bottom, 114, 120 bottom, 121, 128, 130–131, 152 bottom, 168 bottom, 169 bottom, 176 left, 176 bottom, 192 centre, 193, 194, 205 bottom, 212, 213 top, 213 bottom, 218 top, 222 top, 222 bottom; Hatay Museum, Turkey, 37 bottom; Lucien Hervé, Paris 204 top; Hirmer Fotoarchiv, Munich, 28, 32, 41 top left, 44 bottom, 46, 48, 52 bottom, 62, 65, 68, 69, 177; Joseph H. Hirshhorn, 204 bottom; Franz Höch, 176 right; Humboldt Universität zu Berlin, 192–193; Irish Tourist Board, 12 bottom; A. F. Kersting, London, 88; Walter Klein, 208 bottom; Sir G. Keynes, London 188; Eugen Kusch, Schwartzenbruk,

221 top; Linden Museum, Stuttgart, 216 top; Mansell-Alinari, 56–57, 78 top, 85, 140, 141 bottom, 144, 148 bottom, 154 centre, 156, 160, 161 bottom, 164 bottom, 170 bottom, 185 top; – Anderson, 149, 154 bottom, 165 right; – Brogi, 141 top, 145 right; Bildarchiv Foto Marburg, 77 top, 77 bottom, 80, 92, 136, 145 left, 196 bottom; M.A.S., Barcelona, 9 right, 96 right, 97, 132, 166 bottom; Leonard von Matt, Buocks, 108 bottom; Metropolitan Museum of Art, New York, 96 left, 108 left; Photo Meyer, 165 left; Ministry of Public Buildings and Works, 169 top; Museum of Anthropology, Mexico City, 218 bottom; Musée Guimet, Paris, 102 top left; Museu Nacional de Arte Antiga, Lisbon, 148 top; Museum of Modern Art, New York, 201 bottom; 205 top; National Archaeological Museum, Athens, 12 top left, 50 left; National Buildings Record, 195 bottom, 197 top; National Film Archive, London, 200 top; National Gallery, London, 166 top; National Museum of Ireland, 72 bottom; National Museum, New Delhi, 101 left; National Museum, Tokyo, 116; National Tourist Organisation of Greece, 52 top; Nottingham City Art Gallery, 180 bottom; Ny Carlsberg Glyptotek, Copenhagen, 55 top left, 189 top; Oeffentliche Kunstsammlung, Basle, 208 top; Antello Perissinotto, 40 right; Josephine Powell, Rome, 100; Presse, Bild, Poss, Regensberg, 173; Rapho, Paris, 130 top; Dr. Oskar Reinhart, Winterthur, 192 bottom; Jean Roubier, Paris, 72 top, 127, 129, 137; Sakamoto, Tokyo, 13 bottom; Service de Documentation, Paris, 184 top; Julius Shulman, Los Angeles, 209 top; Staatliche Museen zu Berlin, 89 left; Studio Haig, Amman, 63 bottom; Wim Swaan, New York, 105; Taylor Museum, Colorado Springs, 216 bottom; Universitetes Oldsaksamling, Oslo, 9 left; C. Reyes-Valerio, Mexico City, 220 bottom; Vatican City Photographic Archives, 57 right; Victoria and Albert Museum, London, 180 top, 196 top; H. Roger-Viollet, Paris, 133, 168 top, 181, 217 top left; Josiah Wedgwood and Sons Ltd., 189 bottom; Achille Weider, Zurich, 8 top, 8 bottom.